Digital
Cinematography

Dedication

To my wife

Anne

With all my love

Digital Cinematography

Paul Wheeler BSC FBKS

OXFORD AMSTERDAM BOSTON LONDON NEW YORK PARIS
SAN DIEGO SAN FRANCISCO SINGAPORE SYDNEY TOKYO

Focal Press
An imprint of Elsevier Science
Linacre House, Jordan Hill, Oxford OX2 8DP
225 Wildwood Avenue, Woburn, MA 01801-2041

First published 2001
Reprinted 2002

British Library Cataloguing in Publication Data
Wheeler, Paul
 Digital cinematography
 1. Cinematography
 I. Title
 778.5'3

Library of Congress Cataloguing in Publication Data
Wheeler, Paul
 Digital cinematography/Paul Wheeler.
 p. cm.
 Includes index.
 ISBN 0 240 51614 1
 1. Digital cinematography. I. Title.

 TR860 W49
 778.5–dc21 2001033440

For information on all Focal Press publications visit our website at
www.focalpress.com

Printed and bound in Great Britain

Contents

Preface

When I joined the BBC's film department thirty-six years ago as their youngest trainee, video was a huge machine in an air-conditioned room. By the time I left to go freelance, by which time I had become a Senior Film Cameraman, the BBC was just introducing portable ENG video kits consisting of a camera and a separate U-Matic recorder. Those of us who used film and our colleagues who used video belonged to very different parts of the industry and it was rare, if not unheard of, for someone to cross the invisible divide. Now I have happily used, and written a book about, digital cameras that are roughly the size and weight of the most sophisticated Super 16 mm film cameras. Time has certainly moved on.

With my first book *Practical Cinematography* I set out to put down all the technical and craft knowledge that a film cinematographer would need to know to work as a Director of Photography. In this book I am attempting to do the same for the digital cinematographer. The scope of the book ranges from the basic science through the procedures that a cinematographer will need to go through to set up a shoot, to a chapter dedicated to high-definition cinematography.

Digital Cinematography has evolved from the papers I wrote for the highly successful Digital Cinematography short course I devised and still run at the National Short Course Unit. I always felt that cinematographers gain just as much from images as from the written word, we are, after all, picture people, and I have therefore included 125 illustrations.

The objective of this book is to inform the student and working cinematographer alike and hopefully persuade some of my colleagues that, after years of shooting film, digital cinematography can be both very rewarding and great fun.

About the author

Paul Wheeler has a wealth of practical experience both as a film and digital cinematographer combined with wide experience as a highly respected trainer. He has also written the companion book to this entitled *Practical Cinematography* which covers much the same areas but for film cinematographers. After twenty-five years with the BBC, by the end of which he was one of only six Senior Film Cameramen out of a total of sixty-three DoPs employed there at that time, he left to go freelance.

In the eleven years since leaving the BBC, Paul has had a flourishing career which has bought him many awards including two Independent Producers Association (INDIE) awards for Digital Cinematography. In between shoots he has stood in as Head of Cinematography at the National Film and Television School several times and has also spent a couple of terms as Head of Cinematography at the Royal College of Art MA course. He is also a regular visiting tutor at the London International Film School. He has designed and run the highly respected Digital Cinematography course at the National Short Course Training Programme.

Paul is a member of the British Society of Cinematographers (BSC) and a Fellow of the British Kinematograph, Sound and Television Society (FBKS). He now prefers to limit his training to short courses and writing as this is easier to fit into his busy shooting schedule.

Acknowledgements

Neil Thompson of Sony UK who has shown great enthusiasm and support for this book as well as unbounded patience. Significant contributions have also come from Deanne Edwards, Paul Turtle, Alan Piper and Gary Willis.

I should also like to thank Chris Hunt and Richard Price of the Performance Company and Iambic Productions together with Clive Parsons of Film and General Productions for their generous support and for permission to quote programmes I shot for them.

For many of the shoots quoted in this book I was fortunate enough to have as my Camera Operator Ian Powell who died in a car accident in 1999. I miss his skill and friendship greatly.

All the illustrations are the copyright of the author with the exception of:

Copyright Sony UK – the cover picture, Plate 9 and Figure 11.11.

Introduction

Digital cinematography is a relatively new craft. While much may be learnt from the film world there are many other factors for the digital cinematographer to understand. This book is an attempt to encapsulate all the basic technical and craft knowledge needed to become a fine digital cinematographer.

The book is divided into six parts: Digital Cinematography; The Director of Photography's Craft; The Shoot; The Technology; High-definition Digital Cinematography; and The Sony DVW In-camera Menus. It is written in plain English with 125 illustrations. The layout of the chapters is designed to offer a book which can easily be read from beginning to end or, using the table of contents and the extensive index, the reader can find a particular subject that might interest them at a critical point in their shoot.

Many cinematographers from a film background might be wary of the new technology or simply feel they must dislike it on principle. This would be a very great shame for, as I hope this book demonstrates, digital cinematography can be an exciting system, capable of producing pictures of superb quality, and over which the cinematographer has far more personal control than with the film image.

Part One
Digital Cinematography

1
Why digital cinematography?

Introduction

There must be three groups of cinematographers that most often find themselves new users of digital cinematography. There is the traditionally trained and experienced film maker, the experienced video technician who probably fully understands analogue video and there is the student who might wish to work with the film medium but for reasons of cost find themselves shooting digitally.

It is wrong, these days, to look upon tape either as an inferior medium or as a direct replacement for traditional film techniques. At the introduction of photography the phrase 'from today painting is dead' struck fear into the hearts of many an artist and yet oil, watercolour and crayon all still flourish. The knowledgeable and skilled cinematographer, whatever camera they happen to be using today, will realize that digital cinematography is not a direct replacement for anything but an additional and exciting tool in the armoury of any visual storyteller.

Budgetary constraints are all-important but a sensible production will look at all the options and parameters that affect the decision as to what they are going to originate their pictures on. A production that will never be projected but is intended solely for television and perhaps containing a large number of effects would be well advised to look seriously at the Digi Beta camera for they will then be laying down their images in the same format in which they will be required to enter the effects post-production arena.

I have made several television series with excellent scripts and wonderful casts knowing full well that the decision to shoot on Digi Beta, and thus save money on origination costs, has helped pay for both the other inputs. Would we all not prefer a better script than a flashier camera? Of course, occasionally the budget allows you to have both and those productions can be especially rewarding.

If you refer to the chapters at the end of this book you will see that high-definition digital cameras are now challenging traditional feature film techniques. Again 35 mm is not dead, there is simply more choice for the discerning cinematographer, and long may our choices increase.

Exposure meters

The first thing that happens to a film camera operator when moving to digital cinematography is the loss of the exposure meter for much of the time. While a meter can be useful when prelighting a set, the cameras having a nominal equivalent ASA rating of around 320, during the actual shooting it is much better to have a well-lined-up colour monitor by which to judge one's work.

Tonal range

Cinematographers coming from a film background will also notice a much-reduced tonal range compared to film. Television sets, and indeed the transmitting system, are limited to a tonal range of the equivalent of a five-stop range of exposure. Some film negatives are capable of recording up to eleven stops of tonal range. It should be noted that the restriction in the tonal range is at the recording stage and not necessarily within the camera head. The colour receptors and the initial processing stages within a Sony DVW 700 or 790, for instance, are capable of dealing with some ten stops of tonal range. This means that within the camera you are making some of the decisions that you would normally make when you transfer on a telecine machine a film negative containing an image having a ten-stop range and lay this down onto tape which has only the five-stop range.

Exposure control

Because the tape will record only five stops of tonal range it is vital that the initial exposure is as accurate as possible. Unlike shooting film for television transmission where final decisions as to colour balance, density and gamma are made long after the initial exposure at the telecine grading, all these decisions should be made when using a tape camera at the moment of exposure.

With the film-to-tape process you always have a first image, the negative in this case, with far more information on it than you might need to transfer to tape. This allows a selection process to take place at this time. Once you have recorded your image within a video camera you have no selection process available. In tape-to-tape grading the image can be changed but there is no additional information to go looking for. It is this restriction on the later grading of a tape image that contributes heavily to the video look so hated by many film cinematographers. If the original recording can be exposed to give very closely the image that is desired for the final transmission then the image should be much more acceptable to a film person's eyes.

Image stability

More and more television is being shot on location, sometimes with a very small multi-camera outside broadcast (OB) unit, but increasingly frequently with a single camera in a style similar to traditional film making. While later analogue cameras produced a very acceptable image the very nature of the electronic signal meant that every time it was shown or rerecorded the image might be fractionally different. With a digital signal where every value is written to the tape as a number using

a binary code it is almost impossible for the image produced to alter in any way. This leads to a very robust image that can go through many postproduction layers without any discernable deterioration.

Greater perceived detail

A digitally recorded picture will, quite possibly, be perceived to have more detail or greater clarity than the same image recorded by an analogue process. This in the main will be because there will be far less picture noise to interfere with fine detail rather than the detail itself being finer.

Repeatability

Another useful difference between analogue and digital cameras is that many of them have a removable set-up storage medium. The Sony DVW 700 cameras, for instance, have a solid-state camera control card (CCC) onto which can be recorded all the parameters to which the camera has been set. This has several advantages. As all the settings are also made in the digital domain, that is, they have number values, then every time the settings are read from the card to the camera the image produced will be identical. Restoring the full range of camera parameters with an analogue camera was never as precise or reliable.

If you are working with several cameras at once getting them to match is simply a matter of setting up one camera to your liking, recording the settings, removing the card or storage medium and inserting this into another camera and reading the settings from the card to the new camera. Both cameras will now produce the same imagery.

Portability

The latest breed of digital cameras, which are sometimes referred to as camcorders for they contain both the camera head and the VCR (video cassette recorder), are very portable, weighing only a little more than the earlier generation of analogue cameras. The increase in weight is often only created by the need for an on-board battery of greater capacity, for the digital processors are a little more power-hungry. A modern digital camera will probably be a little larger than a 16 mm camera and a little smaller than a 35 mm camera.

Part Two
The Director of Photography's Craft

2
Creating a look

Decide what you want

The first thing to do before you even switch on the camera is to try to see in your mind what you wish the image on the monitor to look like. This is known as previsualization. It is not always possible – sometimes you just have to put time aside, perhaps lunchtime during a shoot, and work through the menus until you get a feel for where you want to go. Remember that if you end up with something you hate you only have to put in your original camera control card and press 'read' to get back to your original settings in just a few seconds so even wild experimentation is quite safe.

If you have been able to decide in what directions you want to push the image they will usually come under a small number of easily defined headings such as:

Sharp or soft
Cold or warm
Colours saturated or desaturated
Do you wish to reduce skin tone detail?
Are you going for a 'film look' ?

The cameras are very capable of giving you considerable control over all these parameters. Here are a few pointers as to what you might like to do. Much more information on individual settings can be found in Chapters 19 and 21.

Sharp or soft

The Sony DVW cameras allow you considerable control over various kinds of definition in the images they produce. You can vary both the vertical and horizontal definition, alter the crispening, which deals more with tone-to-tone edge definition, or simply vary the amount of detail shown. Detail is the nearest variable to that which a film cinematographer would understand as definition or sharpness and on all but the rarest occasions I make this my primary adjustment for this parameter. More often than not I reduce the detail from the factory setting and

would suggest you might like to try −15 as a starting point if you wish to go in the same direction. For this parameter minus numbers reduce the definition.

If, on the other hand, you are about to photograph an ultra-modern glass and steel building you may wish to emphasize the hard edges of the shapes and resetting to +10 might appeal to you. The great thing is that with the aid of a decent monitor, even a high-resolution 9-inch will be good enough − you can see exactly what you are getting.

Cold or warm

There are two useful ways of changing the overall colour with the DVW 700 camera and three with the DVW 790. The first and most obvious is to go to the matrix page and alter the basic response of the camera. If you increase just three of the matrix lines R–G, G–R and B–R you will warm up the response of the camera. I only ever move all three of these values by the same amount and I find 10 units to be quite a pleasing overall warming of the image.

The second way is via the white balance. If you white balance on a very pale blue sheet of paper the camera will remove the blue tinge of the paper and make it look white thus adding an overall warmth to the picture. I used to do this a lot with analogue cameras but find moving the matrix settings in the digital cameras more successful for the effect is then utterly repeatable.

There is a third way if you are using a DVW 790. You can go to the page controlling white balance and set it to be warmer or colder than standard. If you do this, and then white balance on a white card or paper, the warmth or coolness you have chosen will automatically be added to the image.

Saturation and desaturation

It is very simple to increase or decrease the saturation of the image. You simply add or subtract value to all the lines on the Matrix page. I usually like a slightly desaturated look compared with the factory setting so I often set all my Matrix values to −7. If you are looking for a punchier effect try zero or even +7. Either way your monitor will tell you what your setting will look like.

If you wish to both desaturate and add warmth, say, then you can make the adjustment across the board for saturation and then add the numbers in the three lines you would have put in for colour control only.

Skin tone control

You have independent control of the amount of definition you can take out of skin tone. On the DVW 700 you simply set numbers, remembering that in this setting positive numbers reduce skin tone definition. In the DVW 790 menu there is a further series of settings. You can grab the particular skin tone you wish to affect. This can be useful if you wish to affect one actor more than another. It is also possible to grab a skin colour and alter the colour, though I have never found a use for this that can't be achieved a quicker or simpler way. For instance, slipping in a Wratten 812 filter will nicely warm up an actor on a cold day and is much quicker than having to find the appropriate page and make

changes, then go through the whole routine again when you want to remove the effect.

The film look

For the DVW 700 Sony can supply four camera control cards that are supposed to emulate the look of Kodak's four most popular film stocks. The DVW 790 has, within its menu, the most popular of these so that it can simply be switched in. You will find this under Gamma table on the page labelled Level 8.

My own feeling is that this approach does not really work, I don't like the look they give, I do not find it gives a convincing emulation of a film image. To my eye one is degrading the quality of the digital image to try to, unsuccessfully, produce an image from a different medium.

My own approach is to look at what the digital cameras can do really well, try to understand the parameters that affect the digital image and work within this new and slightly different palette. One would not try to paint a picture in oils while attempting to make it look like a watercolour.

Nevertheless if you are using a DVW 790 the 'film look' comes free so I recommend you switch it in some time and decide for yourself if it is to your taste.

3
Lighting

Useful styles

All video cameras seem to be more at ease with softer rather than harder lighting. This may well be because as the recordable tone range is limited and only encompasses five stops of exposure, or a lighting ratio of 32:1, they are prone to burning out highlights more quickly than film. They also do not fade from dark greys gracefully into black in the same way as film but once they reach the limit of their shadow recording ability, clip to full black. The digital cameras are, however, much better than analogue cameras at controlling the progress into the limit of both the highlights and the blacks.

It is possible to program the digital cameras via the parameters on the page labelled Level 4 which includes Master black, Master black gamma, Knee point, Knee slope and White clip, etc. By using these controls, which are more fully explained in Chapters 19 and 21, you can arrange for a roll-off into maximum white and minimum black. You cannot, however, extend the recordable tonal range beyond 32:1, only make for a smoother transition into the extremes. Handled carefully, this can lead to an attractive result.

I find it is always better to work with rather than fight the look of any system, be it chemical or electronic, and the difference between a digital camera and an analogue camera and, indeed, a modern film emulsion is no more than the developments we have seen in the photographic emulsions over the last fifteen years.

Soft lighting

The modern digital cameras handle soft light really well but don't be afraid of making that soft light come from quite an aggressive angle, if you wish bring it round oblique and high to the subject's face. If your subject is strongly featured and playing a strong character this will serve them particularly well. Having used an aggressive soft light you will find you need very little, if any, fill light with these cameras. This can be a wonderful bonus and is a feature you should explore. I suggest you never add fill light until you have looked carefully at your monitor to observe the effect of such a key light.

The reason these cameras don't need as much fill light may, in part, be due to the fact that the camera head can handle ten stops, a lighting ratio of 1024:1, but the electronic processors turn this into a five-stop, 32:1 ratio, before sending it to the video recorder. As a result of this interpolation I get the impression that the lower order of brightnesses coming out of the camera head are boosted and this would give the effect of there being more fill light.

There are many books that extol the single-source lighting set-up – if only one could get away with it. With these cameras this can sometimes actually be achieved. If you have achieved it but find the result a little boring (possibly there is little separation between the subject and the background) add a little backlight. You will need less than on film because of that shorter tone range. It does not matter which side you bring it in from: the same side as the key light is more logical as light in most environments tends to come mainly from one side but it may simply look more attractive from the opposite side from the key as this will be the darker side where a backlight will appear to have more effect.

The soft light I use most is a simple quartz lamp, often a redhead or a blond, bounced off a Lastolite collapsible reflector. If I am going for a glamorous or warm and friendly look I will often make this a gold reflector. If I want glamour with a slightly harder edge I use the reflector known as Sunlight. This has slightly less warmth and is more reflective, giving a slightly harder edge to the shadow. On location I find Lastolites invaluable. They take up very little space when folded, are very durable and with the universal bracket can be quickly attached to a conventional lighting stand. They also work very well outdoors where they can provide a lovely soft fill without the apparent source you would get from using a lamp.

Hard lighting

Digital cameras can photograph a scene lit with hard direct lighting but do watch your monitor for any area on the subject's face that goes to full black, as this is often unpleasant. Strangely, when using hard light with these cameras much greater care must be taken with the strength and positioning of a fill light than with film lighting.

Coloured sources

The digital cameras handle mixed colour light sources far better than film. I often exploit this. The modelling of any scene, particularly the human face, relies on the difference in values of the various light sources landing on that face. It is the contrast between the values that produces the modelling. The recordable brightness range of these cameras is limited but coping with mixed colour lighting is extended compared with film. One can increase the apparent contrast between sources by changing the relative brightness or by changing the relative colour differences, or both. Try lighting a face with the very low ratio of 2:1, the key being only half as strong as the fill light. Now add a backlight with only the strength of the fill. It will not look too exciting. But now put a quarter CTB (colour temperature blue) filter on the backlight and a quarter CTO (colour temperature orange) on the fill light. Now bring up the strength of these two lamps to the same strength as they were before you added the filters. They will need an increase of around a third of a stop to

compensate for the absorption of the filters. If you now look at your monitor it will seem to be much more dramatic. The contrast between the sources will have appeared to increase, indeed it has, for you have added colour contrast to brightness contrast.

4
Lighting ratios

Defining a lighting ratio

A lighting ratio is the figure we give to a measured relative difference in brightness between two parts of a scene. As opening the aperture by one stop doubles the amount of light reaching the camera, two surfaces where one is brighter by one stop of exposure than the other will therefore have a lighting ratio of 2:1.

Where there are several surfaces, each a stop brighter than the next, each time you open the range of your comparative readings by one stop the amount of light reaching the film will double, therefore the lighting ratio will double. Figure 4.1 shows the relationship between the difference in brightness measured in stops against the resultant lighting ratio.

```
1 Stop Range = Brightness Range of 2:1
2 Stop Range = Brightness Range of 4:1
3 Stop Range = Brightness Range of 8:1
4 Stop Range = Brightness Range of 16:1
5 Stop Range = Brightness Range of 32:1
6 Stop Range = Brightness Range of 64:1
7 Stop Range = Brightness Range of 128:1
```

Figure 4.1 Lighting ratios

Visualizing lighting ratios

It is important, before lighting a scene, to be able to visualize the lighting ratio you are going to use. It is very time consuming to have to change your ratios after you thought you had finished lighting the set, it is unprofessional and the delay makes you unpopular with the production office.

In order to easily visualize lighting ratios look at Figure 4.2. Here the lighting ratio between the highlight and the body of the sphere is 2:1. The ratio between sphere and shadow is again 2:1. From shadow to the deep shadow is 4:1. The chart at the lower half of Figure 4.2 shows all the various ratios between all the parts of the sphere and its shadow.

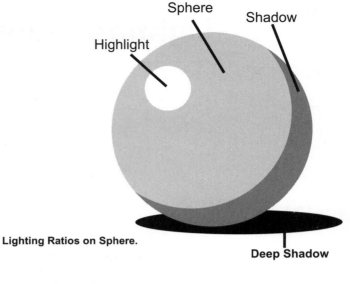

Sphere

Shadow

Highlight

Lighting Ratios on Sphere.

Deep Shadow

Highlight : Sphere = 2:1

Sphere : Shadow = 2:1

Shadow : Deep Shadow = 4:1

Highlight : Shadow = Highlight : Sphere x Sphere : Shadow = 4:1

Highlight : Deep Shadow =

 Highlight : Sphere x Sphere : Shadow x Shadow : Deep Shadow = 16:1

Sphere : Deep Shadow = Sphere : Shadow x Shadow : Deep Shadow = 8:1

Keep this sphere in mind and you will easily visualize all the important brightnesses on any set.

Different lighting ratios for film and television

Even the finest cinema screen can reflect only a limited amount of light. In a very good cinema the difference between the darkest perceivable black and the whitest white will measure a difference of no more than seven stops. The black will never read as absolute black for there will always be some spurious light, even if it is only that which has arrived as atmospheric flare, for the highlights in the scene displayed have to travel through the atmosphere in the cinema. The film cinematographer's lot has been much improved since smoking was banned in many cinemas.

This means that the maximum lighting ratio that can be displayed in the final product is 128:1, the equivalent of seven stops of exposure dif-

ference. It is important to realize that any parts of the scene outside this ratio of 128:1 will have, on the screen, no detail or information in them whatsoever. They will appear as either solid black or solid white. Keeping all the important information in a scene within the lighting ratio of the final delivery system is therefore crucial to the success of the scene.

When shooting for television matters are more constrained. If you look at your television screen when it is switched off it will appear to be dark grey. This is as dark as it will ever get. When a picture is displayed on the television screen parts of that picture only appear black, or darker than the screen when switched off, because of the way our eyes and brain expect to perceive the relative brightness between the highlights and the shadows. A strong highlight anywhere in the scene will make the blacks appear darker still.

Even the finest television screen can only display a brightness ratio of 32:1 or the equivalent range of five stops of exposure range. It is important, therefore, not to light anything in a scene that you feel the audience should be able to perceive, even if only as a faint texture, outside a lighting ratio of 32:1. As with the cinema, but now over a much restricted range, any part of the scene outside this range will appear as either solid black or solid white. Parts of the scene that are solid black or white on a television screen are far less pleasant than in the cinema for they attract electronic noise and, as this is an unnatural phenomenon in normal vision, even an untrained viewer's eye and brain will instantly know something is wrong. This must therefore be avoided.

Using lighting ratios on the set

The most common use we put lighting ratios to is the control of how we light the human face. If you have successfully lit a face and you find it particularly pleasing for the mood you are looking for, then the simplest way of noting your success, at least in part, is to record, or simply remember, the lighting ratio.

If you were lighting a rather light piece with, say, a leading lady aged perhaps late forties but playing a part written as thirty or so, a lighting ratio of 2:1 would be very flattering. This is because with the brighter side of the face only twice the brightness of the darker side the shadows in the smile lines by her eyes would only be half the brightness of the lit side of the face. As there would be little difference in brightness between the smooth skin and the lined skin the lines would hardly show – all very flattering.

Using the same principle, but in reverse, your leading man in the same piece might benefit from a lighting ratio of 4:1. This would make him, certainly by comparison with his leading lady, a little more rugged than perhaps in real life, often a benefit.

Were you to be lighting a more dramatic piece, say a thriller, then you might let the lighting ratio on your leading man rise to 8:1 or three stops' difference. The night scenes for the same film might rise to 16:1 but this is very dramatic. The detail in the shadowed side of the face is going to start to disappear soon and will almost certainly show as black on television.

Controlling the whole scene

As we have seen, the overall lighting ratio that can be shown on television is 32:1. The digital camera does not quite conform to this rule. While the VCR (video cassette recorder) can only record an image with a brightness ratio of 32:1 the camera head is capable of converting an image with a somewhat greater range into an electronic signal. The internal circuitry then compresses or converts this range to one that can be handled by the recorder. The degree to which this electronic compression is allowed to take place and the decisions made by the designers can greatly affect the naturalness of the image, especially of a high-contrast scene.

The effect of not recording the whole scene

In nature an outdoor scene can easily have a lighting ratio of something like 2000:1. Imagine how Plate 1 might look if you were standing behind the camera. Deep in the shadow under the trees on the far right of the picture you might get a spotmeter reading of T1.4. A reading on the sunlit snow on the top of the far mountain might give a value of T48. Here is a range of eleven stops giving a lighting ratio of 2048:1. As far as I know there is only one film stock available to film camera operators with a range approaching 11 stops and video cameras, even the finest digital cameras, cannot approach anything like this range.

The examples shown here can only display the principles involved for even the finest printing on the best paper can only provide a reflected brightness range of 16:1 or a range of four stops. Nevertheless if you first look at Plate 1 and imagine this as the original scene, then think what kind of image you would record only using a portion of the full tonal range. Plate 2 has only three quarters of the tonal range of Plate 1. One eighth has been taken away from the shadows and one eighth from the highlights. Now suppose we record this reduced image, store it and then bring it back to display it at as high a brightness ratio as possible. The result would be much as shown in Plate 3. The darkest part of the recorded image has been stretched back to the blackest black the medium can achieve and the whites have been stretched out to the peak white of the chosen medium. In this example the blacks and the whites have been stretched out to the same value as in the original image (Plate 1).

The final image (Plate 3) has changed as a result of being stored as a package containing only three quarters of the information in the original scene. If you look carefully at the tree on the left of the picture in both Plates 1 and 3 you will notice that virtually all the information about the pine needles has disappeared and the tree is now just a silhouette. If you now make the same comparison between the snow on the peak of the far mountain in the two illustrations you will see that again the fine detail information evident in Plate 1 is missing in Plate 3.

This is a common failing in low-end video cameras. In top-end digital cameras these matters are handled very well and only rarely will the effect be noticeable to a lay audience but the digital cinematographer needs to be continuously aware of this phenomenon and make sure it is kept within acceptable levels using the camera menus, filters such as Tiffen Ultra Con's and, for a scene such as Plate 1, remembering to have the DCC (dynamic contrast control) program on the camera switched on if the camera has one.

My choice of illustration was not accidental for during the taking of this still I was also shooting with both 35 mm motion picture film and a Sony DVW 700 camera. It is interesting to note that while the still, originated on 100 ASA film in a Canon Ixus camera and scanned directly from the negative for publication, the 35 mm print and the Digi Beta image are all subtly different, they are all very attractive and each medium has handled this image with its very long tonal range in an admirable fashion.

This only goes to show that one does not have to be too concerned with these matters but simply to be aware of them and take appropriate action to obtain the finest image possible.

5
Colour temperature

What is colour temperature?

Colour temperature is important to the digital cinematographer for a number of reasons. Technically it is vital that any light source that is to appear neutral in the final rendition of the scene is emitting light of the same colour balance as that for which the camera has been set up. Artistically it is important that the cinematographer has an understanding of the psychological and emotional effects of the colour of light within a scene and that they have complete control over this colour.

In order to evaluate and control anything we must have a unit of measurement and a means of measuring. We measure differences in colour temperature in degrees Kelvin (°K) sometimes using a colour temperature meter.

The unit of measurement, °K, is named after William Thomson Kelvin, a British physicist who, at the end of the nineteenth century, developed a means of quantifying that which makes colours different. His experiment was quite simple. He took a beam of daylight coming through a hole in his window shutters and caused it to pass through a simple glass prism so as to form a rainbow effect on the opposite wall. He then placed a standard mercury thermometer in the path of each separate colour and noted that the reading was very slightly different. Thus he discovered the relationship between the colour of light and the temperature that relates to it.

Kelvin didn't leave his discovery there but went on to propose that if a black body, i.e. one having no reflective surfaces and which can therefore only emit light, is heated to a glowing state then the light coming from it will have a different colour depending on the temperature to which the body is heated. The classic way to illustrate this is to imagine a poker being put into a fire. Initially the poker is black iron but as it warms it first glows deep red then a straw colour and as it becomes hotter still it appears white. If the fire were hot enough, say something akin to a blacksmith's furnace, then eventually the iron would appear to be a blue/white.

Here we must guard against a simple confusion. At lower temperatures the colour emitted by a heated black body is red and at higher temperatures blue, but we think of red as warm and blue as cold. Our

emotional reaction to colour comes from nature where cold days are thought of as lit by blue light (snow scenes, for instance) but we react to red scenes as warm – think of a room lit by a log fire. So remember, the actual temperature required to achieve a given colour temperature is the reverse of how we emotionally react to the colour of light emitted.

The colour temperature of a source is deemed to be the temperature of the source in degrees Centigrade plus 273°C, minus 273°C being defined as the temperature of absolute zero. In practice we find that there are some slight changes, some physical and some due to the source not being a truly black body. Therefore a tungsten filament lamp will have a colour temperature approximately 50°K above the actual temperature of the filament.

Filters and Mired shift values

In order to change the colour, and therefore the colour temperature, of a light source we usually put a filter in its path. A blue filter will cause the light passing through it to appear more blue but it will also reduce the intensity, or amount of energy, of the light. This is because despite, occasionally, the evidence of our eyes filters do not add colour but can only absorb or subtract colour. A blue filter will therefore be absorbing red light in order to make the subsequent light appear more blue. It does this by converting the light absorbed into heat which, as we saw earlier, has a direct relationship to light, they both being a vibrational energy. It is important to remember this for it is one reason why gelatine filters on lamps first bleach out and eventually burn through.

In order to evaluate the effect of a filter we must have some unit with which to measure its effect. These are called Mired shift values. A Mired value is a mathematically more useful measurement for this purpose than degrees Kelvin but still represents, albeit in a different form, the colour temperature of light. A Mired shift value is therefore the shift in the colour temperature of the light passing through it that any given filter can cause to occur.

Before going any further it should be understood that in practical digital cinematography one never has to calculate the mathematics – one looks at the monitor, refers to the tables or switches the colour temperature meter to give a direct read-out in shift values. The formulae are shown here as an explanation of the cause and effect of the theory.

A Mired value can be expressed in the mathematical form:

$$\text{Mired value} = \frac{1,000,000}{\text{Colour temperature in degrees Kelvin}}$$

A conversion table (Figure 5.1) shows at a glance the Mired values of colour temperatures from 2000°K to 6900°K in steps of 100°K.

ºK	0	+100	+200	+300	+400	+500	+600	+700	+800	+900
2,000	500	476	455	435	417	400	385	370	357	345
3,000	333	323	312	303	294	286	278	270	263	256
4,000	250	244	238	233	227	222	217	213	208	204
5,000	200	196	192	189	185	182	179	175	172	169
6,000	167	164	161	159	156	154	152	149	147	145

Figure 5.1 Colour temperature relative to Mired shift values

Certain filters have the ability to convert light from one colour temperature to another. The Mired shift value will be approximately the same at any given starting value. Therefore for a given filter the change in colour temperature caused will be more or less the same if the source of light starts at 2000°K or 6000°K. This makes choosing correction filters very simple.

Each filter can therefore be categorized as having a particular Mired shift value irrespective of the light source it is affecting. The value of this Mired shift can be expressed as:

$$\text{Mired shift value} = \frac{10^6}{T2} - \frac{10^6}{T1}$$

where T1 represents the colour temperature of the original light source and T2 represents the colour temperature of the light after passing through the filter.

The Mired shift value can be either positive or negative. If filters deal with changes in the blue or red part of the spectrum they are called light-balancing filters (LB filters). Brown or reddish filters, shown in the left-hand column of Figure 5.2, lower colour temperature but the Mired value will, being a reciprocal function, be increased. Such filters, therefore, have a positive value. Bluish filters, shown in the right-hand column of Figure 5.2, have a negative value.

Filters which deal with the green, or its complementary colour magenta, are known as colour compensating filters (CC filters). They work in exactly the same way as light-balancing filters in that the value is always added allowing for its mathematical sign. Figure 5.3 shows the shift and filter factors for CC filters.

Colour-compensating filters have only a limited use in digital cinematography as they are primarily available for fine-tuning colours in transparency or reversal work. They do come into their own, however,

Figure 5.2 Filter Mired shift values

Positive – towards Red				Negative – towards Blue			
Filter		Mired Shift	Filter Factor	Filter		Mired Shift	Filter Factor
81	-	+9	⅓	82	-	−10	⅓
81a	-	+18	⅓	82a	-	−21	⅓
81b	-	+27	⅓	82b	-	−32	⅔
81c	-	+35	⅓	82c	-	−45	⅔
81d	-	+42	⅔	80d	-	−56	⅓
81EF	-	+52	⅔	80c	-	−81	1
85c	-	+99	⅓	80b	-	−112	1⅔
85	-	+112	⅔				
85b	-	+131	⅔				

Figure 5.3 Colour compensating filters

Positive – towards magenta				Negative – towards green			
Filter		Value	Filter Factor	Filter		Value	Filter Factor
5m	-	+2	⅓	5g	-	−2	⅓
10m	-	+4	⅓	10g	-	−4	⅓
20m	-	+8	⅓	20g	-	−7	⅓
30m	-	+13	⅔	30g	-	−10	⅔
40m	-	+18	⅔	40g	-	−13	⅔

when a cinematographer has to work with available light from fluorescent tubes which often have an excess of green light. This discrepancy can be corrected by putting the appropriate magenta filter (magenta being the complementary colour to green) over the tubes or in front of the lens if no other source of light is to be added.

Filters have another important value, their filter factor, and this is also shown in the tables in Figures 5.2 and 5.3. This is always expressed as the part or whole of a stop on the lens and as a fraction of a real number or a real number plus a fraction. This is the amount that the lens must be opened up to allow for the amount of light absorbed by the filter. Therefore a filter factor of ⅓ will need the aperture to be opened by a third of a stop. Similarly, a filter factor of 1⅔ will need the lens aperture to be opened by one and two thirds of a stop.

Here it is important to understand the difference in approach when adding together Mired shift values and filter factors. If you put two filters in front of the lens then you will combine their Mired shift values taking regard of their mathematical sign. i.e. combining two filters having shift values of +35 and −10 will result in a combined Mired shift of +25. But if their filter factors were ⅓ and ⅓ then the combined filter factor will be ⅔ and the lens must be opened up by two thirds of a stop. Filter factors are always positive so are always added together.

In practice it is usual to consider changes of 100°K or more as important as this is the smallest change the eye is likely to notice unless it is possible, within the scene, to compare the sources, in which case differences down to as little as 20°K may be noticeable. This may occur, say, when a row of windows have one lamp each outside them representing sunlight. In this case very accurate measurement and filtration of the lamps will be required to get them all within a 20°K range.

The colour temperature meter

Colour temperature meters come in two basic forms reading either two colours or three. The two-colour meter reads only blue and red. It is not sophisticated enough for a working cinematographer but is useful for setting filters on lamps, as this usually only concerns blue and red.

The best colour temperature meter you can possibly obtain for digital cinematography is a well-lined-up colour monitor. Here you will be able to see, instantly, any problems and very easily gauge how much, and what, correction is needed.

In the unlikely event that you need to light a set in advance of the arrival of the camera and monitors, and assuming you judge that this location has some colour problem, you will need a colour temperature meter. A three-colour meter is required if readings are to be made from fluorescent tubes, mercury vapour lamps, etc. as all these sources have problems in the green or magenta spectrum.

The most popular meter in this category is the Minolta. This meter can be set to read directly in degrees Kelvin or can have any colour balance programmed into it. It can then be interrogated to read in the Mired shift values needed to correct the light source to a camera set up for either tungsten or daylight via its internal filter wheel. The meter will give both positive and negative values. There is also a chart on the back of the meter very similar to that shown in Figure 5.2 so that the equivalent internal camera filters or Wratten filters in front of the lens can be chosen without the need to make reference to any other source.

Figure 5.4 Colour temperature of various light sources

DAYLIGHT SOURCES		
Candle Flame		1,930 °Kelvin
Dawn or Dusk		2,000 °Kelvin
An hour after Sunrise		3,500 °Kelvin
Early Morning/Late Afternoon		4,500 °Kelvin
Average Summer Sunlight		5,500 °Kelvin
Sunlight from a blue/white sky		6,500 °Kelvin
Light Summer Shade		7,000 °Kelvin
Overcast Sky		7,000 °Kelvin
Average Summer Shade		8,000 °Kelvin
Hazy Sunlight		9,000 °Kelvin
Summer Sky	up to	20,000 °Kelvin
ARTIFICIAL LIGHT		
Domestic light bulb		2,800 °Kelvin
Photographic Incandescent Bulb		3,200 °Kelvin
Tungsten Halogen Bulb		3,200 °Kelvin
Photoflood		3,400 °Kelvin
3,200 °Kelvin +¼ blue Filter		3,600 °Kelvin
3,200 °Kelvin + ½ blue Filter		4,100 °Kelvin
3,200 °Kelvin + full blue Filter		5,550 °Kelvin
HMI, CID & MSR Lamps – approximately		5,500 °Kelvin

Location sources

Figure 5.4 shows the colour temperature of a number of known light sources. It is interesting to note that a drop of 1 volt in the power supply to a tungsten bulb will usually drop the colour temperature by approximately 10°K.

For the digital cinematographer wishing to re-create daylight convincingly it is important to understand that the different sources – direct sun, shadow and deep shadow – will all have different colour temperatures. There are a number of reasons why the different kinds of daylight have different colour temperatures. Direct sunlight varies, mainly, due to the amount of the earth's atmosphere it has to pass through and the amount of cloud in the sky. In the morning and afternoon the light has to pass obliquely through the atmosphere and at noon it is taking the much shorter path directly from above. This together with dramatically varying amounts of water suspended in the air will clearly change the colour of the light that is passing through the atmosphere.

In the shadowed area matters are different. If a reading is taken with the meter turned directly away from the sun, but still in the same place as where the sunlight reading was taken, the light reaching the meter will be that reflected off the clouds and the atmosphere itself, and this will be bluer than the direct sunlight reading. In the deep shadow there will be no direct sunlight and all the light will be reflected. It will therefore be bluer still. This is useful in that getting those colours right can give a powerful message to the audience as to the time of day of the scene.

Figure 5.5 shows a number of readings which were taken in early August in London when sunrise was 5.28 am. As you can see, the direct sunlight and the shadowed readings are almost transposed in the three and a half hours from morning to noon.

Figure 5.5 Colour
temperature at various times
of day

Direct Sunlight	Shadow i.e. meter turned away from sun	Deep shadow
8,30 AM 4,500 °K	5,300 °K	6,400 °K
Noon 5,350 °K	4,550 °K	5,450 °K

Correcting lamps

Correcting may not be an entirely accurate word in this context. We use it when we want to convert a tungsten lamp to daylight or a daylight lamp to tungsten. You can, of course, make partial conversions, as we shall see.

To convert a tungsten lamp to daylight you must put a full colour temperature blue (CTB) filter in front of the lamp. You will lose a considerable amount of brightness as, due to the filters absorbing the red light, the lamp has become much less efficient. To convert a daylight lamp (say, an HMI) to tungsten you must put a full colour temperature orange (CTO) filter in front of the lamp. Again you will lose a considerable amount of brightness, though not quite as much as in the previous example.

To convert a daylight scene for a tungsten-balanced camera you either use the internal filter wheel or put a Wratten 85 filter in front of the lens.

Of course, you can make partial conversions for the sake of art. For instance, if you were to film an interior that had a practical window in the shot with a daylight scene outside it and you wished the window to be just a little colder than the interior, thus heightening the feeling of separation between the interior and the exterior, then you might decide to achieve this as follows.

The exterior you can do little about without going to considerable trouble so leave it as daylight, say, 5500°K. Light the interior with light corrected to half daylight, say, 4100°K. You achieve this by using tungsten lamps with half blue filter (½ CTB) or daylight lamps with half orange (½ CTO) filter. Which you choose matters little, it just depends on what is more convenient.

You now have an exterior that appears colder than the interior. If you correct the camera to the interior you have achieved the objective. You do this by using either the intermediate filter in the camera wheel or putting on the lens a filter equivalent to a half CTO. This filter is the either the camera's 4300°K internal wheel or a Wratten 85C (Mired shift value = +81).

Now camera and interior are in harmony and the exterior appears a little cool. This can be a very pleasing effect.

If you were shooting the above scene from the outside and wanted to make the interior look cosy and warm then leave the lighting exactly as it is and correct the camera to full daylight. Simply change the camera filter to the internal 6300°K filter or put a Wratten 85 on the front of the lens. The exterior will now be colour correct and the interior will be warm and inviting.

Quarter blues (¼ CTB) are often used on backlights to increase the feeling of separation of foreground from background.

Night exteriors are often shot using tungsten film with full or half blue lamps. Full blue is often described, usually by those in Europe who don't like the effect, as American moonlight which is different from American night, which is what they call day-for-night in France. This comes from its, dare I say, overuse in some American films. There is good logic behind full blue, though.

What is moonlight? It is sunlight bounced off the moon and the moon is colourless or, at most, pale grey. The light leaving the moon after it has been bounced off will have been reduced in brightness but it will not have had its colour temperature changed in any dramatic way. When it arrives on Earth it will still be the full blue of pure sunlight by comparison with our tungsten foreground and film.

You must make the artistic decision on how blue you want your moonlight to be, but there is no getting away from it – real moonlight is roughly the same colour temperature as daylight.

6
Filters

Camera filters

We use filters in cinematography to alter the image either for technical reasons to correct the colour of the light to that required by the camera or, perhaps, because we may wish to change the image in some way that will enhance our storytelling powers. The former is often necessary, the latter much more fun.

The majority of digital cameras come with one, if not two, wheels between the lens and the splitter block. The Sony DVW 700, for instance, is factory-fitted with one wheel containing a clear space marked as 3200°K, this is the correct colour balance of the camera itself, a filter which corrects the camera to a light source of 4300, roughly equivalent to a Wratten 85C and a position marked 6300 which is a full correction of the camera to daylight. There is also a position on this wheel marked Cross Filter which is a light four-point star filter.

The second wheel has no colour correction and only concerns exposure being made up of neutral density filters. The first position is marked straight through and has, as one would expect, no effect. The second is marked ¼ ND and reduces the exposure of the transmitted image by a quarter or two stops, the equivalent to a 0.6 ND film filter. The third position is marked ¹⁄₁₆ ND and reduces the image brightness by four stops or the equivalent to a film filter of the value 1.2 ND. The last position on this wheel is marked ¹⁄₆₄ ND and reduces the image brightness by six stops. The equivalent film filter would be 1.8 ND. Marking the filters as a fraction of full exposure will seem very curious to anyone from the film industry as will the chosen Kelvin correction values. A balance of 3200°K is the same as that of tungsten film but 6300°K is very odd as all daylight motion picture films are balanced at 5600°K, the internationally recognized colour temperature of nominal daylight. Nominal daylight is deemed to be the average colour temperature of daylight where the sky is an even mixture of clear blue and cloud.

The majority of coloured filters which originate from the film world are known by numbers or a combination of numbers and letters – for instance, 85 and 85B. These are simply the catalogue number they are to be found under in the Eastman Kodak Wratten Filter Catalogue. All filter manufactures will use the Wratten Filter Numbers for their version

of the filter in their list that conforms to the transmission characteristics of the filter in the Wratten list. A Wratten catalogue complete with transmission graphs can be an illuminating read once you know how to interpret the information.

Effects filters are usually described by some term that indicates what change they will make to the image (for instance, fog filter, etc.).

Colour Compensating filters

Colour Compensating filters, or CC filters, are carefully stepped filters in the primary colours or their reciprocal colour. They are used, in front of the lens, to correct the source light to the film in use. They are in small steps so you need a lot of them to be able to cope with any situation. In reality we rarely use CC filters in digital cinematography. They are mainly used in still photography to obtain an accurate original transparency as with the reversal process there can be no correction later.

Colour Correction filters

This phrase usually refers to filters used to correct a daylight scene when shooting with tungsten-balanced film. The usual full correction filter is either the 6300°K internal filter in the camera or the Wratten 85 glass filter. The alternatives if you are using glass in front of the lens are:

Wratten 85 Full correction OR 6300°K on the camera internal filter
 85C Half the correction of the straight 85 OR 4300°K internal filter on the camera. Often used when interior is lit to the same colour balance so that any exterior, say through a window, appears slightly cold.

All the glass filters can also have a neutral density built into them. For the 85 these are available as 85BN3, 85BN6 and 85BN9. Each unit of 3 stands for a density of 0.3 which exactly halves the light passing through the filter. Therefore a 85BN3 reduces the exposure by one stop as compared with the straight 85. Likewise the 85BN6 reduces the exposure by two stops and the 85BN9 by three stops again in addition to the straight 85. There is also, in many digital cameras, a separate filter wheel which will introduce, just behind the lens, a series of neutral density filters. The markings on the filter wheel are very different from anything a DoP from the film world might understand. They are marked in something like ¼, ¹⁄₁₆, etc. These markings express the mathematical reduction in the exposure. As a film man I find this approach almost incomprehensible but needs must.

Skin tone warmer

A Tiffen 812 is very effective in warming up skin tone while having a negligible effect on the other colours in the scene. This is particularly useful for a close-up on a cold day.

Sepia, coral, tobacco, etc.

Just as you would expect from their names, these lend an overall colour tint to the scene. They often absorb quite a lot of light to do this. Test

them on a monitor before commencing your principal photography. This is not to say that they cannot be very effective, it's just rather surprising to find exactly what they do sometimes. A coral or a sepia are some of my favourites for a digital camera.

Graduated filters

Grads, as they are always known, are usually coloured or neutral density filters. They are used to colour, or darken, one part of a scene without affecting the rest of the scene.

If, for instance, you were using a neutral density grad to attenuate a sky that was too bright then you would need a filter taller than the actual frame size so that you would have enough to slide up and down in order to place the edge of the grad accurately on the skyline. If your standard filter size was 4" × 4" then you would order your grads in 4" × 6". A 0.6 (i.e. two stops) neutral density grad is probably the most useful – I always carry several. Grads can be ordered with either a 'hard' or a 'soft' edge. I find soft-edged grads are usually the more successful. They are usually supplied where the maximum density of the filter is either 0.3, 0.6 or 0.9. The lighter one would, for instance, be referred to as a point three ND grad.

Neutral density

Neutral density filters are used to open up the aperture at which you will shoot the scene. You have two choices, the internal camera filters or glass filters in front of the lens. This may be because you wish to reduce the depth of field for dramatic reasons or simply to improve the definition of the lens. Most lenses work best between T4 and T8.

Low contrast

Low contrast filters, as you would expect, reduce the overall contrast of the scene. They do this by bleeding some of the light from the highlight parts of the scene into the shadows and thus lightening them. They usually come in a set of five filters simply marked LC1, LC2, LC3, LC4 and LC5.

The light LC filters are also useful in certain situations for creating a more flattering close-up (see notes on matching later). It has to be admitted that the effect they give is usually more appealing when used with film than when used with a digital camera.

Ultra contrast

Ultra contrast filters are similar to low contrast in that they will bleed highlights into shadows but they will not cause halation or flaring around light sources or spectral highlights as will an LC filter. The LC filter works with light in the image area – the ultra contrast filter works with the incident, ambient light. They come in a range of eight filters marked: ⅛, ¼, ½, 1, 2, 3, 4 and 5. They are superb at bringing up shadow detail when used with a digital camera, I have achieved quite spectacular improvements to the shadows when using these. They are a must for me when shooting digital.

Fog

Fog, in reality, is caused by water droplets suspended in the atmosphere. This causes the image to be degraded more and more the further away from camera the subject is. This is simply because it has more water to penetrate. Fog filters attempt to emulate this effect. The lighter filters reduce both contrast and definition. The heavier filters make things go rather fuzzy, so do not reproduce the effect of nature very well. I'm not convinced by these filters.

Double fog

Double fogs affect flare and definition far less than standard fog filters while having a more pronounced effect on the contrast range of the image. It is claimed that objects near to the camera will appear less affected than those farther away. Again I'm not entirely convinced.

Pro-mist

Pro-mist filters give a glow or halation around intense sources of light that are in shot. They do this without reducing the contrast range as much as you might expect. Highlights become 'pearlized'. They are excellent on a digital camera as they do not reduce the definition as much as most of the other diffusion filters. They come in a set of eight filters marked ⅛, ¼, ½, 1, 2, 3, 4 and 5. I probably have a ¼ clear Pro-mist on the front of the lens for 80 per cent of my digital photography. Personally I'm not as happy with black Pro-mists for digital cinematography as they tend to clog up the blacks which, to my eyes, is already a problem with any video camera. Please don't take too much notice as this may just be a matter of personal taste.

Star

Beware the use of star filters – they can make things look like a poor version of 'Top of the Pops'. They now come in a bewildering number of versions – Vector, Hyper, North, Hollywood, etc. Most also have various numbers of points and widths between the lines on the filter that create the star effect.

I rarely use any but a four-point 2 mm star filter. This is the only one I carry in my own filter kit; anything else I so rarely use that I hire it in. Star filters also add a small amount of diffusion.

The Sony DVW 700 camera has a four-point star filter as the first filter in the density internal wheel. As you will have gathered, I am not too keen on star filters but if you wish to flatter a lady and are on a longish lens where the star effect will not be too apparent the diffusion that is introduced can be very attractive.

Nets

Nets have different effects depending on their colour. A white net will tend to diffuse the highlights into the shadows thus softening the contrast and making the scene higher key. Dark nets will often bleed shadows into highlights. Both will tend to take some of the colour with them.

I have a metal ring that slips over the back element of a Canon J8 lens

with a permanently glued-on very light piece of 10 denier stocking. The advantage here is that the effect remains more or less the same at all the focal lengths of the zoom whereas in front of the lenses the effect is different on differing focal lengths. This is mainly due to the variation in the amount of physical net in the optical path. The problem with this effect is that it is very strong – good for Christmas commercials but a little strong otherwise.

Be very careful that the net put in front of the lens does not become sharp enough to give you a pattern on the scene. This is a particular problem with any short focal length lens. It will become immediately apparent the moment you move the camera.

Nets will lend their own colour to a scene – a brown net will add an overall warmth and richness to the tones, for instance, the darker nets adding more to the shadows and the lighter nets to the highlights. Nets will also give a slight star effect to point sources. A candle flame shot with a black net can look very attractive and romantic.

Matching shots

You need to be very careful when using different focal length lenses during a scene on which you are using diffusion filters. Longer focal lengths will usually need less diffusion than shorter lengths. Fortunately these things are fairly WYSIWYG (what you see is what you get) but you have to look through with the stop on – it makes a difference.

Enhancing filter

This is a very unusual filter which brings out, or accentuates, just one colour without affecting any of the others. An enhancing filter affects the red and orange portion of the scene. If you are to photograph a commercial with a red car as the product do not leave home without a red enhancer – it will bring the car forward a treat.

Fluorescent light correction

The FLB filter corrects fluorescent light to type B film or a tungsten-balanced video camera, and FLD corrects fluorescent light to a daylight camera. If you can light all the set with fluorescent light from the same kind of tube, then white balance the camera to a pure white card or paper, this will be most successful.

Polar screens

Polar screens are used to darken the blue portion of a sky in colour photography as well as reducing unwanted reflections in particular parts of a scene. The classic use is to make the colour of a car more solid by reducing unwanted glare in the paintwork.

They are only fully effective when rotated for best effect – if the subject moves, say our car, then the effect will change as the relationship of the planes of the car change relative to both the direction of the lighting and the camera. This is also true if you pan across a blue sky – its blueness will alter depending on its relative angle to the sun.

Polar filters reduce the exposure by one and a half to two stops. This is best judged on the monitor.

Old filter factors

Filter factors were referred to as a simple prime number where a filter factor of 2 equals a correction of one stop of aperture. Likewise a factor of 3 equals one and a half stops' correction and 4 equals two stops. If you are using a colour monitor simply adjust the aperture for best effect.

The pan glass

This is not strictly a camera filter but the piece of glass, in a holder, often worn around the DoP's neck. These days it is not a pan glass at all but its origins are so strong that the name is now synonymous with that little viewing filter and the name seems impossible to kill off. It must be said that this filter is often worn, yes by me included, as a kind of mayoral chain so that everyone on the set will know who is the DoP.

In the days when all films were made in black and white it was quite hard to visualize the scene before the camera, which was of course in colour, as it might be seen on a cinema screen in black and white. Early black and white film was orthocromatic (ortho – singular, chromatic – colour), meaning it was incapable of recording black and white densities as a true representation of the colour brightness. In fact the film was sensitive mainly to blue light which then required very peculiar make-up.

Black and white film stocks developed into what became known as panchromatic emulsions (pan = many). These emulsions were much more true in their rendition of colour brightness as they could record some red and green.

Cinematographers who were used to orthochromatic film emulsions had considerable difficulty in imagining the tones that would be recorded on the new emulsions. The solution was to produce a viewing filter that the DoP could look through which would, to the eye, give a fair representation of the scene as it would be recorded on the new panchromatic film. Hence the new viewing filter became known as a panchromatic viewing filter – or a pan glass.

As black and white technology progressed various viewing filters were developed and matching pairs were sometimes available for working under daylight and tungsten light.

Nowadays the viewing filters should strictly be called colour viewing filters for they all try to show you the scene, not as black and white, but in colour with the tone scale modified to match the tonal scale of modern colour emulsions.

If one is honest, the most common use of a modern pan glass is to look at the clouds in the sky to see if one can get a matching lighting state from the previous shot. Many film DoPs still judge their lighting by them as, particularly when using a camera operator when looking down the viewfinder may be inconvenient, a colour viewing filter can be a great help in judging the lighting ratio of a scene.

A good gaffer will do the sky watch for you. My gaffer has developed an uncanny ability to guess a cloud's progress across the sky. He might use his pan glass or his gaffer's viewing filter which is incredibly dark and green, as that is the safest colour with which to look at the sun.

For a digital cinematographer, the adoption of a pan glass, if only to look at and judge the clouds, can be no bad thing. They are manufactured by Kodak, Fuji and Tiffen among others. I can recommend any of those three.

Part Three
The Shoot

7
Examples of shoots

Drama

The Queen's Nose

When I was offered *The Queen's Nose* I initially said 'no thank you'. I had liked the script very much (it was from a book by Dick King Smith, he of *Babe* fame) so I was not against the project for that reason but I did not want to go straight onto another tape project as I was currently shooting a series on analogue video and was not enjoying that medium very much. I was also discouraged by the fact that the director wanted to use an operator who did his own focus pulling, not, at that time, my style at all.

Carol Wiseman, the director of *The Queen's Nose*, came to see me on location and totally convinced me that it was the only possible project I should shoot that summer, and so started a long and very happy working relationship. Carol is a lady who I found then, and subsequently, very hard to say no to. Her charm, enthusiasm for a project, and total professional dedication come in equal quantities and you don't find that often in your directors. She further tempted me by saying that it would probably be the first digital drama shoot in the UK and I am a sucker for any technical first.

So before I had finished the analogue shoot I was mugging up on the new Sony DVW 700 Digi Beta cameras we were to use. It seemed to me that if they could achieve half the claims in the brochure we might just be onto a winner. This time I decided not to go down the route of using lenses originally designed for film but try to find lenses designed for video that would give me the look I wanted. Fortunately Paul Turtle at Hammerhead Television, our equipment suppliers for *The Queen's Nose*, was very much of the same mind and introduced me to the Canon J8. In another guise I was familiar with this lens as it is also supplied as a 8–64 mm zoom for use with Super 16 mm film and when shooting in that format I had become fond of it. It also had the considerable advantage over most other video lenses that there was no discernible image size shift when focusing, and as my style includes the use of focus pulls for dramatic punctuation this was important to me.

Because the cameras were new to the UK market we decided to have two with us always. Although we did this right through the first series I have never again bothered for the DVW 700 has proved to be just as reliable as any film camera I have used.

Paul Turtle led me very carefully through the camera's menus and showed me how to tune the camera to my own style of image making. I owe much of my current proficiency in this area to those early weeks of preparation with Paul. When the first day of principal photography came around I was no longer reluctant to shoot *The Queen's Nose* but could hardly wait. The cameras seemed to be giving me pictures I had never dreamed could be arrived at so easily with a video camera, and certainly not on location. My newly introduced operator, Ian Powell, was fast becoming a friend and I could do nothing but stand back in admiration at his ability to point the camera and focus it at the same time, getting the subject sharp, even with very wide aperture settings, and he composed the picture like a true film operator.

We had a few stunts in this, the first series, and not wanting to risk our precious DVW 700s we looked for a video camera that we could use like a 16 mm film gun camera or GSAP camera. The small Sony top of the range amateur digital cameras looked promising, size and weight being what we needed, and cost only a little over £1000 ($1440). The drawback was that although the image that was initially recorded looked fine, once it went down the editing and postproduction route it deteriorated rapidly. We tried everything without avail until one of us, I can't remember who, thought of using the camera on which the pictures were originally recorded as the playback machine, instead of a deskbound player in the cutting room, and then re-recording directly onto Digi Beta, never going back to the camera master. This produced remarkable results which, for stunt shots at least, could hardly be criticized when cut into the Digi Beta camera originals. From then on we kept the tapes with the stunt cameras they were shot on until the end of each week and then sent the cameras with their respective tapes (we were using two stunt cameras) to the cutting room at the end of each week's filming. They would then be transferred to Digi Beta before being digitized into the Avid and the cameras would be back on location ready for the following Monday morning.

The conclusion we drew from all this was that the amateur tape heads and circuitry, while being very impressive for the money, were not as compatible one to an other as professional machines. I have since often used this technique of camera play-out, and it has remained the best way I can find of matching amateur cameras to professional ones.

For the look of the series I hung on to a comment of my wife's after she had read the script. She thought it was about the last summer that the junior lead would spend as a girl. Next year she would start to become a woman, and girls should always remember that summer as a sunny one. I hung on to this as my talisman whenever I was not quite sure what to do with a scene. This idea was also the thought that drove us when setting up the basic settings for the main camera control card.

Together Paul Turtle, Ian Powell and I decided that the quickest and simplest way to run the camera was to have a main card create the overall look and, for occasional shots within a scene that needed changes, I would ask Ian to alter the camera settings to my desired changes, while I would dive into my filter box and bring him any new filtration I required. This was very successful and Ian was soon on top of the

settings I used most frequently. He hardly ever needed to be reminded after the first week of shooting.

After a couple of weeks I had produced a second camera control card, written by trial and error, for any night scenes. This much speeded up any change in scene from day to night when the schedule called for it.

The scheme for the basic camera control card was not too complicated. I took a little of the edge definition out, warmed the picture slightly and reduced the colour contrast a little using the gamma page. On the skin tone page I added a little hue and took out just a little detail, leaving the range very wide. This produced a gentler look more appropriate to the script and also easier on an eye trained in film. Almost all the time I kept a quarter Pro-mist on the front of the camera although this was occasionally increased to a half Pro-mist for some close-ups.

Our two leading ladies, playing mother and daughter, were of slightly different skin colours, the daughter being very pale indeed. The mother was very attractive with hardly a line to be seen so I had few problems here. Nevertheless for the mother's close-ups I took out just a little skin tone detail and went up to a half Pro-mist, not in any way because she needed it (she certainly did not) but my style is to flatter and the script was kind and gentle, so this seemed appropriate.

For the daughter I kept the skin tone detail at the normal card setting but took up the skin tone hue as far as it would go. This never looked unnatural but still left her just a touch paler than I wanted. I therefore added a Tiffen 812 skin tone warmer to the front of the camera. This filter is quite pale and, because it limits its effect to hues very close to Caucasian skin tone, brings up this colour without any noticeable change to the background colour. As both the camera's skin tone hue control and the 812 were changing the image in the same direction the overall affect was seamless and attractive.

There were a number of dream scenes in the script and I used everything from Pro-mists through Vaseline to Sellotape stuck on an optical flat and was surprised how often the camera handled the image very well. The only thing to watch out for in this area is that as the camera and lens combination produces even more depth of field, at any given aperture, than 16 mm you have to keep a very careful eye out for your effect filters becoming sharp.

All the male leads were cast as appropriately as their female counterparts so I had no problems here and, in the main, shot them with what had become my standard camera control card and the quarter Pro-mist, as this was contributing to the overall look of the series. One junior male lead was nearly as pale as the junior leading lady, so his close-ups were shot with the 812 filter but without altering the skin tone hue.

Judgement as to how to make any changes to the image was always made by simply looking at a well-set-up monitor (see Chapter 10) and in bright sunlit exteriors I would often be found, together with my monitor, under a coat until a kind property department found me a large piece of black cloth which from then on I kept strapped to my monitor trolley so as to have it readily available. Most of the crew went home from that shoot with what they thought to be amusing stills of a curious small black hill with my backside sticking out of it! Sometimes keeping your dignity as the DoP can be trying but it is, I find, good for crew morale for them to know the guv'nor doesn't mind making a fool of himself in the cause of art.

After several weeks of shooting the camera set-up evolved into something very appealing and the settings I finished the shoot with are those shown as the 'PW' settings in Chapter 19. It was also this first series that won the INDIE award for Digital Cinematography in the year that award was created. The third series, two years later, won me my second INDIE award in the same category, not bad for a series I nearly turned down. The viewing figures have been so good that Carol has been asked to recut the first three series into feature-length shows and even after an appreciable break I have just been asked back to shoot series four.

Series four will be from a new script. The BBC have agreed to let us move from a 4 × 3 picture aspect ratio to one of 16 × 9 and as I have gained much more knowledge of camera programming I am really looking forward to seeing what we can do with it, particularly as for the first time on this series we are to shoot with the DVW 790.

The Merchant of Venice

The Merchant of Venice, by William Shakespeare, came to me as a Digi Beta shoot and ended as a Digi Beta shoot, but for some five weeks between being offered the picture and commencing principal photography it drifted onto and out of most available formats. The overall producer, Richard Price, telephoned me to ask if my wife and I would like to accompany him to the National Theatre, London, to see the play, which I knew from experience was the precursor to Richard wanting to film the production.

The play was staged, roughly, in the 1930s and it was stunning. Very little colour had been used in either the sets or the costumes. Only the actors' skin tones seemed to be accurate and this lent a fantastic period feel to the production which stopped 1930 seeming too modern. During the interval Richard told me that the budget would be far less than we had for *Oklahoma!* which we had shot on 35 mm film just a year before but, since there were no songs or dancing, this should be possible and, incidentally, this meant we would be using Digi Beta. He did, however, suggest that if it could be delivered on HDTV (high-definition television) he could secure a further sale that might more than cover the extra costs involved.

Coincidentally I had just been privileged to see the preproduction version of the Panavision digital camera which was to be based on the Sony F900 camera. Naturally I suggested to Richard that we should use this camera and he asked me to investigate the possibility of doing this.

Panavision were very keen to put their cameras on such a high-profile production but after investigating realized that with only a month to go to starting production, and our needing three cameras and all the back-up gear that goes with this kind of shoot, they very honourably told me that we were starting just a couple of months too early for them to feel secure in not letting us down. It should be remembered that at this point in time the first Sony F900 cameras were only just being delivered from the factory. Unfortunately, even for the chance to use this fabulous camera, the production could not be delayed. The next idea came from Tony Covell at a company called VFG (Video, Film and Grip). VFG was slated to supply both the Digi Beta equipment and our lighting equipment. Being a film man from way back, Tony suggested that we could use his Arri BL4s cameras and record the output from their colour video assists on computer-like hard disks. This would create a huge saving as

we would only have to pay Telecine the length of the cut negative. Thus the extra film costs would only be the cost of the negative and its processing costs. This suggestion got very near to being accepted but the added costs still came to just a little more than the revenue from the extra sale, so this too was abandoned despite a very good deal being offered by Kodak.

I have only described the variety of discussions we were having to illustrate how, for many productions these days, the choice of recording medium is not as clearcut as it used to be and that any cinematographer would be well advised to be conversant with all the available systems.

In the event I found the decision to stick with Digi Beta could be turned very much to my advantage for I had just completed the chapters for this book which describe the camera menus, and so I was more familiar with them than ever before. It came to me that I might be able to move the National Theatre colour palette, created by their designer Hildergard Bechler, onto the small screen in a very interesting way, taking her work as an inspiration for the artistic and technical approach to our production.

Most of the original sets and costumes from the National Theatre were to be used on our shoot and not all the colours, particularly those of the set, would photograph well or appropriately. I knew from experience that the slightly muddy cream of most of the set walls, which look wonderful to the eye, would reproduce on television as a much warmer tone, thus ruining the understated palette of the theatre production. I therefore set about experimenting with the menus in the Sony DVW 700 cameras we were to use and see if I could not only correct this problem but take the whole idea further and give the television version a visual signature all its own.

Trevor Nunn, who directed the theatre production, was to jointly direct the shoot with Chris Hunt, the same combination that had very successfully worked on *Oklahoma!*, so I had some access to their thinking, though it was limited by them both being extremely busy just prior to the shoot. This meant that there was limited time to discuss the look of the production other than them both saying 'think film noir and Berlin in the 1920s and 30s'. Now that may seem helpful, and I am a fan of film noir, but know that to reproduce it properly means that you must light every shot individually. We were to shoot with three cameras and needed to complete twelve minutes of the finished product every day of our fifteen-day schedule. Further, while I am very happy shooting digital, anything approaching the very high contrast black and white imagery of that genre is not the digital medium's natural forte.

After some experimentation I decided to set all the matrix values on the DVW 700 cameras to the same levels but these levels would be very well into negative figures. I also pushed the Master gamma a lot higher than my normal setting. This trimming of the camera's image settings produced a magical look to the sets but, as I had feared when the settings were set high enough to give me the set and clothing colour management I desired, the skin tones had all but disappeared.

I could have tried to bring this back with menu control but decided to go down another route. On *Oklahoma!* I had used huge gold reflectors I had had specially constructed to give a wash of colour to the foreground artists. This was to provide all the cowboys with a readymade tan. As this colour came from a soft light, the fall-off of the lights' penetration into the set was acute, so the colour did not end up affecting

the sets. I decided to use this technique again but this time introduce some red filtration of the lamps playing into the gold reflectors in an effort to reinstate some of the actors' skin colour.

I was very pleased with the overall result. I had reduced the colour saturation of the sets and clothes to 30 per cent of that seen on the monitors before making the menu changes and had, with my lighting, returned the skin colours to some 70 per cent of their original colour, just where I wanted them for pallid Venetians.

As the production progressed I ended up with four camera menu settings, all recorded on individual camera control cards, each one representing a look more appropriate to the scene being photographed than the original master look. By the end of the shoot I had camera control cards labelled Master, Night, Day, and Night Club.

The use of the camera control card was invaluable on this shoot. Very often I would make small changes to both the colour of the light on the actors and the settings in the camera's menu on a scene-by-scene basis. Having made the lighting changes I would experiment with one camera's menu until I was satisfied and then write this to a spare fifth card and stroll round the other cameras reading the card I had just written.

These performance productions where one has to shoot something a little over two and a half hours of television in fifteen days, working eleven hours a day on set, that being twelve hours from call to wrap with an hour for lunch, are only successful if they are meticulously planned. This means for me, the Director of Photography, having to plan the lighting needed for all twenty-four scenes in advance and during the week of preparation, before principal photography, somehow rigging virtually all the lamps I am going to use for the whole of the shoot.

We were shooting on Stage 'L' at Pinewood Studios, which has a very good grid or joist system in the roof that will support motor- or hand-operated hoists. I decided to rig aluminium trusses, each half a metre square by however long I needed them, close to the roof and put most of my lighting on them. This, naturally, had the inherent danger of making the key lights on the actors too high and a little less flattering than might be ideal. I counteracted this by filling the actors' faces with my large gold reflectors keeping them as low in height as practicable. This worked very well given the style I was trying to create – 'digital noir'.

A couple of weeks before we were to start rigging I saw my first floor plan with most of the set shown (see Plate 4). The first thing I did was to scan this into my laptop computer. Over this floor plan, using the Corel Draw graphics program, I then designed a basic lighting rig. I do this by first showing where I want the trusses in the roof to hang. This will then look like Plate 5 where they are shown as grey rectangles. Next I draw the lamps I will be using with small symbols shown for reference down the right-hand side of the page as in Plate 5. Having gone through every scene and decided what lamps I will need, remembering that some lamps can be used in the same positions for different scenes, I now draw in all the lamps I am going to require, again as in Plate 5, and this becomes a file labelled Blank Lamps. Having put them all on the plan I then colour code them as to the most useful filters to rig them with at the beginning of the shoot. This requires working through the script until you get to the point where you need to make too many changes for the initial rig to be workable and this, which I call the basic lighting rig, looked like Plate 6.

I printed off several copies of the Basic Rig file and gave one to each

of the electricians and riggers who were to put up the lighting. These were on A4 paper with an A3 (twice the size) copy for my gaffer.

While the lighting was being rigged I set up what was to become my lighting desk which is shown in Plate 7. As yet I did not have all three cameras but had ordered one together with a high-quality monitor to enable me to work on the camera control cards. I also set up my laptop computer so that I could always be on set to help solve any problems that came up while at the same time starting work on the detailed lighting plots for all the twenty-four scenes in the script. While the plot for the first day had to be very accurate and incorporated into the basic rig by keeping the computer and my portable colour printer on the desk, I could always be refining tomorrow's rig in the gaps in the work on the current day's shooting, thus, hopefully, always being one step ahead with the necessary lighting plot for the coming days.

All the 124 lamps in the rig plus the additional 38 lamps on stands were fed back, via dimmers, to a control board on my lighting desk. I and my gaffer, Gary Willis, together with the control board operator worked from this desk with our video monitors in front of us as in Plate 7.

The daily lighting plots were created by opening the file Blank Lamps and rotating and colouring each lamp to be used in an appropriate fashion. Lamps that were not to be used in that scene were left coloured white. The lighting plot for Act 3, Scene 2, Parts 1 and 2, for instance, resulted in the drawing shown in Plate 8. The large blue lamp hanging on the middle, square, truss is a projection spot brought in especially for this scene to put a window-shaped light on the extra wall of the set that has been used and is shown by the long grey rectangle at which it is pointing.

The original plan was to have a three-sided set but as preparation progressed it became clear that quite large floating flattage would not only fill in the fourth side to the set sometimes but would also float in to reduce the size of any given room. This gave me one huge problem. I had initially set out my trusses in such a way that I could lower all but one of them to the ground for filter changes and the like. Now with the additional flattage I could not get any of them down for most scenes. Fortunately my gaffer had ordered a couple of scissor lifts for the rig week and we kept these on for the rest of the shoot to enable us to get at the lamps.

If all this seems daunting don't let it worry you. By simply taking one scene at a time and plotting that, then adding it to the overall plan, it is not too hard to achieve this kind of lighting rig. It would, on the other hand, be unreasonable to take a contract for a job such as this if you don't enjoy visualizing how a scene will look in advance and take pleasure in forward planning. I happen to enjoy what I think of as intellectual lighting. Seeing it in advance, in my mind's eye, and working out the problems before starting gives me a real thrill.

Small Hotel

A few years ago this production, and many others like it, would not have been made at all, which would have been a pity. Digi Beta offers the opportunity for projects with minimal funding to be made to broadcast standards, thus allowing new and emerging film makers to get a foot in the door. First, there is a huge saving in film stock and processing charges but the key to economy, from the cinematographer's point of

view, is to use a small amount of lighting and to light incredibly quickly and simply. These economies should not be confused with being cheap or second rate.

The use of Digi Beta as opposed to film does not reduce the lighting time or budget because the camera is more sensitive, or in film terms, has a higher ASA rating. In fact a DVW 700 has an approximate equivalent ASA of 320. It should be perfectly possible to make the same economies on a film shoot. However, as Digi Beta is sometimes used for low-budget productions, where the saving in film stock and processing costs are significant, it will be in this digital domain that the cinematographer may need to perfect their ability to speed things up while still producing a quality product.

I believe that any lighting scheme should initially be inspired by what is in the script. I have, therefore, outlined each scene before describing the lighting to show the reasoning behind the decisions that were made.

The entire story of *Small Hotel* takes place in a hotel in the half-hour before midnight on New Year's Eve as the new millennium is about to be ushered in. There are five main locations within the hotel plus a very convincing model of the exterior of the hotel. The model was shot against a blue screen with a blue screen in the windows so that I could pan from one window to another as the story moved location, the scenes behind the windows being inserted in postproduction.

The five main locations within the hotel were:

The ballroom
The foyer
A cheap bedroom
A luxury bedroom
The card room

The ballroom

The action starts with a close-up of a mirror ball in the ballroom shot, initially out of focus, with the main titles laid over it. As the titles end the ball becomes sharp, the camera pulls back and cranes down to reveal an elderly couple of expert dancers sweeping round the dance floor. They are alone save for two children of about twelve years of age at the far end of the room. Despite both the children being girls, one is dressed in a very sharp 1920s-style pinstripe man's suit with an Italian hat and the other is in a ballet outfit complete with tutu. The camera follows the dancers and lingers, briefly, on the children to introduce them to the audience.

The lighting scheme obviously included a small spotlight for the mirror ball which, because this is meant to be a working hotel, could be in the shot. The room had wall lights and I left these on. We managed to fix an 800 watt redhead in one corner of the room without the need for a stand and bounced this off the ceiling through a half CTO (colour temperature orange) filter. Two 500 watt Mizars were again fixed without stands at the opposite end of the room. I wanted these two hard backlights, for though they were not strong by the time they had projected their beam the length of the ballroom (it was admittedly a small ballroom) they would cause all the sequins on the dancer's dress to sparkle well. So with four lamps and the practical wall lights we were lit. I put a number 1 Pro-mist on the camera and to really give the specula highlights a 'zing' I also dialled in the cross-filter in the camera.

The foyer

In the foyer, where the besuited young girl is seen to observe all the comings and goings of various characters, I lit this area fairly conventionally with Mizars clamped in the ceiling and a practical on the reception desk. Outside the front door there was a small veranda. We had to shoot through the front door in the daytime when it was supposed to be night so we erected a small tent of black drapes over this. The wooden lattice of the veranda and a motor scooter parked in it, which arrives early in the story, gave a totally convincing impression of night as I lit it a little coolly and about one stop below the camera exposure.

The cheap bedroom

The first bedroom we see in the plot is the cheap bedroom where a man who is estranged from his wife is living in an extraordinarily untidy fashion. To contrast this with the rest of the hotel I had only a bedside light on, and in my mind, the overhead light. There was a bathroom off the bedroom in which action would also take place. I bounced a redhead in the bathroom and another in the bedroom both to simulate overhead lighting. I added one direct Mizar in the bedroom to behave as the bedside lamp. This gave a very stark image, just what I was looking for as it was in contrast to the very dramatic events that would take place in this room. I did, however, put in a boldly shaped light, using a pup, through the door from the corridor. This was to remind the audience, every time someone came or went, that the rest of the hotel was more interesting and luxurious. This pointed up the state in which the occupant of the room was keeping himself.

The luxury bedroom

The second bedroom was wood panelled. Here an ageing professor of history was to entertain a whore with whom he had arranged to have sex on the stroke of midnight. We rigged eight Mizars fixed to a very high picture rail and lit in a discreet way, echoing the four or five practical lamps I had asked for in the set dressing. As the woodwork would soak up light and, anyhow, I wanted a very rich feel I filled all this with a 48-inch gold Lastolite illuminated with a 800 watt redhead. The countdown to midnight is seen as a digital clock on the professor's computer which, fortunately, could easily be a laptop so we had no problem photographing the screen.

The card room

This scene involves two card players, one an elderly lady dressed as a man and the other a young man, dressed as a spinster in black. The audience is led to believe that the elderly lady might well be God and the young man the Devil. If this is the case they are playing for the future of the world for a huge meteor is heading Earth's way and whether it crashes into Earth depends on the outcome of the game.

We fixed a dark green plastic light shade over the table, put a strong, clear, household bulb in it and led this back to a dimmer so as to have complete control over it. By carefully adjusting its height between shots ever so slightly the actors were actually keyed with this practical light. All that remained was to add a backlight for each of them. Far beyond them in the background was a sofa which would occasionally be occupied by the children, who were a linking theme throughout the plot. The sofa received a severe cross-key and a complementary backlight. At no

time did I put any fill light on the scene for I intended to use quite heavy smoke. The excuse for this was that God was seen to be smoking, and I knew from experience that the smoke would pick up quite enough light from the key lights and scatter it about the set effectively enough to provide all the fill light I would need for a very low key scene. This very effective lighting plot used only five lights and a practical lamp.

If this picture was going to remain on schedule it was essential that I used simple but effective lighting plots that would take very little time to rig. I wouldn't like to work with such a pared-down lighting rig all the time but sometimes the challenge of having to think through lighting scenes in advance, and reduce them all the while, can be very stimulating. Just as stimulating as having a dozen sparks and several truckloads of lights.

Documentary

The ABBA Story

I was in the process of planning *Oklahoma!*, which was to be shot on 35 mm with three cameras, when one of the directors, Chris Hunt, rang me to ask did I still do documentaries? I asked what kind of documentaries and was, in effect, asked if I would like to spend a week in Sweden interviewing all four of the members of the 1980s pop group ABBA. Two weeks later we were shooting in Stockholm. In the end we went to Stockholm twice as well as shooting for several days in London.

The production was funded sufficiently well to be able to shoot with a Digi Beta DVW 700 which was fortunate as much of the original material was to be intercut with 35 mm footage from an ABBA feature film. This decision also enabled me to take much more control of the original images than had we been shooting on any other medium. The primary aspect ratio was to be 16:9 but we knew many transmissions would be in 14:9, so compositions had to work in both picture widths. I therefore put up my usual 14:9 box in the 16:9 viewfinder so that I was always aware of this. On this project I was to be operating myself.

The first thing I did was to write a menu to a camera control card specifically for the project. The main differences from the settings described in Chapter 19 were to reduce the detail level to around –30, reset master black to 0 and switch the skin detail ON. I wanted a slightly more luxurious feel to the images. ABBA were, after all, the epitome of glam rock.

On the first visit to Stockholm we encountered rather poor weather, very flat dim light with a little mist which would occasionally turn to a fine light rain. This was particularly unfortunate as we had gone to considerable trouble to get permission to visit the island in the Stockholm archipelago on which stood the little summer house where Benny Andersson and Bjorn Ulvaeus wrote many of the songs together. Bjorn was to meet us there for an interview. Even on documentaries I never travel without at least the majority of my 4 × 4 inch filter kit with a good 4 × 4 inch matte box, and on this occasion, as so often, it saved the shoot together with some crafty lighting for the interview. Here I was fortunate that Gary Willis, my usual gaffer, had happily agreed to come along as our only documentary spark.

Despite the water in the atmosphere reducing the definition I still kept my favourite ¼ Pro-mist filter on for I like what it does to the highlights.

Using the camera menu, I increased the detail level a little and then reduced the skin tone detail so as not to age Bjorn. I did this because of the increase in wrinkle definition that would come with the increase in detail level. This much improved the look of the image on our 9-inch colour monitor. I never have trouble talking directors into carrying the monitor themselves for they appreciate having it next to them so much. The image still looked rather cold and as Bjorn was to be discussing how he and Benny wrote their songs here in the summers this was inappropriate. I slipped a Wratten 85C filter into the matte box behind the Promist and the picture improved immediately. Instead of 11 am on a bleak island on a rainy day (reality) our picture now showed a soft summer's evening. These changes were much to our liking and we were ready just in time to shoot Bjorn arriving on the island from his hired boat.

Having shot an attractive sequence of Bjorn coming ashore and walking up through the bracken to the summer house we now had to set up for the interview. The summer house was quite basic, with one bedroom, a tiny bathroom and a small glassed-in veranda. Gary quickly discovered that there was a small amount of power still available in the summer house and suggested we use the Arri pocket par we had brought with us. We sat Bjorn in a chair close to the window which was camera right of him, and then moved a standard lamp to the other side of and slightly behind Bjorn. Gary set up the pocket par out in the garden and put a half CTO (colour temperature orange) filter on it, the lamp itself being an HMI and giving out daylight. At a little over Bjorn's eye height the light coming into the summer house looked just like late evening sun. Had it been a brighter day our pocket par would have had little effect so in this respect we were lucky with the weather. I am a great believer in being an opportunist with lighting and where we might have got depressed at the available light we were able, quite simply, to turn it to our advantage.

This simple lighting set-up looked very pleasing, Bjorn was keyed from camera right, the standard lamp produced a pleasant three-quarter backlight and the available light provided the fill. The lit intensity was also just right to let us see the land beyond the glass but gave it an exterior feel, that is, just a little brighter.

The Arri pocket par is a very small HMI lamp of only 125 watts but is so efficient that its light output seems to be from a luminar of much greater strength. It also has several other advantages: it comes as a kit with several clip-on filters and diffusers and it can be run from mains electricity or from batteries using a DC ballast. I rarely go documentary shooting without one. A pocket par and four dado lights, small but powerful tungsten lamps, will light an enormous area very beautifully if used thoughtfully. Add to this a 2 kilowatt blond and a couple of 800 watt redheads that you can bounce off Lastolite reflectors and you have, to my mind, a close to ideal documentary lighting kit.

Filming the two women from the band required care, for most of the audience would remember them as being ravishingly beautiful. Fortunately they are still both enormously attractive women. One of them would only agree to being filmed outdoors though the other agreed to a full, lit, interview. For the exterior we were still under rather flat lighting but now with a weak sun and no rain. I kept the ¼ Pro-mist on, used standard colour filtration and dialled in about 70 per cent of the available skin tone detail reduction. As it was a rather cold day and, despite excellent make-up, our subject could not but help looking a little cold, I added a Tiffen 812 filter in front of the lens. The 812 is a very

pale pink, of such a colour that it only warms up Caucasian skin tone without noticeably affecting the rest of the scene. This combination worked well.

For the lit interview, which we were to do in Benny's recording studio, I bounced a 800 watt redhead off a gold Lastolite as the key which produced a very flattering effect as it was placed to be around three-quarter frontal. I moved a table lamp into the background on the opposite side of the frame to the subject and clipped a dado light onto a rafter above and behind this practical lamp to give a stronger appearance of its effect. We let a little daylight seep through the blinds to give some small patches of cooler light in the background. I am very fond of subtly mixing the colours of light sources. The digital cameras handle this very well, sometimes better than film, and it can greatly increase the three-dimensional look of the picture. Again I dialled in 70 per cent of the available skin-tone reduction. As the subject was understandably a little nervous of the event, Chris, the director, picked up the 9-inch monitor from our feet and turned it round for her to see. Fortunately she approved and I am sure this helped to create what, in the end, was a very relaxed and successful interview. Rarely does one have lighting praised so quickly!

On our second visit to Sweden Chris decided to book a helicopter so that we could get some aerial shots of Stockholm and of the island we had already filmed. We booked a nose mount for the camera which, when it turned up, was less sophisticated than we had hoped for. There had been a misunderstanding somewhere as to the cabling that would come with it so I had no control over the lens functions and could not switch the camera on or off from inside the helicopter. Further, the remote pan and tilt, which I did have control over from the cockpit, was very jerky and not smooth enough to use in shot. Nothing daunted, up we went. We quickly discovered that despite all these shortcomings we had one huge advantage, a wonderful pilot.

So there we were with a supply of 32-minute tapes and my usual filter kit. We would switch the camera on immediately before takeoff and, after half an hour's shooting, find a deserted bit of land on an island somewhere. On landing Gary would jump out of the back seat and run round to the camera, change tapes and make any adjustments I needed, then climb back in and off we would go for another half-hour. I was unable to get out of the aircraft easily as I had the remote head control and our 9-inch monitor on my lap. I found that by setting the auto-iris to have a slow reaction I could safely leave it switched on.

After a couple of tapes our pilot soon recognized what we wanted. He also had excellent English, and would fly our shots looking sideways at my monitor rather than out of the windscreen. It was only after we finally got down that we realized what a wonderful piece of airmanship this was and also pondered what might have happened if the same trick had been tried by someone less skilled. Despite all our adversities we got some wonderful pictures, even managing to fly over the island with Benny and Bjorn's summer house with a graduated filter on the camera, our pilot keeping the grad bang on the horizon.

By this second visit Chris had a very good idea of how the material was going to cut together and wanted some specific shots, two of which had to be exactly matching wide shots of Benny arriving at his studio in his four-wheel drive early in the morning and leaving late at night. We had no second camera to leave on a locked-off shot so I volunteered to

do it all with the camera menu and my filters. We set up a delightful shot with Benny's studio, which is an old single-storey converted warehouse by the water's edge in Stockholm, on the left of shot with Stockholm in the background across the water filling the rest of the frame. A road ran along the water's edge and turned left up the side of the studio. For dawn I went for a pale cool effect using only half the daylight correction available in the camera, the 4300°K setting on the filter wheel, adding a light graduated filter to attenuate the sky a little so that there was just some gradation in the clouds. It was snowing lightly so the effect was quite convincing. We had Benny drive up and go into the studio. To change this to night I took all the colour correction out of the camera, reduced the detail level a little to give that feeling that you can perceive a little less at night and put on three graduated filters to really bring down the sky. Gary had, meantime, been rigging every lamp we had pointing from inside the studio at the blinds on the windows and illuminating the entrance porch. I then underexposed by nearly three stops from the camera's preferred exposure. This time, as Benny left, I asked him to switch his headlamps to high beam and turn the car around so that the headlamps swept across the camera nicely backlighting the snow. It was all very convincing and Chris got his two shots of the start and finish of Benny's day all in half an hour. My biggest problem was putting all those filters on without snowflakes landing on them for which they seemed to have some kind of magnetism. Again the opportunistic approach worked to our advantage.

When it was all cut together our originally shot material stood up excellently to the 35 mm archive pictures, all our in-camera and filter enhancements were utterly convincing and had saved a huge amount of money in postproduction. The final 90-minute programme was a great success, gaining the record for the highest viewing figures for a programme of its type and being nominated for a BAFTA (British Academy of Film and Television Arts) award.

8
Crewing

For fiction

There is an unfortunate misconception among producers that if you shoot digital you can work with a much smaller crew than with film. To make the judgement simply on the recording format is, in my view, foolish and probably comes from looking at the history of the two mediums from the wrong perspective.

It is true that most, but not all, video shoots to date have used smaller crews. This is because they are conceived from their beginnings as low-budget productions and, had the decision been made to shoot them on film, it too would have been done with the smallest crew possible.

This argument also applies to the minutes of cut film per day that can be the expected output from the crew. It is not film that limits the average production to between 4 and 5 minutes a day nor tape that allows maybe 9 minutes a day. I averaged nine and a half minutes per day shooting *Oklahoma!* on 35 mm. On *Oklahoma!* the budget was sufficiently high that a very high quality was achieved. It is the budget and the available schedule that should dictate the output demanded by the producer.

There is another significant and unfortunate result of these misconceptions. With some rare exceptions tape is not usually scheduled for any production having even the slightest chance of affording film. As a result, tape has rarely been given the chance to show its true potential as, with the lower budgets to which it is usually confined, the quality of the design input is often so poor, the shooting rate so high and the crew so small that it becomes impossible to produce a high-quality product no matter what you are recording on.

Should the DoP operate?

Not if you want your digital output to look as good as possible. As I have said elsewhere, the viewfinder on the cameras is very poor compared with any film camera so I believe that it is essential that the DoP stays back at a correctly set-up colour monitor in order to judge the output.

Do you need a focus puller?

Operators with a television studio background are used to pulling focus for themselves. Allowing them to continue to do this can be very dangerous. Those of us who are trying to produce really good images out of the digital system are usually trying to work at very wide apertures in order to reduce the depth of field to something that looks similar to that usually expected on film. Once this lower depth of field is achieved the focus-pulling difficulties become the same as for film and a fully trained and experienced focus puller becomes essential. More often than not this desire to reduce the depth of field, and have softer backgrounds, comes not only from the DoP but will be a requirement of the director.

Do we need a loader?

No, there is no job for a loader but there is a vital job for a slightly differently trained camera assistant. Fortunately many very good film loaders are just as skilled and useful on a video shoot. Tapes still have to be changed, labelled and report sheets prepared for the cutting room. Still more importantly, the colour monitor will have to be set up, organized and lined up. Most of my camera assistants who perform these tasks are more than able to line up the monitor and I have come to rely on them to do so. Whereas I would not necessarily have the time to do it, my camera assistants will check the line-up every time the monitor is moved and after every break.

If you are on a multi-camera shoot then the logging of the tapes becomes vital and a camera assistant can end up the busiest person on the set.

Do we need a clapper board?

If you are shooting fiction my answer is definitely yes. It takes only the slightest error in the camera, the play-out machine feeding the off-line editing suite, the conform suite or in the creating and reading out of the edit decision list (EDL) for a shot, or whole scene, to go completely out of sync or, even worse, end up cut into the wrong place. If a film-style clapper board is used there is always the visible shot number to refer back to and the physical clapper to re-sync to. This has saved a producer a considerable amount of money many times.

There is another reason to use a clapper board which is just as important. Most technicians and indeed the cast are so tuned to knowing a take starts with calling the number and banging two bits of wood together that they don't really go quiet or, more importantly, really start to concentrate, until they hear the board. It pumps up the adrenaline and you will find you are going for far fewer takes if you use a clapper board than if you do not. That can be a big saving.

Do we need a grip?

I'd hate to go filming any kind of fiction script without one. The modern style of shooting usually involves a very mobile camera and the grip, or dolly grip in the USA, is the person to provide this quickly and smoothly. They also provide all the usual toys and accessories one expects on any shoot. A good grip's van is an Aladdin's cave and a

treasure trove of solutions to problems. They also do all the usual and useful things like having the required camera support needed for the next shot already set up, and that can really speed things up.

Sound

The personnel requirements for sound hardly vary at all between film and video. The route chosen for postproduction will dictate whether or not the sound is recorded on the video tape FM (frequency modulated) tracks alone or if a second recording is to be made, in which case this is usually recorded on a portable DAT (digital audio tape) recorder. Either way, there will usually be a cable between the camera and the recordist.

Clearly for a fiction production the recordist, more properly referred to as the mixer in the UK, will not be able to operate the mixing desk, the DAT recorder and the microphone so the minimum sound crew will nearly always consist of a mixer and a boom swinger.

Electricians

Another popularly held misconception is that video cameras need less light. This is a fallacy. The baseline equivalent film speed of a digital camera is usually 320 ASA to tungsten light, the same as one of my favourite film stocks.

One is frequently lighting to balance with existing sources such as daylight or practical lamps within the set and then exactly the same amount of light will be required no matter how you photograph the image. This said, I am often using a lens setting around one stop wider on video than I might for Super 16 and two stops wider than for 35 mm. This is to obtain roughly the same depth of field purely for artistic reasons. The differences will be obtained by the choice of film speed in the film camera, the sensitivity setting on the video camera and with neutral density filters in front of the lens.

When all these considerations are taken into account it becomes clear that the same number of electricians are likely to be needed and that their number will be dictated far more by the script and the way you intend to shoot it than by what you are recording the image on.

If I am asked for a ballpark guess at the size of my lighting team I usually say a gaffer plus three people. This may go down to a gaffer plus two for a script with few complications and rise to a basic team of a gaffer plus six people on a more complicated shoot. My preference is to keep a basic team with me and augment it with extra labour when needed.

For factual

Crew size

I have shot corporate videos with just myself and a recordist. This, strangely, is much harder work than the same shoot might be on film. The video kit is considerably heavier! It's mainly the batteries that make the difference – digital video cameras are power-hungry. The video camera's battery will weigh twice as much as that of a Super 16 camera and will last for nothing like as long. The video camera still uses a large amount of power when only on standby, a film camera uses none.

So you have the choice between three lightweight film batteries each capable of shooting ten rolls of film or six heavy video batteries each probably only going to last three tapes. These figures give you roughly the same total recording time.

Given all this weight, if you are shooting as a two-person crew, it is essential that all the members of the production team are aware of the problem and help with any moves of location.

Life becomes much easier if you can have a third person with you. I am exceptionally lucky in that my gaffer is just as happy to come out on a corporate video as to light a feature film. Further, he does not confine himself to the electrics and is now well able to achieve quite difficult focus pulls. It helps considerably when your gaffer has also become a personal friend.

I find no difficulty in occasionally working with the camera on my shoulder with a minimal crew and the next week lighting a big picture. While the big lighting jobs are wonderfully challenging, once in a while doing it all myself keeps me sharp and makes me appreciate my full crew even more when I next work with them.

Clapper boards

For documentaries I make a drawing of a clapper board on my computer (see Figure 8.1) with the production name, the director's and my name already printed on it. When printed out I have this laminated at the local stationers. By using a white board marker, with a small piece of cloth taped to the blunt end, roll and slate numbers can quickly be changed and photographed. While this does not help solve any future sync problem, making sure it goes on at least the beginning of every roll can help ensure that a roll does not go missing when a label has been forgotten.

Providing a board already printed up with the production's name will surely impress the client but I also always carry one made out with no names or titles except my own. You can fill in the blanks with the same pen and pop a strip of Sellotape over them as temporary protection until the next shoot. I always keep a blank board in the back of my shooting bag, even on film shoots.

Figure 8.1 A laminated clapper board

Once you have your laminated clapper board replacement it is a good idea to flip it over and send messages to the editor if you are using the camera to record a wild track. Simply use the white board pen to write something like – Office Buzz Track Interview with Mr X. You will find the editor much appreciates this kindness.

9
The Director of Photography's preparation

The recces

The recce, the English colloquial abbreviation for reconnoitre, or scouting as it is known in the USA, comes in two parts. Recceing with the director and/or the location manager some time prior to principal photography is usually productive and enjoyable. The technical recce, which usually occurs just a week or two before the shoot commences, when the DoP has to finalize all the technical requirements, is usually straightforward hard work.

Recceing with the director and as few other personnel as possible is a most creative process. It is the time, if you haven't worked together before, to get to know each other and understand each other's visualization of the piece. At this stage there is often, still, a choice of some of the locations to be used and making the decisions together, helped by the location manager, is a valuable investment in the final look on the screen.

There will be much discussion on a director's recce as to costs and facilities needed for the various scenes. One should make the director aware of those scenes which may require out of the ordinary equipment or labour. It is not uncommon for the director and the DoP to discuss the value to the story of individual scenes as this relates to their costs, and make sure they are spending the budget on the important scenes rather than, as can happen, find they are spending huge amounts of cash to solve problems on scenes which do not necessarily warrant that investment.

Only when you have seen the primary locations can you start to put the images together in your mind. I often ask for photocopies of the leading actors' *Spotlight* pictures before the recce so that I can more easily put faces into the rooms and spaces.

I find the technical recce perhaps the hardest and most intense part of the film-making process for in just a few days I must finalize all the technical requirements, agree with my gaffer as to the logistics of every

location and ensure that all the equipment suppliers, and the production office, are aware of the call-off of equipment for the next several weeks.

During these few days all the other departments will be bringing you their problems, where they impact on your own. Decisions made now must be of the highest quality as a poor judgement at this stage will come back to haunt you in several weeks' time.

It is for these reasons that I make the most thorough preparations and produce the lists discussed below.

Preparing for a shoot

As schedules get tighter and budgets decrease perhaps the most effective way a cinematographer can reclaim lighting time on the set is to invest time in preparation. Without good preparation too much time on set will be spent answering unnecessary questions and trying to steal time to make arrangements for upcoming shooting days which are not, as yet, fully organized. Thus, with good preparation, a DoP's time can be better, and more enjoyably, deployed.

I find that the most effective way of releasing time is to publish, before the first day of principal photography, a series of documents which allow anyone connected with the necessary arrangements to refer quickly, and easily, to the DoP's requirements and make their contribution without further reference to the cinematographer. Two things need to happen for this to be without trauma and to be effective. First, the cinematographer has to give the time to the project and, second, they must have a system in place to produce the documentation efficiently.

If you are comfortable using a computer then things are easier. One thing computers are exceptionally good at is repeat business. Once you have generated a list they seem to positively revel in your ability to make changes to that list and to deliver a new version very quickly.

My greatest ally in this important area of efficiency is a Psion palmtop. A Psion with even a small amount of memory, sensibly organized and with occasional clearing out of old data, can hold two agendas – one your personal diary and another your technical schedule. In the Word program you can easily store five or six basic lists of equipment, one for each type of camera you are likely to use. My Psion contains all this together with an enormous database of just about every technician with whom I have ever worked.

If you do not want to use a computer the alternative is to use a check box list. Here you carefully write out your lists with just about everything you could possibly need on any production with a tick box against every entry. For each new production you photocopy your original list and then just tick the items you require on this occasion.

There are three publications I provide the production with and they all serve a different purpose:

The technical schedule (Figure 9.1) (see pages 56–58)
The camera equipment list (Figure 9.2) (see pages 60–61)
The location lighting equipment list (Figure 9.3) (see pages 62–64)

In order to discuss the use, importance and preparation of these documents I will refer to just one television series, *The Queen's Nose*, a production of six half-hour slots shot in England for primetime television transmission. This format contains most of the problems associated with

any production. It is also valuable that all the lists come from the same production for, in many ways, they are interrelated.

The technical schedule

Using a program such as the Agenda on the Psion you can generate a very accurate diary of all your requirements for the whole of a film. Figure 9.1 (see pages 56–58) shows the technical schedule for the whole of *The Queen's Nose* shoot. Before going on a recce enter 'Camera: Normal Kit' and 'Lighting: Normal Kit' on all the shooting days. Then enter your days off so that they show on the agenda; this gives you an entry for every day of the whole shooting period. Now, referring to the production's draft schedule, enter either a brief description of each scene or the scene numbers you are going to shoot on all the given dates. For this production I chose the descriptions as I knew a new script was on the way and I did not want to have to change all the numbers.

Having prepared your agenda in this way as you go round the locations on the technical recce all you have to enter are the changes from the normal kit.

Publish this technical schedule as widely as possible and as soon after the last recce as is humanly possible. Apart from having saved the first assistant director and the line producer a lot of effort you have now made it possible for the production office, should location dates change, to easily track your extra requirements just by looking at the old date, seeing which scenes the equipment relates to, and posting the requirements to wherever the scenes move to in the new schedule as planning progresses.

By producing this kind of technical schedule you make it easy for the office to keep the production on-track and you have created a situation whereby you will be bothered far less on the set as things change. Hence you get more time to do what you really enjoy – shooting the movie!

You might like to look at Tuesday 8 August (Figure 9.1 (page 57)); the last line reads 'MINI CAMERAS for wheelchair race'. We took over an entire hospital ward and had teenagers staging a Formula 1 race using wheelchairs, an interesting challenge!

The camera equipment list

The camera equipment list will probably be published twice. The line producer, or production manager, will usually ask the DoP early on in the production run-up for a guess, or wish list, of the equipment that will be required as the basic kit in order to get competitive quotes from different suppliers. This does not take away the DoP's right to nominate a preferred supplier.

It is important that this list is reasonable and not an 'if only I could have' list. At this stage of preproduction one does not want to frighten the budget controllers with a foolish amount of equipment. It is more important to list a reasonable kit in order that comparative estimates of different suppliers' prices may be obtained.

Once the supplier has been chosen and the recce is over and a basic list can be decided upon, it is vital that you provide this new list as soon as possible. This is not only so that a firm quote can be obtained but is important to the DoP, who needs to be sure that the chosen supplier can deliver all their requirements or if they need to subcontract

THE QUEEN'S NOSE TECHNICAL SCHEDULE @ 14^{th} July

July

Sat 15	**DAY OFF**
Sun 16	**DAY OFF**
Mon 17	Road/Bus stop/Bus interior/Portobello Market
	Standard kit of local supply
	2 cameras at Portobello Market
	Bazooka + off set on pub balcony
Tue 18	WASTE GROUND
	Genny + Batt Lights
	MINI CAMERA for bicycle stunt (in helmets)
Wed 19	EXT + INT Bicycle shop
	Standard kit – Local supply
	Tungsten & HMI Battery lights (possibly to appear in shot)
Thu 20	PARKER HOUSE
	Standard Kit
Fri 21	PARKER HOUSE
	Standard Kit
Sat 22	**DAY OFF**
	AM RECCE STUDIO
Sun 23	**DAY OFF**
Mon 24	PARKER/garden/kitchen/hallway
	Standard Kit
	MINI CAM for tree stunt
Tue 25	PARKER's Kitchen
	Standard Kit
Wed 26	PARKER's House + road in front Standard Kit
	+ CABLE to ROAD
Thu 27	INT/EXT Parker House
	Standard Kit
Fri 28	Parker House – Harmony's Bedroom
	Standard Kit
Sat 29	**DAY OFF**
Sun 30	**DAY OFF**
Mon 31	CANAL/Parker living room/Hallway
	CINE JIB at Canal only + second grip
	GENNY + standard kit

1 of 3

Figure 9.1 *The Queen's Nose:* technical schedule; page 1

THE QUEEN'S NOSE TECHNICAL SCHEDULE @ 14th July

August

Tue 1 PARKER HOUSE/Bathroom/Garden
 Standard Kit
Wed 2 PARKER HOUSE/Garden/Kitchen/Melody's bedroom
Thu 3 PARKER HOUSE/Road/Bathroom/Kitchen/Living Room
 WOODEN FRAMES & Rosco scrim to be fitted to hospital
 TODAY
Fri 4 PARKER HOUSE/Mrs Parker's Bedroom
 Standard Kits
 PRE LIGHT STUDIO TODAY
Sat 5 STUDIO SHOOT
 Standard camera kit
 LIGHTS – see separate lighting list
Sun 6 **DAY OFF**
Mon 7 HOSPITAL WARD
 Standard Kit – LOCAL SUPPLY
 60 amp Cee form tails from FTVS and fitted
 by House Electrician
 ROSCO scrim on wooden frames outside ALL windows
 in Harmony's ward (from balcony)
 NB this will be fitted Thursday 3rd Aug
 MINI CAMERAS for wheelchair race
Tue 8 HOSPITAL WARD
 Standard Kit – LOCAL SUPPLY
 MINI CAMS for wheelchair race
Wed 9 HOSPITAL WARD & PARKER HOUSE
 Standard Kit – LOCAL SUPPLY
 MINI CAMS for wheelchair race
Thu 10 PORTOBELLO ROAD/Post office/Adventure playground
 GENNY + Standard Kit
Fri 11 BICYCLE CRASH/Parker Garden/Wigwam
 GENNY + Standard Kit
Sat 12 **DAY OFF**
Sun 13 **DAY OFF**

2 of 3

Figure 9.1 *The Queen's Nose:* technical schedule; page 2

THE QUEEN'S NOSE TECHNICAL SCHEDULE @ 14th July

Mon 14 INT-EXT – PARKER HOUSE
 Standard Kit FROZEN FAMILY
Tue 15 Parker House
 Standard Kit
Wed 16 Parker House
 Standard Kit
Thu 17 Parker House
 Standard Kit
Fri 18 Parker House
 Standard Kit
Sat 19 DAY OFF
Sun 20 DAY OFF
Mon 21 FOOTBALL GROUND
 GENNY + Standard Kit
 2 CAMERAS as per normal + Focus puller for Paul's camera
 50'EXTRA track (100, total) @ football pitch
 15 foot ZIP UP TOWER with boards
 to go under legs as it will be standing on Astro Turf
Tue 22 SUPERMARKET/BURGER
 BAR/CANAL/MOTORCYCLE
 GENNY + Fluorescent banks
 + 2 × Kinds of Fluorescent Tubes
 (supermarket – Philips TLD 80w/83 tubes)
 8 × 8' PHILIPS DAYLIGHT tubes for Burger bar
 Bickers motorcycle towing rig
Wed 23 PARKER HOUSE
 Standard Kit
Thu 24 PARKER HOUSE
 Standard Kit
Fri 25 PARKER HOUSE
 Standard Kit
 WRAP

3 of 3

Figure 9.1 *The Queen's Nose:* technical schedule; page 3

some equipment, they then have sufficient time to make the necessary arrangements.

Figure 9.2 (see pages 60–61) is a copy of the camera equipment list as delivered to the production office of *The Queen's Nose* just after the technical recce. Not only is all the equipment very accurately detailed but the assumed supplier is noted, as these may differ for various parts of the kit. For this production we had two cameras throughout, for two reasons. First, this was one of the first series to be shot in the UK using digital cameras so a back-up was considered prudent. The cameras have proved to be just as reliable as film cameras so I have never taken a second camera for this reason since. Second, the director envisaged some two- or even three-camera set-ups so it was very convenient to keep a second camera with us at all times.

The accuracy of this list is important for it is quite possible that someone in the production office may have to book the equipment while all the informed staff are out of the office. It is only fair to them that you have produced a list which can be read down a phone by someone who knows little about camera equipment. This is not only a kindness to them but also an insurance policy for the DoP.

In addition, the pages are clearly numbered as to page number and the full number of pages (see the bottom right-hand corner of the page) and at the top-right corner the publication date is shown. This is very important. The DoP will quite likely deliver a number of updated versions of the camera equipment list as the production nears the first day of principal photography. It is very important that anyone on the production who needs to refer to the list can easily see which is the latest version.

The camera equipment list, as illustrated, is exactly as written in my Psion palmtop computer. A simple cable is available to connect the Psion to almost any desktop printer. Using this cable a DoP can return from a recce and, say over lunch, print out various lists etc. in order to have them ready for an after-lunch production meeting. This kind of organization is appreciated by the production.

You will see in Figure 9.2 that I supply my own telephoto lenses. In order that non-technical people understand I call them telephoto but, in fact, they are not. They are true prime lenses, that is, the lens must be as long as the focal length and not telescoped to a shorter physical length. I have always liked the images from big prime lenses and believe it is more attractive than from some telephotos with all the extra glass they require. I have had all three lenses modified to Universal mount so I can quickly fit an adapter to either a Sony mount for digital or an Arri PL mount for film. A Sony DVW camera fitted with my 500 mm lens together with its lens hood, the lens now seeming to be 650 mm long, is quite a sight.

The lighting equipment list

As with the camera list, in all probability, the production office will need an early list in order to obtain comparative costings from differing suppliers. Unlike the camera list, where a close guess of the requirements can be made from reading the script, with the lighting list it is very difficult to give a reasonably accurate judgement of one's needs before having seen all the locations. Nevertheless a list to base budgets upon will be requested.

My gaffer and I usually solve this by offering a list from a previous

THE QUEEN'S NOSE *CAMERA EQUIPMENT* *@ 14th July*

Cameras *Supplier: Hammerhead*

2 × Sony DVW – 700 Digital Camera kits with:
2 × Canon J8 lenses, and 4' clip on matte boxes.
1 × Canon J14 Lens
2 × Crozial 4" Matte Boxes
2 × Crozial Focus control unit

Electronic accessories *Supplier: Hammerhead*

2 × 9" Colour monitor – battery/mains
14" Colour monitor + location stand
Sony camera control unit (RM-P9) with long & short cables
6 × 12 volt heavy duty batteries
2 × 30 + 2 × 15 meter drums of video leads
Assorted short video leads

Telephoto Prime Lenses *Supplier: P. W.*

180mm Zeiss Sonnar T 2.8 (Universal Mount)
300mm Kinoptic T 4 (Universal Mount)
500mm Kinoptic T5.7 (Universal Mount)
All above with Universal – Sony mount adapter.

Filters *Supplier: P. W.*

4" Square Filters
85. 2 × 85N6. 85C. Tiffen 812
Promist 1/4, 1/2, 1, 2 & 3. Ultra Contrast 1, 2, 3 & 4.
Graduated filters: 0.6 & 0.9 Harrison soft edge.
2 × Polarising filters. Optical Flat.
3×4" Square Filters
85B, 85C, 85BN6, 81EF, Tiffen 812.
0.3, 0.6, 0.9 N.D. Mitchell soft edge grads
Cokin Pro. 3 × 4"
Sunset I & 2 Grads, Grads: B I, B2, G1, G2.
3" Square Filters:
85B, 85C, 85, 85BN6, 81EF, FLB, 82C, 82B.
Coral 6, 8, 10, ND6, ND9, LC I, LC2, 4 Point Star.
No's. I & 2 Diopters, Split Field Diopter.
Series 9 Filters:
Plus 1 Diopter, 85B.
Nets: Black Dior 10 Denier, Brown Silk, White etc.

1 of 2

Figure 9.2 *The Queen's Nose:* camera equipment list; page 1

THE QUEEN'S NOSE *CAMERA EQUIPMENT* *@ 14th July*

Additional Filters:
6' square Armoured glass
Large selection of gelatin filters to be charged as used.

Grip Equipment *Supplier: Steve Pugh*

Ronford Fluid 7 Head (150mm Affi bowl fitting)
Pee Wee Dolly with 150mm bowl and Moy adapters + Moy risers.
3 Way Moy leveler
Doorway dolly
Paddle mount
Off set arm
Walk round
50' straight rail + 2 curves
Low rocker
Bazoka
All usual grips 'Toys'

Legs For Camera I *Hammerhead*
(N.B. F7 Head for Camera 1 from Grip)
Ronford medium duty alloy tall & short legs (Arri 150mm Bowl Fitting)
Ronford dedicated spreader

Heads & Legs – for cameras 2 & 3 *Supplier: P. W.*
Mitchell Gear Head (Moy fitting) with double scissor wedge & front box.
Schulz Heavy duty Carbon Fiber tall & short legs (Moy fitting)
"Banjo" wooden spreader.

Ronford Fluid 15 Head (150mm Arri bowl fitting).
Ronford medium duty alloy tall & short legs (150mm Arri bowl fitting)
Ronford dedicated spreader.

Moy head to Arri bowl legs adapter.
Shoulder Holder PRO hand held kit.
Vinten Monopod.
Newman Sinclair Monopod

2 of 2

Figure 9.2 *The Queen's Nose:* camera equipment list; page 2

THE QUEEN'S NOSE *LOCATION LIGHTING LIST* *@ 14th July*

A small alternator + some additional kit will be needed for location days
Please see Technical Schedule

HMI
4 – 2.5K Strand Supernova MSR
4 × 1.2 Arri Suns
4 × 575 HMI's
2 × 200 HMI's
I × HMI Battery lamp
I × Medium Daylight Bank Chimera for 1.2 Arrisuns with Louvers

TUNGSTEN
2 × 2k Fresnell
2 × 2k Blonds
4 × 800w Redheads
4 × Ik Pups
8 × Mizars or Kittens
4 × Dedo lights
2 × Lee Zaps
1 × Battery lamp

PRACTICALS

Selection of tungsten household bulbs, clear & frosted. 4 x 60w
+ 4 × 100w "Daylight" BC bulbs 4 × No I + 4 × No 2 Photofloods

FILTERS & CONSUMABLES

1/4, 1/2 & Full Blue
1/4, 1/2 & Full CTO
0.3, 0.6 & 0.9 ND gel
Cosmetic Pink, Defusion Fl, F2 & F3, 3002 Rosco soft frost,
Hampshire Frost & Spun Glass etc.
Rosco Gold & Silver "soft" reflector
Rosco silver/black scram
Blackwrap.

1 of 3

Figure 9.3 *The Queen's Nose:* location lighting equipment list; page 1

THE QUEEN'S NOSE *LOCATION LIGHTING LIST* *@ 14th July*

STANDS

10 × Triple Lift
10 × Redhead / Blonde stands
10 × Flag stands + arms
2 × Low boy
2 × Double wind up
2 × High Rollers
2 × Double stand extensions

CABLES

63 amp extension – 200 feet
32 amp extension – 5 × 100 feet + 5 × 50 feet + 5 × 25 feet
16 amp extension – 5 × 100 foot + 10 × 50 foot + 10 × 25 foot

MAINS DISTRIBUTION

2 × 63 Dist. box
4 × 32 Dist. box

JUMPERS & SPLITTERS

3 × 63/ Open ends
2 × 63–32
8 × 32–16
12 × 16–16
6 × 4 way 13amp
6 × 2 way or 1 way 13 amp
10 13amp – 16amp jumpers
8 × 16amp male – chock block

ACCESSORIES

2 × Long polecats
2 × Medium polecats
3 × Short polecat
2 × Doorway polecats
2 × Trombones
4 × Flat plate turtles
6 × Spigot reducers
10 × Magic arms

2 of 3

Figure 9.3 *The Queen's Nose:* location lighting equipment list; page 2

THE QUEEN'S NOSE *LOCATION LIGHTING LIST* *@ 14th July*

Accessories Cont.

6 × "C" clamps
6 × "G" clamps – large
4 × Sash clamps
4 × Arri special clamps
2 × Pallet Knives
Selection of 1/2 & 1 stop nets Good selection of flags & charlie bars
2 × Large ulcers 2 × 4×4 foot reflector, hard & soft, 6 × Mizar snoots
& baseplates, 10 × sand bags
I × Large ladder
2 × Medium steps
1 × 10 foot scaffold pole
2 × Big ben
6 × Double barrel clamp
1 × Bag plastic zip ties
8 × Poly holders
4 × Frame holders
2 × 4' × 4' foot frames
12 × Safety chains
4 × 2k In line dimmers
2 × Hanks of sash
2 × Rolls gaffer tape
100 × crock clips
6 × Head covers
1 × Practical box
1 × 12 × 12 foot Butterfly + Griflon & Silk
1 × 6 × 6 foot Butterfly + Griflon & Silk
6 × 8×4 sheets of Black / White Polly Board

3 of 3

Figure 9.3 *The Queen's Nose:* location lighting equipment list; page 3

production which had a similar script and schedule; this at least provides a starting point. This provisional list only needs to contain the lamps and will look roughly as in the first page of Figure 9.3 (see page 62) but without the filters and consumables. The suppliers will be able to give a rough estimate from this as all the accessories are fairly standard.

During the recce my gaffer and I will be continually updating the list of the lighting equipment we will need to carry as the standard kit together with a daily extras list which will eventually become part of the technical schedule.

As soon as the technical recce is complete my gaffer and I will sit down with either my Psion or my laptop and compile the full list of all the lighting equipment we will require. As I can never remember all the bits and pieces he likes to have, we will either modify a previous list from an earlier production or if the list required is radically different, he will simply dictate the new list to me and I will type it into the computer. This results in a list as shown in Figure 9.3 (see pages 62–64). This figure is the actual list used on my example production of *The Queen's Nose*.

We then either fax this to the production office or deliver it the following morning. A copy is usually also sent directly to the supplier. Some urgency is required at this time as one is usually only a few days away from principal photography by the time the last location has been recced, final budgets need to be agreed, and the supplier needs to make sure that all the equipment on the list will be ready and on the lighting truck.

Requirements for the generator and lighting equipment truck do not go on the lighting list. My gaffer makes these arrangements directly with the lighting company. The same applies to cherry pickers and towers and all these will appear on the technical schedule together with any equipment required on a daily basis.

10
Technical preparation for a shoot

Technical checks

If you are hiring a camera kit it is prudent to check it all thoroughly in sufficient time to return any piece of equipment for exchange or maintenance and still have sufficient time to comfortably make your first call time on location.

It must be said that if you are hiring from a reputable company there is only a very small likelihood of your finding any problems but if you, or your camera assistant, haven't checked everything then you only have yourself to blame if you arrive on location with faulty equipment.

The tripod

First set up the tripod; check it fits the spreader and look for any signs of the damping fluid leaking from the head joints. Next, check that each damper setting works properly and that you can arrive at a setting with which you feel comfortable. If you have a two-piece pan bar make sure that the extension bar fits easily or, if it comes fitted, check that it comes apart easily. Pan bars frequently get overtightened and the two parts can become almost impossible to separate.

Check that you have been supplied with the correct adapter plate to go between the tripod head and the camera.

The camera base plate

Put the camera onto the tripod, not forgetting to lock the tilt mechanism first. Now is the time to make sure that the camera is rigidly attached to the tripod head. Many video cameras have a long plate with a vee slot at one end and a key pin at the other so that the camera can quickly be fitted or removed from the tripod. This arrangement is fine so long as the fittings are correctly adjusted, but they frequently are not. The locking mechanism in this arrangement requires that, when attaching the camera to the tripod, the camera is pushed forward very firmly. This causes wear and misalignment very quickly and the camera starts to become quite a

sloppy fit onto the intermediate plate. This in turn makes the camera very irritating to operate. If your camera feels sloppy or rattles on the plate get the supplier to make the necessary adjustments before you leave for location.

Camera checks – record/playback

Set up the monitor and check you get an output from both the Test Out socket on the side of the camera and the monitor socket at the back of the camera. Line up the monitor as described elsewhere in this book.

Record both some bars and a couple of minutes of scene with the time code set to record/run, rewind the tape and check that the image of both the bars and the scene are clean and free from noise or drop-outs. Drop-outs look a little like dirt sparkle on film. Check also that during playback the join between the bars and the scene goes through without a glitch. This will tell you that the record/run time code is matching the outgoing and incoming shots seamlessly.

If your sound person is with you, and they should be, then make sure that they check all their inputs and outputs and that they are happy with both the record and monitor levels.

Lens checks

Make sure that the lens zooms smoothly and, if such controls are fitted, you can adjust the speed and attack of the motorized zoom control to settings with which you are happy.

Back focus and the star chart

Now check the back focus of the lens. You should do this regularly. As the camcorder is designed to be hand-held using the grip attached to the lens as the main handle, the joint between the camera housing and the lens can become misaligned due to the forces occurring at the lens mount.

To reset this adjustment, known as the back focus, you will need a star chart (see Figure 10.1). Most star charts consist of a simple star, as in the centre of Figure 10.1, but with black segments on a white background. I believe the one shown is a considerable improvement in that it has test areas at the corners of the frame. By being white on a black background it reduces the chance of flare within the lens, thus making the test more critical and it carries a 16 × 9 frame test.

You should have a star chart of such a size that the width of the circle nearly fills the width of a standard office sheet of paper. Mine also has the instructions given in Figure 10.2 on the reverse side so that I don't have to remember the exact details of how to carry out the procedure. I have had it laminated so that it is virtually indestructible and is easy to keep clean.

Switch the lens to automatic exposure and find a lighting situation where the exposure on the star chart is very near to wide open without having any of the filters on the filter wheel in place. On the DVW cameras that is A and 2. Set up the star chart around 6 feet (2 metres) away from the camera.

All the following adjustments should ideally be carried out judging the effect on a monitor with the chroma taken out to show a black and

Figure 10.1 The improved star chart

Figure 10.2 Setting the
back focus

1) Set the lighting to give a correct exposure with the lens near or at wide open.

2) Put the star chart at around 6 feet, or two metres, away from the camera.

3) Zoom right in and focus the lens in the normal way.

4) Look at the dots on the back focus ring – they should coincide. If they don't and you are sure you have a back focus problem then move them to coincide and refocus the lens.

5) If you can possibly do so check all the focus adjustments on a monitor, with the chroma taken out, so you have a black and white picture.

6) Adjust the lens to wide angle and rotate the back focus ring until the star chart looks sharp.

7) Zoom in and adjust the lens focus.

8) Zoom out and adjust the back focus.

9) Repeat steps 7 and 8 until no further improvements can be made.

10) Lock the back focus ring.

11) Run through steps 7 and 8 again to check the back focus ring did not move when you locked it.

NB You may have to go through steps 7 and 8 several times before the focus is correct at both ends of the zoom without any refocusing being necessary.

white picture. The camera viewfinder is not of sufficiently high quality to make accurate judgements. Zoom into the star chart and focus using the normal focus on the lens. Zoom right out. If you see the star go fuzzy you need to reset the back focus. The configuration of the star chart is such that it is very easy to judge focus, if the chart is in focus only the centre of the star will be fuzzy, if the chart is out of focus the fuzzy area will have expanded to a much larger diameter. Assuming your chart now has a large fuzzy area when the lens is zoomed out look at the back of the lens near to where it joins the camera, there will be a ring with a locking knob, There will probably be two very small dots, one on the ring and one on the lens body. In an ideal world the back focus is correct when these two dots exactly line up. If you suspect the back focus needs resetting loosen the locking knob and rotate the ring until the dots do line up. Now rotate the ring until the star chart looks as sharp as you can get it.

Now zoom back in and refocus the lens in the normal way and zoom out again and get best focus using the ring at the back of the lens. You

will probably have to repeat these operations six or even eight times until the star chart looks sharp at both ends of the zoom range. When it does, carefully lock the ring at the back of the camera making sure not to move the ring. It is a wise precaution to zoom in and zoom out once more to check the ring did not move while you were locking it.

Figure 10.2 is a simplified list of the above operations for you to use as an *aide-mémoire*. It is this list I have on the reverse of my star chart.

If you fail to get the star chart sharp at both ends of the zoom range you may have a more serious problem and will need to take the lens and camera back to your supplier.

Time code

There are two formats of time code available on the camera and it is wise to check with your picture editor which they would prefer. Most often when shooting a documentary, where the sound is being recorded only on the video tape, you will be asked to use record/run time code. If you can't get hold of the editor and you are recording sound only within the camera then I would recommend this setting.

With record/run the time code numbers only run when the camera is running. This means that right through the whole of the recording the camera will have made seamless joins in the picture information shot to shot and the time code will have been recorded in a continuous unbroken stream of numbers. This makes the editor's job a lot easier.

If you are also recording sound on a separate machine or, indeed, are using any other additional cameras then you need to use the alternative time code setting known as F-run or free run. This setting is used when any external device needs to record exactly the same time code as the camera. Once the time code has been set (see Chapter 14) the time code will run continuously and each shot will have associated with it whatever time code was running at the time. It will not, therefore, have a continuous stream of numbers running throughout the whole of the recording on the tape. There will be gaps in the number sequence every time the camera is stopped.

The advantage of this system is that the external device can lock its internal time code to the figures set in the camera at the start of the day's shooting: most equipment will still be in perfect sync after at least 8 hours. Alternatively, a BNC cable can be taken from the TC out (time code out) socket on the side of the camera and run to any other device which can then be slaved to the camera's time code. In this configuration you can use record run or free run, whichever your picture editor prefers.

Free run time code is often referred to as 'time of day'. This is because it is common to set the time code figures to represent the true time of day.

Accessories

For serious drama work it is quite common to set up a video camera to take many of the standard film camera accessories. Indeed Arriflex themselves make a base plate for the Sony DVW cameras that can be fitted in place of the standard quick-release tripod plate. Not only is it exactly the right thickness but it has all the correct mounting holes and threads to enable all the Arri matte boxes etc. to fit the DVW camera.

Matte boxes

I am very keen on using the finest matte box you can afford. If you set up a digital camera outdoors on a fine day, and keep the monitor indoors so that you can really look into the shadows, it is often possible to detect up to half a stop of difference in the flare that is introduced into the shadows of the scene when a tiny lens shade, as supplied with the lens, is used as against when the camera is fitted with a proper, film-style, matte box.

The flare comes not from the blue sky but from the soft light emanating from the clouds, and this soft light can find its way past all but the best matte boxes.

Lightweight matte boxes that can accept a couple of 4-inch filters come either to fit directly onto the lens or use a pair of 15 mm bars fixed to the camera mounting plate.

If you are able to use something like the Arri MB 14 or 16 matte box this will come with an Arri sliding base plate, which has the added advantage of allowing you to balance the camera on the tripod head, and the camera plate allows you to use heavy-duty 19 mm bars. Onto bars of this dimension you can fit all the film-style lens accessories you could wish for.

The Arri matte boxes also come with clip-on front mattes for different focal-length lenses. This ability to reduce the front hole, or matte, to a size only a fraction larger than the image to be photographed increases still further the efficiency of the flare control of this matte box.

Follow focus devices

The perceived wisdom is that video cameras, in general, have great depth of field, so much so that this is seen as one of the drawbacks when comparing a video image with a film image. As you will have gathered from other parts of this book, there are ways of both lighting and controlling the camera to get a digital video image having something very close to the depth of field many of us find attractive in the film image. At this point it becomes difficult for the camera operator to pull focus for themselves, as is prevalent in the television studio world, and a film-style focus puller becomes, if not essential, then a huge advantage.

Once the camera has been fitted with an Arri sliding base plate and its associated 19 mm bars all the film-style accessories can be used. These include both manual follow focus devices and electronic ones.

If a film-style lens such as the modified Canon J8, J9 or J14 is used then the gears on the lens will permit the use of a full Arri Lens Control System. This, from a single handset, allows remote control of focus, zoom and iris. It is very sophisticated and can be taught, very easily and quickly, all the parameters of the actual lens in use.

Lenses originating from the video world can be used with film style follow focus units but they are not quite as successful. The gears that surround the lens are of a very different pitch, so it is important to check that you have the right gears available with the follow focus to mesh successfully with the lens you are using. One of the things that is changed when a video lens is converted to film style is to give much greater travel for the full range of the focus, thus allowing a finer control.

Viewfinders

Most cameras come fitted with a short black and white viewfinder. It is important to check that you can adjust the back ocular to give you perfect focus. This may vary, for if you normally wear glasses you have to chose if you will wear them when operating the camera. Unlike a film camera, you don't have to stop the light getting into the viewfinder, so it is much easier and safer to wear your glasses when operating. If you are short-sighted but prefer to operate without your glasses then a back ocular with greater correction is available which might help you.

For serious drama shooting especially if, like me, you are a fan of the geared tripod head, you will find operating with the short viewfinder a little uncomfortable. There is a solution to this in the form of a long viewfinder which makes matters as comfortable as a film camera fitted with a similar device.

Plate 9 shows a DVW camera set up with a long viewfinder and mounted on a Arri geared head. The stick going down from the viewfinder tube is called an eyepiece leveller and is attached at the lower end to the rotating base of the head. This rod ensures that the eyecup stays at the same height no matter what the inclination of the camera and makes operating very comfortable indeed.

Plate 9 also demonstrates a DVW camera in nearly its ultimate full drama mode. The camera is supported on a geared head with both a quick-release plate and a Arri sliding base plate from which extends a pair of 19 mm bars on which are mounted a manual two-speed follow focus unit together with a matte box capable of holding two 4-inch filters – any film technician would feel at home with this rig.

No matter what viewfinder you chose, you must set it up correctly. No viewfinder currently available can match the image quality of a good monitor so the better you can set it up, the happier you are going to be.

The first thing to do is to set up a monitor which can easily be viewed with one eye while your other eye is to the viewfinder. You don't have to use alternate eyes but this does make things simpler. Before you start, switch the camera to bars and line up the monitor correctly. Now take out all the chroma in the monitor. Adjust the viewfinder controls, which will normally be found on the front face of the viewfinder to match the monitor as closely as possible. You now have a viewfinder set up as best as possible.

Currently I can't recommend any colour viewfinders as they all give me a headache within a few minutes.

Monitors

Choosing a monitor

The choice of monitor for location work, in the UK at least, seems mainly to be between a 9-inch monitor, which may come in either normal or high-resolution forms, a standard 14-inch monitor, again specifiable as normal or high resolution, and a 14-inch Grade One monitor, the latest of which can handle a serial digital signal which, ostensibly, will give you a higher quality picture than the more standard component video signal. I always try to specify a high-definition monitor no matter what size I am going to use.

Nine-inch monitors

A well-set-up 9-inch monitor is perfectly adequate for documentary location work and in the hands of an experienced director of photography or lighting director can also give sufficient information to satisfy their requirements. It will be more acceptable on drama if the DoP or Lighting Director (LD) has previously shot similar scenes using a larger monitor and is therefore confident that the system is working and how it is likely to look.

It is not uncommon for supplementary monitors for the sound department etc. to be 9-inch, though the camera crew should make it very clear that it is the sound department's responsibility to feed their monitor and under no circumstances must they be allowed to use the same camera feed as the DoP, for, in certain circumstances, this may reduce or change the quality of the DoP's picture without their being aware of the change with possibly disastrous effects.

Fourteen-inch monitors

I always prefer a 14-inch monitor if there is sufficient labour on the crew to move and rig it. Until recently I did not favour a Grade One monitor for I felt them unreliable when bounced around on location, but I have recently changed my mind. It may be the monitors have improved, it may be I now need the better picture, but I think the most likely reason is that the suppliers have also come to the conclusion that they are a little more delicate and pack them better.

On the television series on which I am currently working the 14-inch Grade One monitor arrived packed in a freight case of which only the front and back is removed to reveal the plugs and sockets at one end and the screen at the other, the monitor remaining in the bulk of the case protected by more than 2 inches of hard foam. This packing was arranged so that all the ventilation holes in the monitor's casing had adequate breathing channels through the foam. This monitor has been a joy to work with – it is very stable and seems to be exceptionally reliable. The only drawback is its bulk and weight, so if we have many locations in one day I try to be kind to my crew and use the 9-inch monitor, though when I do I always miss the quality of the Grade One.

Choosing a monitor can be a very individual matter but I find it is best to stick to one monitor as much as possible. With the best will in the world there will be differences between even two apparently identical monitors even after you have lined them up, so find one you like and stick to it as much as possible. If you have to change the basic type of monitor you are using try to keep your old one for a while and run them side by side so that you can get used to the differences.

Lining up the monitor

This could be the most important section you read in this book.

My approach
Before I describe the various approaches to judging the results of your lighting on a monitor I must point out that my technique involves only one carefully lined-up monitor and that only ever showing the picture to be recorded. The other more complicated (though some would say more

sophisticated) ways are only discussed to give the reader a wider view of the subject.

There are many different approaches to visually checking your work on one or many cathode ray tubes while shooting. One school of thought says that you must have three all dedicated to the DoP, or LD, no matter how many are fed for the LD and other members of the unit. These three would most likely be a Grade One monitor, to look at the picture, and two oscilloscopes, one displaying a waveform (this being known as the waveform monitor) and another known as the vectorscope, which shows a curious six- or twelve-pointed star which, if you know how to read it, will tell you the relative signals associated with the various colour elements of the picture.

It is possible to insert a converter box between the camera and the monitor so that the image on the monitor can be switched between picture, a waveform display and a vectorscope display.

While I can interpret the images on both a waveform monitor and a vectorscope I find their use on the set inhibiting. If I were shooting film would I be continually be referring to a graph of the sensitometric curve? No. Would I be looking at the colorimetry curves of the film stock in use three or four times before I was happy with the colour balance of the lighting for any given scene? No. So why would I want to get myself even deeper involved with the values associated with brightness and colour when shooting digital? I can think of no reason to confuse myself in this way and, for me, there are very good reasons for this decision.

I feel good lighting does not come directly from technical knowledge. That knowledge merely permits the person possessing it to express their emotions, their feelings and responses to the scene they are about to shoot in an articulate way. The knowledge must be in the background if they are to light in a technically competent way, but it should stay in the background in order to let the feelings and emotions come to the fore and create something which we may call the Art of the Cinematographer.

If you chose to follow my practice it is most important that you line up your monitor in such a way that you may utterly rely upon its image. The methods are simple and reliable. If you feel a little naked without your waveform monitor and vectorscope and would like further information on how to interpret their output then there are many excellent technical books on the subject. I can happily recommend the *American Cinematographer Video Manual* for a very practical approach to these subjects, especially for NTSC users.

Why take such trouble?

Whenever I come to line up my monitor at the beginning of a shoot I am invariably struck by how much contrast I will take out of the line-up set by the supplier. I have come to the conclusion that this excessive contrast on most monitors contributes heavily to the disappointing lighting one sees from many digital cinematographers. If a cinematographer is lighting to a monitor showing too much contrast what will be the result? They will reduce the excessive brightness in the highlights by stopping down the lens and then add far too much fill light in order to bring up the shadows. The result of this is that they will be putting most of the important information in the screen well within the 32:1 contrast ratio available to them and their images will appear far flatter than necessary. It will also have many more of the undesirable characteristics we associate with poorly shot video.

That is why I chose to start this section with the sentence 'This could be the most important section you read in this book'. I like the phrase 'If it looks right it is right' but with video this is only true if your monitor is lined up correctly.

Lining up a PAL monitor
In order to line up your monitor you must first arrange for the camera to send the colour line-up bars to its monitor output socket. Some digital cameras have only one type of bar format available and some have a wide selection. To line up a monitor where both the camera and monitor are working in the PAL format I always use the EBU (European Broadcasting Union) colour bars format as shown in Plate 10.

Before lining up your monitor, particularly if it is a Grade One monitor, you may have to find the switch, or switches, that give you manual control of the brightness, contrast and chroma knobs. There are seven very simple steps to a perfect line-up:

1 Switch the camera to bars output.
2 Using the brightness control adjust the extreme right-hand dark bar to match the density of the surrounding unused screen area.
3 Switch the monitor to Blue Only. You will usually find this switch somewhere near the bottom-left of the monitor controls.
4 Using the Chroma control adjust the extreme left-hand dark bar (the second bar in from the left) again until the density of the bar exactly matches the surrounding screen density.
5 Using the Contrast control adjust the extreme left-hand bar, which is white, to a perfect white.
6 Switch off the Blue Only control.
7 Switch the camera back to picture and your monitor is perfectly lined up.

Helpful hints
For steps 2 and 4 above you will find it easier to get an exact match to the surrounding screen area while reducing the brightness of the bar. For step 5, if you are setting this just by eye then increase the contrast until the bar is just bleeding into the adjacent black bar and then back off until there is no sign of bleeding and the bar appears white, not burnt out. Another description often used is that you should reduce the contrast until the white bar ceases to 'glow'.

If you have had to make any significant changes to the line-up it is prudent to go through the whole loop again until you find you are really making no more changes. This will be particularly necessary, in my experience, when you first come to line up your monitor just after it has been delivered.

For a truly perfect line-up you will need an exposure meter with a number of specific attributes. It must be an incident meter, be able to be fitted with a flat white plate over the sensitive area rather than a dome and it must be able to read a flickering image. This last attribute is the hardest to find in an incident meter. It also helps if the meter can read directly in foot candles.

If you have such a meter then for step 5 in the line-up procedure fit the flat plate and put it in contact with the monitor screen over the extreme right-hand white bar. Now adjust the contrast until the meter reads as near as possible to 27 foot candles. I use my Cinemeter II as it is ideal for the purpose and has circuitry specifically allowing it to read from a

television screen. If your meter cannot read in foot candles but has all the other attributes then you are looking for a reading roughly equivalent to a fiftieth of a second, or 24/25 frames per second with a 180° shutter, and an aperture or T 2.5 using 400 ASA film.

Lining up an NTSC monitor
To line up a NTSC monitor you must first send to it SMPTE (Society of Motion Picture and Television Engineers) colour bars, as shown in Plate 11. Do this by switching the camera control to Bars. The first parameters to set are Chroma and Hue. (A note to those used to PAL: there is no Hue control in the PAL system.)

Somewhere on your monitor you will find switches labelled red, green and blue. These may not be immediately accessible, so see if there are any doors or covers that might reveal them. Having found them, switch off both the red and green displays. If the monitor is fitted with a blue only switch use this instead. You should now be looking at the output of the blue signal only. On the screen you should now see four vertical bars in blue with three much darker bars between them. Below each blue bar you should be looking at a much smaller and rectangular section to the bar. Ignore for the moment all the other portions of the screen.

What we now have to try to achieve is a situation where colour and brightness of all four blue bars match, as near as possible, the smaller rectangular sections below them. The two controls we are going to adjust now are Hue and Chroma. Adjusting the Hue control will mostly affect the appearance of the middle two bars and adjusting the Chroma will mostly affect the outer two blue bars. Adjust both controls until you have the best possible match between the large vertical bars and the smaller sections below them on all four blue bars. When you are satisfied with your result switch back on both the red and green colours or switch off the blue only control.

The second parameters to set are Brightness and Contrast. Find the sixth bar from the left, which will be red, and looking slightly below it now find three narrow vertical grey bars. If at first you can't find them then increase the brightness until they appear. Somewhere on the front of your monitor you should find a switch labelled Color/Monochrome. Switch this to Monochrome. You now need to reduce the brightness of the middle bar of the three small bars until it only just disappears, leaving the right-hand sides of the three little bars still just visible.

Towards the lower left-hand segment of the screen you will find a white square, Using the Contrast control, adjust this square until it just bleeds into the adjoining areas. Now back off the Contrast control until this effect just disappears. As with a PAL monitor, this is often described as reducing it until it ceases to 'glow'.

With any television format the Brightness and Contrast controls are never wholly independent of each other. This is especially true of NTSC, so you may well have to go through the loop of making adjustments to both controls until you find you are no longer making any more changes.

When you are satisfied with your line-up switch the Color/ Monochrome switch back to Colour and your camera back to picture. Your line-up is now complete.

Ambient light
It must be recognized that having lined up your monitor under one ambient lighting condition the line-up will no longer be accurate should that

ambient lighting condition change. You should therefore make it your habit to always line up again if the monitor is moved. If you are using an incident meter to set contrast then it is good practice to keep the meter with the monitor.

Cabling your monitor

How you cable your monitor may not seem important, but in fact it is vital to your success.

Termination

If you are simply feeding one monitor directly from the camera this should not be a problem. If you are looping from the camera to one monitor and then on again to another monitor, understanding termination is vital. The simple rule is that the last monitor in the line must be terminated. This may, on some monitors, be done with a simple switch or you may have to put a termination plug onto the Video Out socket of the last monitor on the line. If you don't, the danger is you will see a different image on each monitor and quite likely none of them will be correct.

Serial monitors

Even if you get your termination right the number of monitors hung onto a single camera output can disastrously affect the quality of the image. Do not accept an image amplifier between any source and the monitor you, the DoP or LD are going to watch. They may claim to be transparent, that is, adding no changes to the image, but, believe me, I would never stake my reputation on it.

Best practice

The monitor the DoP or LD is going to watch should come from a single output on the camera. No other monitors should be fed from this output and no monitors should be fed down-line from the DoP's monitor. This rule should never be broken.

Choose another output from the camera for any other monitors and do not be swayed from this opinion. I have let this happen in the past and it was a disaster. Please learn from my experience.

On-screen monitor information

With some of the newer cameras, notably the Sony DVW 790, you can sometimes select what information, in addition to the picture, you would like displayed on the monitor screen. If you chose to take a serial digital feed from the rear BNC socket on the DVW 790 you can then add additional information to the image. On the other hand, if you are happy with a component video signal then you have the option of selecting a number of additional bits of information on the screen. To find out how to do this refer to Chapter 21.

On my current series I started by insisting that I had a serial digital feed to my 14-inch Grade One monitor direct from the Rear BNC, everybody else getting a feed via Test Out where much more information was available. This proved to be an error. The director, quite reasonably, wanted to see a 14:9 box overlaid on the 16:9 image we were recording. The script supervisor needed the time code in vision and would have

quite liked the indicator as to the focal length of the lens in use. We now had a situation where the director and I were physically separated, always a very bad thing, and the director and script supervisor were separated, never ideal.

Also there was a psychological flaw in this arrangement for, due to budgetary restraints, I had the only 14-inch picture and the director, completely uncomplainingly it must be said, was watching a 9-inch monitor and having, occasionally, to cross the room to my monitor to see exactly what was going on. We were also looping a feed to the sound mixer.

I quickly came to the conclusion that this was madness and rewired everything, so that I had a component feed with a 14:9 box, time code display and lens length, and the three of us once again became a close team all looking at the 14-inch Grade One monitor. I thought I would be driven mad by the time code spinning away in vision and would miss the added quality on a digital feed. Within three to four days I was completely ignoring the time code figures and, to be honest, was hard pressed to criticize any reduction in image quality. What you see is all that matters, and my mind was not seeing the time code and my eyes could not discern any loss of quality. It is amazing what the human sight/vision computer can do.

Once this new arrangement was in place it was quickly established that anyone wanting another monitor was welcome providing they brought it to the set and cabled it themselves and, without fail, took their feed out of the other socket on the camera.

Plate 1 Full tonal range of 16:1

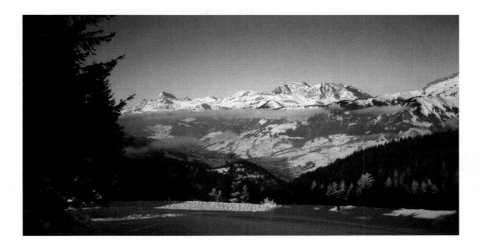

Plate 2 Three quarters of full tonal range

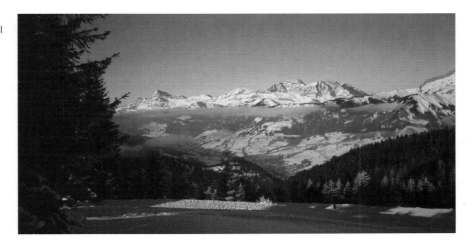

Plate 3 Three-quarter tonal range image stretched back to full 16:1 tonal range

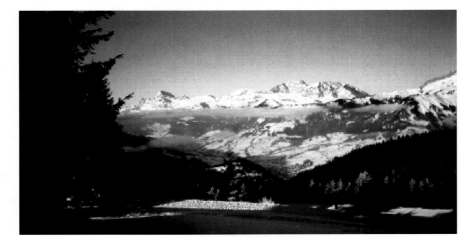

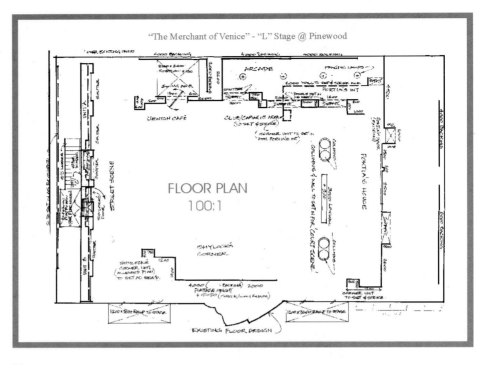

Plate 4 *The Merchant of Venice:* floor plan

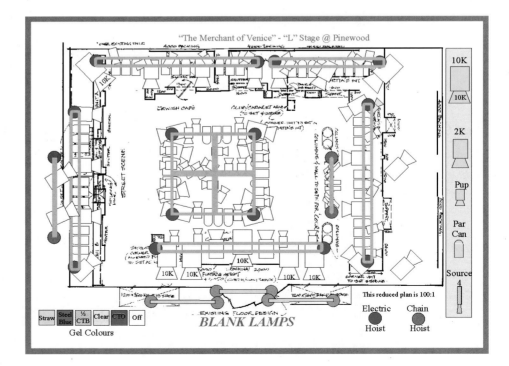

Plate 5 *The Merchant of Venice:* blank lamps plan

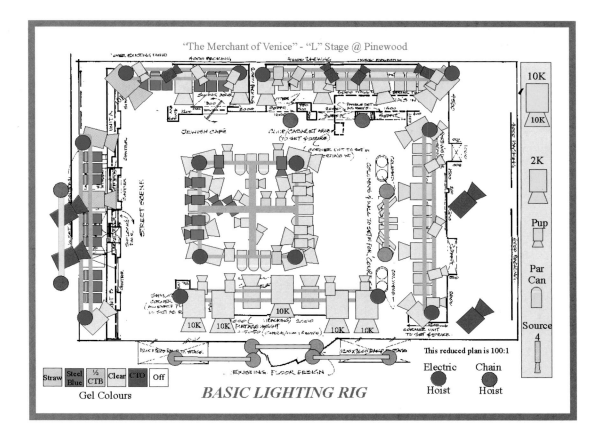

Plate 6 *The Merchant of Venice:* basic lighting rig

Plate 7 *The Merchant of Venice:* studio lighting desk

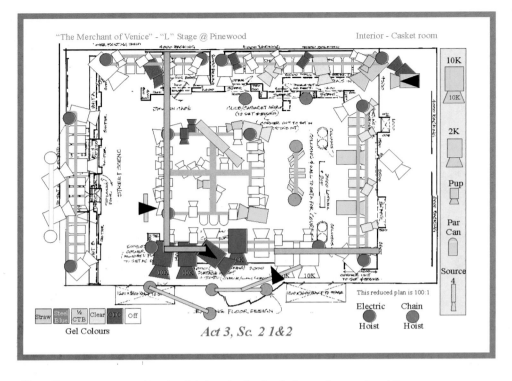

Plate 8 *The Merchant of Venice:* lighting plot for Act 3, Scene 2, parts 1 and 2

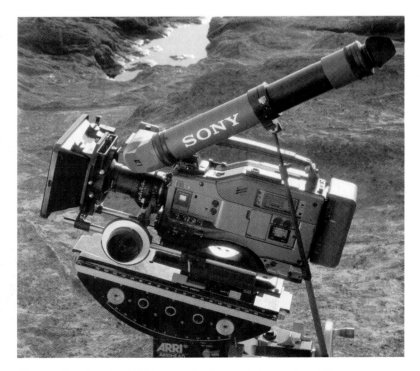

Plate 9 The Sony DVW 700 set up for drama filming. © Sony UK

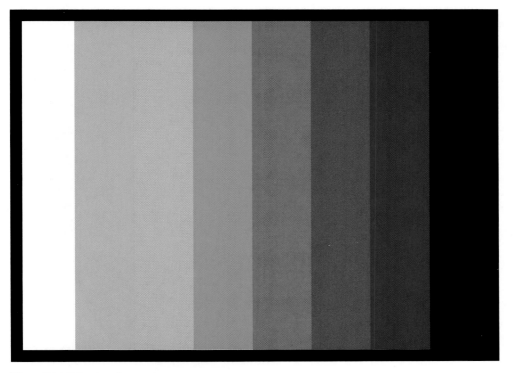

Plate 10 EBU colour line-up bars

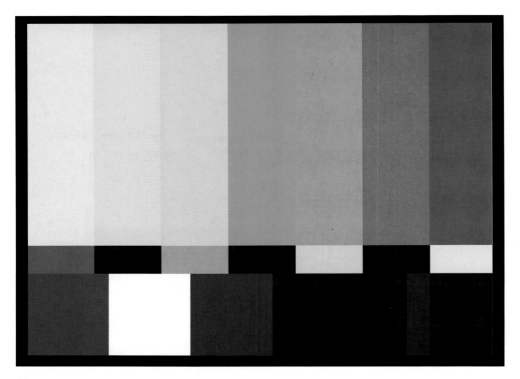

Plate 11 SMPTE colour line-up bars

Plate 12 Three-colour additive colour mixing

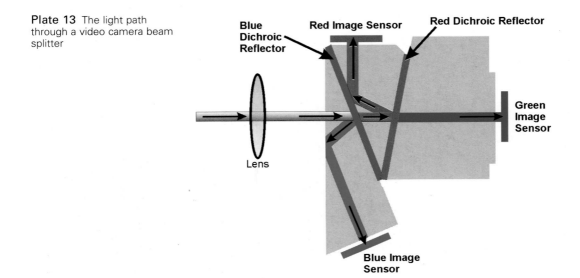

Plate 13 The light path through a video camera beam splitter

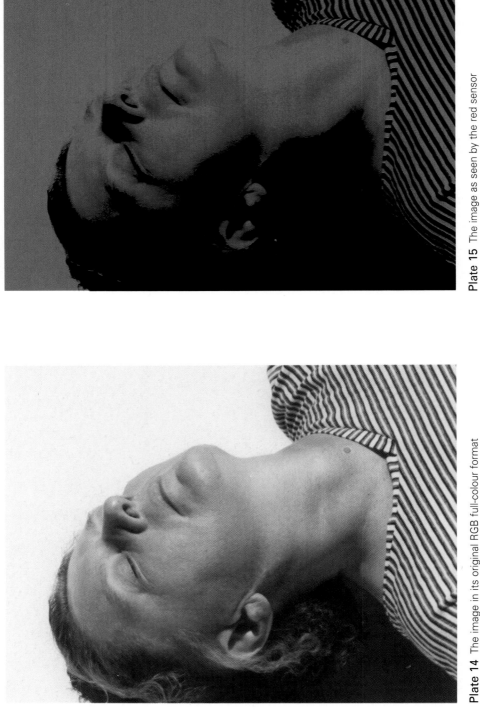

Plate 15 The image as seen by the red sensor

Plate 14 The image in its original RGB full-colour format

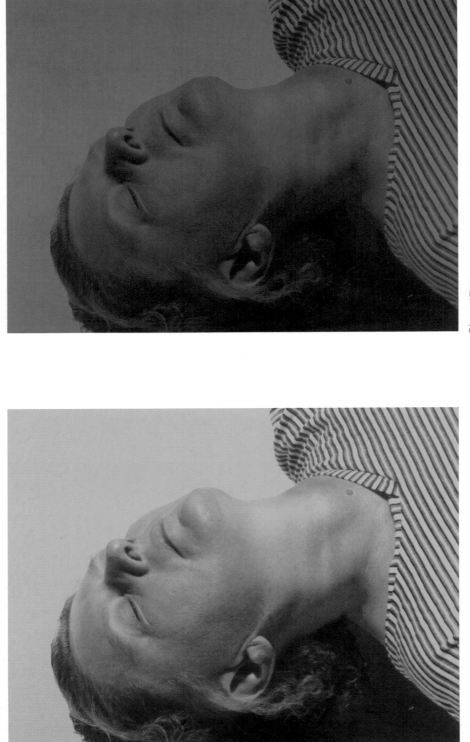

Plate 17 The image as seen by the blue sensor

Plate 16 The image as seen by the green sensor

Part Four
The Technology

11
The camera

The television image

Before we can discuss the workings of the camera it is important to understand how a modern video camera transforms the optical image coming out of the back of the lens into a format that can be recorded as an electronic signal which can then, later, be reconstituted into an optical image on the television screen.

The basic principle is very simple and has been used for many years in the publishing industry. If you break down an image into very small sections and give each of those sections a value, this can be recorded. If you look at any of the illustrations in this book, at first sight they seem to be composed of perfectly even areas of greys for the black and white illustrations and many very realistic colours for those in colour. Were you to take a magnifying glass of even quite limited strength, say eight times magnification, then you would see that all the areas are made up from different-sized dots. The dots are always the same distance apart, they simply vary in size.

If the printer wishes to show an area as pale grey then the dots will be very small. If they wish to show dark grey then the dots will be very large, in fact so large that they very nearly touch each other. By using a large number of different-sized dots the printer can obtain what, to the reader's eye, appears to be an almost infinite number of greys right through from black to white.

Additive colour imagery

In order to apply this principle to a television screen each nominated dot has three parts, each a phosphor which will glow when hit by a beam of electrons, and it will glow with a different brightness depending on the strength of the beam. As the three phosphors glow either red, green or blue a nearly infinite number of colours can be obtained from varying the brightness of each of the coloured dots. If all three dots are glowing at 100 per cent brightness then this will appear as pure white, and if they are all switched off this will represent as near to black as the screen can produce.

Plate 12 shows how this additive colour mixing works. Three beams

of light, each red, green and blue, are projected onto a white background and where all three overlap the colour will appear to be white. Where red and green alone overlap the light appears to be yellow. Where blue and green overlap we get cyan, and where blue and red overlap we see magenta. The three original colours, red, green and blue, are, in cinematographic terms, known as the primary colours and the three colours obtained by mixing equal amounts of only two of the light beams, yellow, cyan and magenta, are known as the secondary colours.

The glowing phosphors on the television screen work in exactly the same way as if they were beams of coloured light and adding light together is known as an additive colour process. Those of you with a background in art will already have realized that adding pigments of red, green and blue together creates a very different effect from adding light together.

Resolution

While the above may explain how we can display an almost infinite number of colours on the television screen it has nothing to do with how we see what we now know to be just an assembly of coloured dots as a high-quality image with, apparently, smooth continuous tones. To understand this we must investigate how the human eye works and, in particular, what the ultimate resolution of the eye might be. Most sources agree that the limit of the eye's resolution is any object whose width represents an angle of view to the eye of 2 seconds of arc. A full circle is divided into 360° and mathematically we divide each degree into 60 minutes and then further subdivide each minute into 60 seconds. So 2 seconds of arc, therefore, represent a very narrow angle indeed. This is a very useful way of measuring the eye's resolution because it allows us to decide how large the smallest dot that the eye can resolve will be at varying distances from the eye.

Looking at Figure 11.1, with the angle much exaggerated, we can see that the size of the minimum resolvable dot on a small screen, near to the viewer, has to be smaller than that on a larger screen further from the viewer. Therefore if we make an assumption as to how large the average

Figure 11.1 Proportional image resolution

home television is and judge the average distance the viewer will sit from it we can calculate the largest size of dot that we can allow our three glowing phosphors to become before the eye will resolve them and not, as we wish, blend them into the next dot. In other words all we have to do is ensure that our three colour composite dots never subtend an angle of view to the audience's eye of as much as 2 seconds of arc.

The vertical definition of the image on a television screen is limited by the number of lines displayed on the screen. In the USA the picture is divided into a 525-line image and in most of Europe into a 625-line image. At first sight the 625-line European image would seem to be better, but we must add into the mix the number of times the image is shown on the screen each second. As the USA has a 60-cycle mains supply and shows half the picture, the lace lines, every 60th of a second and, alternately, the interlace lines also every 60th of a second, a complete picture is shown every 30th of a second. In Europe where there is a 50-cycle mains supply the same lace and interlace principle applies but each complete picture is shown every 25th of a second.

A very significant influence on the number of lines chosen by each country as its standard was the bandwidth available on the UHF (ultra high frequency) transmission system that was going to be used. While every transmission station declares its transmission frequency the actual transmission spreads over other frequencies either side of the primary frequency. This limits how close to each other, on the frequency scale, one can place each station. This bandwidth limitation determines the maximum amount of information that can be transmitted and received in any given second.

In the USA model 525 lines are transmitted 30 times a second. This means that 15 750 lines need to be transmitted every second. In Europe, with 625 lines transmitted 25 times a second, 15 625 lines need to be transmitted every second. These figures are very close indeed for there is a finite limit to the amount of information that could be delivered via the analogue UHF transmitting system used at the time. This limit to the amount of information that could be delivered therefore, in part, dictated the number of lines into which the picture could be broken down.

The horizontal resolution available on the television screen is influenced by the effective number of dots across the screen and this is arranged both to be within the resolution of the eye and at least as good as the vertical resolution provided by the number of lines. There are other matters that affect the apparent overall picture quality. The faster the refresh rate, that is the number of images shown per second, the greater the apparent definition will appear to be. This is a simple function of the overall amount of information presented to the eye in any given time span. This refresh rate also affects the apparent flicker that may be seen on the screen, this usually being most apparent in the highlights.

In practical terms both systems are capable of very high image quality. The differences are very slight: an American seeing a European television for the first time will almost certainly notice the highlights flickering. A European seeing an American television for the first time, if they are in the business, might notice the absence of the same flicker. They may also notice a slight lack of matching in colour rendition from shot-to-shot. The European system transmits an extra piece of information to control this shot to shot colour matching. The American system does not have this facility.

Original Scene Lace Scans Interlace Scans

Figure 11.2 The effect of splitting up an image into lace and interlace scans

Both systems use the principle of transmitting the lines on the lace and interlace system mentioned earlier. This has been used until recently because it increases the apparent refresh rate, thus improving both the apparent definition and the flicker effect. It also, for technical reasons, was slightly easier to transmit the picture this way using the available analogue UHF transmission frequencies. Figure 11.2 shows how the image is scanned. The picture is broken down into a series of horizontal lines which, together, form the whole picture. First, the even-numbered lines are scanned, transmitted and displayed on the television screen. Then the electron beam in the television flies back to very nearly the top of the picture ready to display the missing lines which would be the odd-numbered lines. Thus within every 30th of a second in the USA and within every 25th of a second in Europe all the information contained in the original picture is shown on the television screen. The effect of the eye's persistence of vision, its inability to notice sudden changes, means that the viewer believes they are seeing a whole, moving, picture.

The digital camera

In the video camera a conventional lens, most often a zoom, offers a normal real image to the camera. Things from then on are very different from a film camera.

The camera head

If you remove the lens from the camcorder you will find, just behind the lens mount, two disks which hold the four exposure control filters and the four colour control filters. Immediately behind those there is what appears to be a flat glass plate. It is not a plate but a very sophisticated beam splitter.

To anyone coming from a film background the description which is about to follow will seem like a nightmare, for they expect nothing but air between the back of the lens and the image plane during the exposure.

In order for a modern video camera to function the image from the lens must be split up into its red, green and blue components and each of the resultant images must then be delivered to a receptor dedicated to that colour. While all this separation is happening it is vital that each colour image travels through a light path which contains identical amounts of both air and glass. In order for this to be achieved three prisms are cemented together as in Plate 13. Between the mating surfaces of the prisms are two dichroic mirrors, one reflecting blue light

only and the other red only. Dichroic mirrors are used instead of filters because they enable a far brighter image to be separated.

A dichroic mirror works on the principle of coating a sheet of glass with interference layers which have both a low and a high refractive index. These layers have a thickness of approximately one quarter of the wavelength of the light which is to be separated. For instance, a mirror which has a maximum output of 700 nanometers (nm) and a minimum output of 350 nm is therefore a red reflecting mirror. If the sheet of glass upon which the mirror is coated were to have a higher refractive index than the layer then the maximum output will be 350 nm and it is therefore a blue reflecting mirror.

Looking at Plate 13 you will see that a full, three-colour image enters the block and arrives at the first interface which holds the blue dichroic mirror. All the blue portion of the image is then reflected away, and is then reflected a second time by the outer surface of this, the first prism, finally exiting this prism and arriving at the blue image receptor.

Both the red and green elements of the image pass cleanly through the blue dichroic mirror and the second prism in the block. At the back of the second prism is the red dichroic mirror which separates off the red portion of the image, sending it to the far side of that prism where it is reflected yet again and exits this prism to arrive at the red image sensor.

The green image, having passed cleanly through both the blue and the red mirrors, travels through the third prism to arrive at the green image sensor.

The third prism may look unnecessarily thick, but this is to add sufficient glass to the light path of the green image for it to exactly match the distance travelled by those of both the red and blue light paths. This is essential, for the taking lens will have formed an image in which all colours arrive at their point of focus precisely the same distance from the back of the lens. Therefore with all the three light paths now identical all three receptors will receive a sharp image.

While this splitter block is very clever it has one significant drawback caused by all the glass the images have to travel through. Any image travelling through anything other than an absolutely clean and perfect vacuum will disperse some of its energy away from the desired light path, and this we call flare. One can imagine that an image that is required to pass through three glass prisms and encounter two dichroic reflectors will disperse quite a lot of light on its way. The video camera overcomes this by placing circuits downstream from the image sensors to enhance the picture electronically by improving the blacks and restoring the image to a higher gamma, for that too will have decreased as a result of the overall flare, and one circuit dedicated to removing the appearance of this flare.

While all this electronic image correction and enhancement is very successful it does, in my opinion, contribute to the 'video look' so disliked by film cinematographers. If one shot a piece of film which had, perhaps by accident, had an overall flare on the front surface of the lens then one can imagine the result. There would be a dramatic loss of contrast and the blacks would have become what is referred to as 'milky'. To correct this at the printing stage would be next to impossible, and even if the image were carefully transferred to tape using a modern telecine then while the blacks could be improved and the gamma altered the image would never be as pleasing as had the lens been adequately hooded in the first place. This electronic grading is very much what is

happening in the video camera and I feel is one of the primary causes of the video look.

The settings of these circuits are optimized at the factory and, despite appearing in the engineering menu (see Chapter 17), should be left well alone when shooting in the field.

The image sensors

The beam splitter therefore separates the red, green and blue elements of the image and presents them to the individual, dedicated, sensor chips. Each sensor is in effect a black and white only device which has a single colour presented to it. The output of each sensor can be thought of as representing either a red, green or blue component of the original image. If all three components are simultaneously shown on the screen it might look as in Plate 14, a perfectly normal colour image. Should only the red component be sent to the screen then it would look much like Plate 15. Correspondingly, the green and blue components would appear as in Plate 16 for the green component and Plate 17 for the blue component.

There are two ways of outputting a colour television image from a camera to either a video recorder or a television set. They are called RGB (red, blue, green) or composite. As the names suggest, three cables would be required for the RGB signal and this will result in the purer signal. It is in this format that the image is recorded in the Digi Beta camera. The advantage of the composite signal is that it can be carried on a single cable and this is the more common way of outputting a signal from the camera to a monitor screen.

The image sensor's job is to break up an optical image into bits of information that can be handled electronically and finally recorded on a magnetic tape. The principle is exactly the same as that described in the section on the television image. The sensors are in effect an array of very tiny single sensors each assessing the brightness of the equivalent of the dot earlier described as making up a printed image in this book. In this application each tiny segment of the image is known as a pixel. The greater the number of pixels each colour image is broken up into, the finer will be the resultant definition of the image.

Figure 11.3 shows a black and white image which has been chosen for its very smooth gradation of tones. Nevertheless, if you take a magnifying glass to the picture you will see that it is made up of a huge number of tiny dots which at normal reading distance are totally invisible to the eye. Figure 11.4 shows the same image broken up into a reasonably mild pixellated image. The image is still just recognizable but the individual pixels are clearly defined. Figure 11.5 shows a much coarser pixellated image and in Figure 11.6 the pixellated image is so coarse that had we not seen the original picture we wouldn't have the faintest idea what the image contained.

The important lesson from this is that for the digital camera to deliver a really fine image each sensor is going to have to be broken down into a very large number of very small pixels. In fact each receptor in a Sony DVW 700 camera divides the optical image into 1038 horizontal picture elements and 594 vertical picture elements, giving a total array of 616572 pixels.

Figure **11.3** The original scene

Figure **11.5** The scene with coarse pixellation

Figure **11.4** The scene with mild pixellation

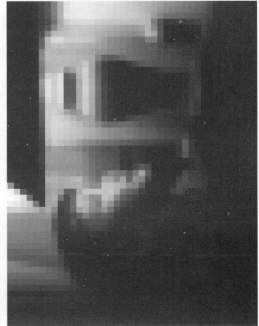

Figure **11.6** The scene with very coarse pixellation

The sensor chip

The sensor chip itself is a printed circuit board (PCB) divided into a grid with horizontal and vertical squares relating to the number of pixels chosen by the camera manufacturer. The whole of each square of the grid cannot be made sensitive for various reasons, including the need for wiring space. Each sensor square therefore comes out slightly smaller than the grid size and the actual sensitive spot is smaller still. Figure 11.7 shows a grid layout in plan and Figure 11.8 a cross-section where the relatively small size of the sensitive area relative to the grid pattern can clearly be seen.

Figure 11.7 Pixel receptor layout

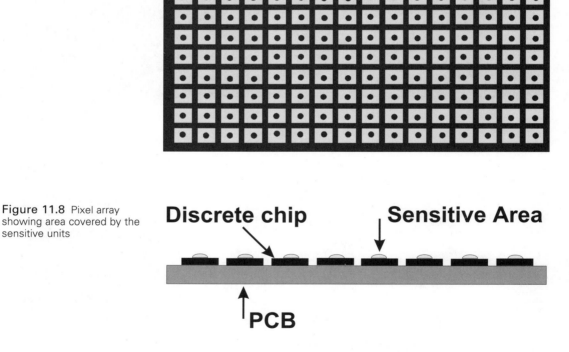

Figure 11.8 Pixel array showing area covered by the sensitive units

The biggest problem with this manner of construction is that only a small percentage of the light energy available for the whole of the grid area will reach the sensitive area. This leads to a serious loss of sensitivity, this being the equivalent of film speed, as, perhaps, only 50 per cent of the energy available within each grid square actually arrives at the sensitive area. To overcome this, some manufacturers overlay the grid with a mesh of small lenses each having nearly the diameter of the grid's width and these lenses focus a far higher proportion of the grid squares' available energy onto the sensitive area. Sony refer to their version of this principle as the Hyper HAD system.

Figure 11.9 shows the cross-section of a sensor array with the lenses in place from which can be seen how the lens covers a considerably greater area than the sensitive area. Figure 11.10 is a much-enlarged section showing just two pixel areas. Very little of the light energy of the optical image is now wasted as all the energy falling on the lens is directed onto the sensitive area of each pixel element.

Figure 11.9 Lens-enhanced pixel array

Figure 11.10 Image being concentrated on pixel-sensitive areas

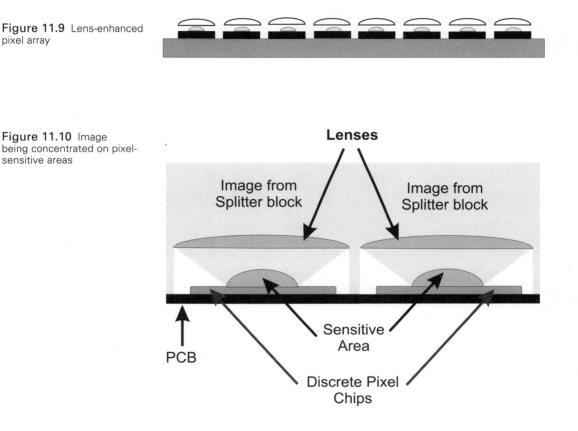

The image signal

While each sensitive area, representing one pixel in the overall image, is an analogue device, the circuitry behind it immediately converts the output into a digital signal. This means that while an analogue signal may be, for instance, a varying voltage the equivalent digital signal will have each minute variation in the voltage represented by a different number. Each number is given a different code in what is known as the binary system. The binary code system is disarmingly simple. By arranging a combination of zeros and ones to represent each number an infinite series of numbers can be recorded but where the recording equipment only ever has to deal with two items, a one or a zero. As these values can be recorded on magnetic tape using the code as a series of ons or offs, it is possible to both record and replay the sequences with great accuracy,

as almost any system can faithfully recognize the switching from on to off with ease.

Although to represent a full frame of television picture a huge number of zeros and ones have to be recorded, it is the simplicity and robustness of this principle that gives this, the digital system, its wonderful accuracy and faithfulness from recording to recording.

The internal circuitry

As this book is intended to be a practical explanation of how to shoot Digi Beta I have no intention of discussing the workings of each circuit or card that lies within the camcorder. Figure 11.11 shows a very simple schematic diagram of the basic functions. The only knowledge the operator needs of the internal workings of the circuitry is that, with the Sony DVW 700 series, by taking the operator side door of the camera, by gently undoing the four screws situated at the corners of the outer plate and lowering this plate to the horizontal where it will come to rest retained by two rather fragile hinges, it is possible to gain access to the switch which will change the menus accessible from the outside of the camcorder from 'User' to 'Engineer'. The switch is very small, though it can be operated carefully by one's finger, and is situated in almost the exact middle of the cards in the camcorder housing. For the purposes of this book it will always be assumed that the switch is set to engineer. For the DVW 790 camera one arrives at the engineering menu simply by holding in the knurled wheel at the front of the camera while switching on the camera. As soon as the viewfinder is fully active the wheel may be released. If the camera is switched on without holding in the wheel it will start up in user mode.

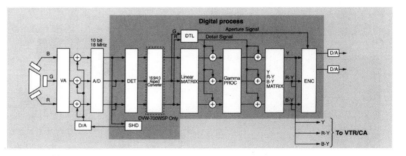

Figure 11.11 Block diagram of digital camera processing. © Sony UK

The only other occasion that this side panel should be removed is if, as sometimes occurs after travelling, the camcorder appears to be malfunctioning in some peculiar way. It may be that one of the circuit boards has worked loose and the contact pins are not seating properly. If this is suspected then, with the camcorder switched off, carefully remove the door and gently press each board into the camcorder housing. If this fails to improve things, contact the supplier of the camcorder as, from experience, they may well be able to suggest something even over the phone. In the unlikely event that you are sent a replacement board in the field it is simple to ensure that you put it into the right slot, for there is a white line running across the outer surface of all the boards. It goes diagonally from bottom-left to top-right and will only form a straight line when every board is in its correct place.

When replacing the outer panel of the camcorder take care to raise it gently so as not to damage or crush any of the wiring between the main camcorder body and the outer panel. Having returned it safely to the side of the camcorder, refit the four screws, being careful not to overtighten them. The screws will still be in the outer panel, as they are fitted with a retaining clip to prevent them coming free of the panel.

12
The video cassette recorder

The VCR

Mechanically the VCR (video cassette recorder) in the Digi Beta camera is similar to most modern VCRs in that it uses helical scan technology. The name 'helical scan' is derived from the path the tape takes around the rotating drum on which are mounted the recording heads.

The Digi Beta camera needs to use this sophisticated method of tape transport in order to be able to lay down sufficient information in a suitably short space of time. As we have seen in the description of the television system, and its modern digital method of turning each value into a code of zeros and ones, all the tape has to hold are the equivalent of ons and offs but (and it is a very big but) the quantity of zeros and ones will be enormous.

Helical scan

If the tape were to travel straight past a static recording head, as in a conventional sound-only tape recorder, it would have to travel at a terrific speed to be able to record the quantity of information being delivered by the recording head. The use of a helical scanning drum maintains the required record head to tape speed while dramatically reducing the linear tape speed.

It does this by wrapping the tape, which is half an inch wide, around most of a drum, approximately 3 inches (75 cm) in diameter. As can be seen in Figure 12.1, the tape is not wrapped around the centre of the drum but makes first contact at one edge and leaves the drum adjacent to the opposite edge. The tape path has therefore described part of a helix, a shape just like one turn on a screw thread, and from this comes the term 'helical scan'.

This helical wrapping of the tape would not, in itself, increase the record head to tape speed but as the drum is made to rotate the relative head to tape contact speed is dramatically increased. There are four record heads each half-way between the outside edges of the drum and spaced at 90° angles around the drum. As the tape is wrapped around

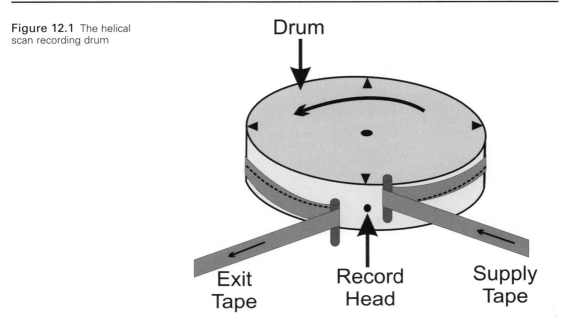

Figure 12.1 The helical scan recording drum

more than 180° of the drum (and there are four heads on the drum) there will always be at least two heads in contact with the tape. Because the tape is wrapped in a helix around the drum the recording head will, relative to the tape, travel not only along the tape but also from one edge of the tape to the other. By switching the record heads on and off sequentially, strips of recording can be laid down at a shallow angle across the tape as shown in Figure 12.2. In addition there are a series of linear, static, recording heads to lay down several control tracks including the time code (see Chapter 14).

Figure 12.2 Recorded areas on the video tape

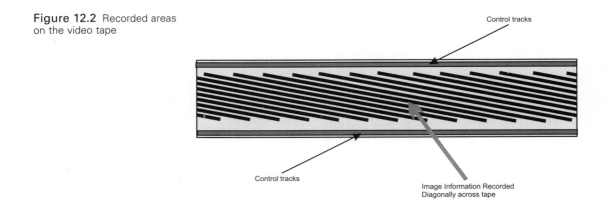

Mechanical considerations

The VCR is not as robust as might be wished, mainly a result of weight requirements, but if treated with respect it will give years of unfaltering service.

The scanning drum

The scanning drum is made to the highest accuracy while being very light indeed. The use of high-quality materials and the manufacturers' considerable experience in designing portable video recorders ensures that there will be little or no difficulty in obtaining reliability providing the operator understands how to treat the device. The drum is very light, not just as a contribution to the portability of the camera as a whole but also to reduce the inertia associated with spinning the drum at a high speed. This reduction in the inertia of the drum brings two benefits. It can be brought up to operational speed very quickly and it will consume very little power to keep it spinning. This second factor reduces the drain on the battery and, therefore, indirectly contributes to a reduction in the weight of the onboard battery.

The drum lacing mechanism

In order to remove a loop of tape from the cassette and wrap it around three quarters of the drum the mechanism has, first, opened the door of the cassette as it entered the door of the VCR. Two rollers then come behind the short, straight, length of tape that is free at the mouth of the cassette. These rollers then travel round the drum in a circle larger than the diameter of the drum but allowing the tape to wrap around the drum. Again due to weight considerations, this mechanism is made of high-quality but very light materials.

A jammed mechanism

Perhaps this is a good moment to mention an invasive operation that one, occasionally, has to carry out on the camera. On the opposite side of the camera to the operator, at the bottom of the camera casing, roughly half-way along the camera body, is a rubber plug about a centimetre in diameter. If you remove this plug it reveals a red plastic button with a Philips-type cross-head slot in it.

Should you have an electrical breakdown such that the camera will not unlace the tape and let you remove the cassette you can, with the camera switched off, insert a cross-head screwdriver into this button and, turning it anticlockwise, very, very gently hand crank the lace/unlace mechanism, thus allowing you to retrieve the cassette. The gear ratio is very low so this will take some time. I have had to do this a couple of times and would counsel you to carry out this procedure only as a last resort. It is much safer for your tape and your camera if you can get the camera back to the supplier where a more thorough and safer method can be deployed. You should only consider this mechanical unlacing of the camera if your rushes on the tape are very important and retrieving them is a matter of very great urgency.

13
White and black balance

White balance

There are three positions for the switch on the side of the camera that determines which form and setting of white balance you are using. The positions are labelled Preset, A and B. With the switch at Preset the camera will white balance to its own internal setting. You can create your own white balance on positions A or B by switching to them and operating the white balance switch on the front of the camera.

In the menu you can chose whether you wish to have a different white balance for every position of the filter wheels or if you want the A and B settings to work on all the filter wheel positions. I prefer the latter. You can locate the page which enables you to make this choice by referring to the appropriate menu chapter in this book.

What is white balance?

Digital video cameras are set up to show a colour correct image when the scene is lit with tungsten light. The outer of the two filter wheels at the front of the camera, situated just above the lens mount and on the operator side of the camera, contains three filters and a clear glass. With the clear glass in place the overall effect is to make the camera have the same colour balance as tungsten-balanced film. The other positions give the colour correction shown in Figure 13.1. This wheel places a coloured filter between the lens and the image splitter block just as one would put, say, a Wratten 85 filter in front of a film camera lens in order to have the correct colour balance when shooting under daylight with tungsten-balanced film.

The cross filter has no effect on colour. It is the equivalent of a light four-point star filter.

Figure 13.1 Internal camera filter – outer wheel settings

Position A	Cross Filter
Position B	Balanced for 3,200 °K
Position C	Balanced for 4,300 °K
Position D	Balanced for 6,300 °K

White balance using a white card

Having chosen the filter in the filter wheel that most accurately reflects the light you are working under, select either positions A or B on the Preset selector, fill at least 70 per cent of the screen area with a white card or paper which is illuminated by the primary source of light you are working under and press the white balance switch on the front of the camera. In just a couple of seconds you should see in the viewfinder 'White Balance OK'. The camera has now electronically given you the best possible colour balance for the conditions under which you are working. Until you make another white balance on the A or B setting you have chosen the camera will always give you the same colour set-up every time you switch to your chosen position.

It is important that you leave the lens set to auto-exposure when you carry out a white balance as the camera is set up to make the correction in this mode. When you make a white balance you just might get 'Low Light' in the viewfinder. If this happens you must move the white card nearer the light source to make it brighter and try again.

Be careful what white card or paper you use to white balance. Office papers that are sometimes called 'high white' or something similar are, in fact, tinted a little blue to give them a whiter appearance and this may affect your white balance. If you use one of these papers you may find your scene looking a little warmer than you expected. This can be attractive but you need to be aware it is happening.

White balance using a coloured card

One way to make a video camera show an image that does not have the same colour cast as the original scene is to white balance to a card or paper that is not white. I don't use white balance very often but should you, perhaps, wish to warm up the overall look of a scene you might white balance to a pale-blue card. The white balance process will remove the blue from the set-up and the overall result will be warmer by the same factor as the card was cool. The reverse is true if you use a pink card; the result will be cooler as the pink will have been removed. Green and yellow, or indeed any colour, can be used in this way and the result will be a colour change diametrically opposed to the colour of the card you are using. I find colours other than pink and blue of very little use unless I still have a green cast from fluorescent lights after doing a standard white balance, when balancing again to a very pale green card can sometimes help.

You can easily obtain pastel-coloured thin card in almost any colour from art shops. They usually come in large sheets but are not expensive and easily cut to standard office paper size. I always carry a folding clipboard with me in which I keep my coloured cards, several white cards (for they are used so often they get dirty) and my star chart for setting the back focus. As the clipboard has a folding cover it keeps everything clean and dry and can easily be folded backwards so that it can be propped up if I am white balancing or setting my back focus when on my own. If you chose to use a cover like this make sure you use a black one. When the paper is clipped to it some of the folder will be in shot and the colour of the folder may then affect the white balance.

White balancing under fluorescent lighting

With digital cameras I rarely use the white balance facility for I prefer to stay on Preset and occasionally use filters as if I were filming. The exception to this rule is when I am filming under fluorescent light. Here I find the best way to white balance is, having checked all the fluorescent tubes are the same make and specification, to take the white card quite close to a tube and balance it there. This is to make sure that no spurious light that may have picked up some other colour from reflection of another surface is being allowed to influence the setting.

The inner filter wheel

The inner filter wheel at the front of the camera has no effect on colour. Again it has a straight-through position with the other three positions having neutral density filters of varying strengths in them. This is to allow you to keep the lens working at a reasonable aperture when filming under bright light. At first glance you might think that using as small an aperture as possible, and thereby getting a great depth of field, would be a good idea. This is not always a good thing for two reasons. First, lenses do not perform at their best at very small apertures; they are usually at their best in the middle of the aperture range. Second, one thing that most film people dislike about video is that everything seems sharp and it is impossible to separate the foreground from the background using discriminatory focus. Deploying these neutral density filters can overcome both these problems. The strength of the neutral density (ND) filters is shown in Figure 13.2.

Figure 13.2 Internal camera filter – inner wheel settings

Position 1	Straight Through	No reduction
Position 2	1/4 ND	Or 2 stops
Position 3	1/16 ND	Or 4 stops
Position 4	1/64 ND	Or 6 stops

Black balance

The black balance is operated by pushing the same switch as is used for white balance in the opposite direction. About the only time it must be used is when you have changed the settings on the gain selector from within the menu. It should also be deployed when the camera is first used, when the camera has not been used for a long time or when the ambient temperature under which you are using the camera has changed dramatically. For safety I run a black balance once a week even if none of the above has happened.

14
Time code and user bits

User bits

The user bits setting, which looks remarkably like time code on the camera display, is quite different from time code in that the figures in it never change unless you change them. You can set four two-digit numbers and providing you have agreed a form of display with the editing suite you can use them to send, on the tape, information such as camera number, roll number, date, etc. The user bits are set in much the same way as the time code and should always be set first.

Time code

Time code is a number expressed as four sets of two-digit numbers recorded digitally along with the image recording in such a way that every single frame of the image has a number all to itself and each frame can therefore be accessed simply by looking for its number. To perform this trick you have to make a few decisions as to how you wish to write the numbers.

Record run time code

This is the most common choice for writing time code especially for factual work, where all the sound will be recorded on the camera's tracks and no other equipment has to be slaved to the camera time code. Having set the numbers with which you wish to start your time code with into the camera and with the switch set to record run (shown on a DVW switch as R-RUN) every time you stop the camera the time code numbers will stop and every time you start the camera the time code will pick up the numbering sequence exactly where you switched off. As the camera always makes a perfect edit you will end up with a perfect continuous stream of numbers, one for every frame of picture, and all in a perfect sequential order. This makes for very fast editing, for a non-linear editing suite can spin through these numbers at very high speed when looking for a particular frame.

Free run time code

Free run time code works on the principle that the time code clock will run continuously and the numbers on it will only be recorded on to the tape when the tape is running. The great advantage of free run time code comes into play when you wish to run several pieces of equipment together and in perfect synchronism. The most common application for this system is when shooting fiction where, more often than not, the sound mixer will want to make a master recording on a separate recorder, probably a DAT recorder.

Synchronising using external time code generators

Due to the way the camera records time code when in free run time code mode, it is unwise to rely on the camera's time code generator and another piece of equipment's time code generator, say a DAT recorder, staying in sync. This is due to the fact that the camera's way of recording time code only allows it to add whole numbers. If the camera has stopped at the end of one shot having recorded the lace portion of the frame and not the interlace portion, then when the camera is restarted the time code will jump to a new, whole, number thus gaining half a frame the DAT recorder has no knowledge of.

If you have, say, shot eighteen takes then the law of averages says you will have encountered this phenomenon half the time – on nine of the takes. You will have a half frame error on these nine takes and therefore be four and a half frames adrift compared with the DAT recorder.

The only solution to this is to link all the various machines by cable from time code in to time code out sockets or provide each machine with an external time code generator, all of which have been synchronised at the beginning of the shooting day. In the UK I invariably do this using 'Lockit' boxes.

Time of day time code

Free run time code is often referred to as time of day time code. This is because the most common set of numbers to start the time code clock on the camera is the time of day at the time of setting. The most common alternative is to set the first two digits to the roll number and leave the rest at zero. This is fine if you are not going to use more than twenty-four rolls of tape, for the first two digits will only go up to twenty-four (the number of hours in the day). The four pairs of numbers representing the time code are organized to represent the hours in a day (24) the minutes in an hour (60) the seconds in a minute (60) and the frames of picture taken in a second (25 with PAL and 30 with NTSC). These are the maximum numbers that can be set in each of the pairs of digits.

Setting time code

The same setting procedure works for both the user bits and the time code so I will describe only setting the time code. Refer to Figure 14.1 overleaf to see where the switches are on the time code control panel.

1 Set the display switch to TC.
2 Set the PRESET / REGEN switch to PRESET.

Figure 14.1 Time code and
user bits control panel

3 Set the F-RUN / R-RUN switch to SET.
4 Set the REAL TIME switch to ON or OFF.
5 If you are using an NTSC DVW 700 or 790 you must now set DF /
 NDF to either Drop Frame or Non-Drop Frame – check with your
 editing suite which they require. If you are using a PAL camera this
 setting is not used.
6 Using the SHIFT and ADVANCE buttons, set the time code you
 require. SHIFT selects a digit to set. Each time you press it the flash-
 ing column moves to the right by one digit. ADVANCE increases the
 number value of the flashing digit.
7 Set the F-RUN / R-RUN switch to the position you or your editor
 prefer. Remember F-RUN (free run), the time code will advance con-
 tinuously, R-RUN (record run) the time code halts when the camera is
 stopped and restarts when the camera is switched to record again.

Resetting time code after removing a tape

If you are using free run time code, time of day, and you remove and
reinsert a tape you have no problem but if you are using record run you

must go through a simple procedure to reset the time code to ensure it runs continuously throughout the whole length of the recordings. To ensure your time code runs continuously carry out the following procedure (referring to Figure 14.1 to see where the switches are):

1 Replace the tape in the camera.
2 Set the PRESET / REGEN switch to REGEN.
3 Use the tape transport buttons on the top of the camera to play back the tape.
4 Watching the playback, find the end point of the previous, last, recording on the tape and press the STOP button.
5 On the back of the handgrip on the lens you will find a RET button. Press this.

The camera will now backspace and play forward to the end of the recording and synchronize the internal time code generator to the last code on the tape. When you start recording the time code will pick up a smooth continuous sequence on numbers just as if the tape had never been removed.

Synchronizing using a cable

If you wish to synchronize several pieces of equipment without relying on the internal time code clock of them all staying in sync (some of them may not even have time code generators) then you need two BNC leads between all the pieces of equipment. From the primary piece of equipment which is to generate the time code on which you wish to record all the other pieces of equipment you must run two BNC leads. You take one from the VIDEO or TEST OUT socket and run it into the GENLOCK IN socket on the next piece of equipment. The second lead you take from the TC OUT socket of your first machine and run it into the TC IN socket of the second machine. If you are running more than two machines then you run two leads from the second to the third machine exactly as you did from the first to the second and so on until you arrive at the last machine.

15
Delivery systems

Television

As we have seen, the normal domestic television, around most of the world, uses a little more than 500 or 600 lines to make up the vertical definition of the picture and is designed to give an equivalent definition horizontally. Providing the audience is not so close to the screen, or the screen so large so that the lines become apparent, this is very satisfactory.

The current cathode ray tubes with their shadow mask technology can do little to improve the apparent definition on the image-forming portion of their screen. Some manufacturers have improved other contributing factors, though. By using a time delay circuit in parallel with the primary circuit delivering the image signal to the tube the standard number of presentations of the image can be doubled. This is done by arranging for the receiver to show 100 (Europe) or 120 (USA) complete pictures a second. There is no extra information involved – it is simply shown more often. This has two effects. First, it vastly reduces any apparent flicker. Second, due to the brain and eye, in combination, having more pictures presented to them in any given time span there is an apparent, small, increase in perceived general image quality.

The cathode ray television tube is, by its very design, limited to a fixed number of vertical lines. However, we will soon all be getting used to truly flat and thin television screens as manufacturing processes have advanced so much that the kind of screens used on colour laptop computers are moving into the domestic television market. These screens are capable of much higher resolution than the current domestic cathode ray tube. They have to be, for the operator of a laptop may be sitting a mere half a metre (20 inches) from the screen and, as we know, the limit of the eye's resolution is 2 seconds of arc. The eye will therefore be able to perceive pieces of information on a laptop screen that are very small indeed. Thus the screens have to be capable of very high resolution.

If these high-resolution screens become common in the domestic arena then there will be opportunities for increasing the number of lines of picture in some very interesting ways. Simply doubling the number of lines and showing each line twice will give an apparent increase in the definition and acutance of the picture. In parallel with this, and in coun-

tries where a high-definition transmission system exists, such a set could easily match the quality of the high-definition picture while also being easily switchable to the lower, standard-definition system.

There are some interesting side effects to all this. Trying to photograph a television or computer screen can be a nightmare. Unless the refresh rate, that is, the number of pictures shown per second, is identical for the screen and the camera what is known as a bar roll will be recorded. This appears as if the picture has a black bar travelling either up or down the screen. Where there is a considerable difference in refresh rates the picture will appear to tumble over itself. This can sometimes be overcome by adjusting the camera's effective shutter speed. With a television camera this does not change the frame rate, it merely changes the time taken to complete each lace and interlace scan cycle. Most US cameras have a switchable setting allowing them to successfully photograph a European television screen and the reverse is true of European cameras.

The greatest problem arises when you try to photograph a standard desktop computer with its conventional cathode ray screen. Computers do not use a refresh rate dictated by the frequency of the local mains supply. Many of them run at something near seventy-five pictures per second and some (and these are virtually impossible to photograph satisfactorily) have the refresh rate determined by the software. This is quite common with computer games, where in order to conserve the computer processing power and memory the refresh rate may be low when there is little happening on the screen and driven much higher when the action becomes lively.

These problems are very rarely encountered when attempting to photograph the screen on a laptop computer. While the refresh rate for any given program will be just the same as on a desktop there is another characteristic of the screen at work in your favour. The decay rate of the screen is much longer. On a conventional cathode ray tube quite soon after the electron beam has passed any given dot on the screen the dot will have decayed in brightness dramatically. With the type of screens used in laptops, and the new generation of thin tube domestic sets, this does not happen. The dot will still be glowing some considerable time after it was initially energized. Most of this book has been written on a laptop less than a year old and the screen on that machine is superb, far better than any of the televisions in our house. Curiously, I happen to have written this chapter on my old laptop which is some seven years old. The screen on this computer has the characteristic high definition but is black and white and has such a long decay time that the cursor appears to leave a trail behind it as it moves. This is simply because seven years ago screen manufacture was not at today's standards and by allowing a long decay time the screen appeared brighter.

There are some very high-quality plasma screens around, and these too present few problems when being photographed.

Projection

Until quite recently the thought of having one's work shown in a theatre using projection television was quite terrifying. I have been known to make some quite elaborate excuses for not attending such a viewing, so avoiding much embarrassment.

Fortunately in recent years matters have improved. The projectors

have become much more powerful, giving a bright, correctly coloured, image right to the extreme corners. The perceived definition of the image has also improved considerably even when the image is coming from a tape containing a signal made up of only the number of vertical lines used in the local domestic broadcast system. This has come about by a number of means. The projected number of lines is often greater than on the recording, and an element of 'spot wobble' is often introduced. This is a technique where the projected pin point travelling across the screen to form the line of image is wobbled up and down at a very high rate. This has the effect of blending one line, vertically, into its adjacent lines, thus making the line structure much harder to see without losing any definition. In effect you lose the gap between the lines.

With the advent of high-definition television systems the ability to show these pictures projected onto a screen as well as film will become at least as important as how the cameras develop. Indeed, from a commercial standpoint it may be more important, for one of the problems the distributors have is the huge cost of making release prints, often many hundred for a successful feature film. The other worry is that once the prints leave them there is always the possibility of their being shown somewhere unknown to them and thus losing the distributors revenue.

A cinema where the image was shown by electronic projection at a quality acceptable to the audience and where the image information was delivered not in any physical form but via cable or satellite would solve these problems at a stroke. In the UK the film *Toy Story 2* was the first to be presented in three of London's main cinemas using solely video projection. This was an ideal choice of film for the images had been created digitally and could therefore stay in this format right up to the point of delivery. The results were nothing short of superb. I cannot but believe that the cost savings of this delivery medium will quickly overcome the cost of re-equipping cinemas, and digital television projection will become common.

It will be interesting to see what financial arrangements are found to allow this revolution to happen for all the costs seem to have to be borne solely by the cinema chains and all the savings lie with the distributors. Nevertheless I believe the advantages are so great that an accommodation between these two parts of the film industry will be found.

Transfer to film

Until the video projection revolution in the cinemas has come about, most theatrical features, if they have been originated on standard or high-definition digital cameras, must have to have the images transferred to film before they can obtain distribution. One of the attractions for low-budget producers, in addition to saving the negative costs, is that their product can stay in the digital domain right up to selling the film to a distribution company. This reduces still further the overall production costs for, apart from, perhaps, a very short section of the material being transferred to film at an early stage to convince both the backers and distributors that the technical quality is there, no conventional film costs will be incurred.

Tape is transferred to film most commonly using a laser scanning process where the image is upgraded to an image having 3000 or 4000 vertical lines and each line is written onto the film using three appropri-

ately coloured lasers. Currently to write a single frame of film at this definition takes around two and a half seconds. As you can imagine, the apparatus to achieve this definition is very expensive and machine time will come at a high price. In fact to transfer an average feature length film of, say, 110 minutes' running time will take 110 hours or roughly four and a half days. It is only necessary to make one transfer as this becomes the equivalent of the camera negative and interpositives, internegatives and release prints can be made from it in the conventional way.

Before going down this route it is essential that the cinematographer makes tests using the transfer house that has been selected to make the master negative, and that a print that has been struck from an internegative via the interpositive is evaluated before principal photography commences. Only then will the cinematographer be able to judge how to lay down the digital pictures in a way most advantageous to the process that will be used to achieve the copy of the film that the audience will see.

Part Five
High-definition Digital Cinematography

16
High definition

High-definition image capture

For some years in the USA, Australia and Japan it has been possible to shoot in a high-definition television format. The image is scanned in a 60 Hz interlace format and this produces a recording system referred to as 60i. The 60 Hz interlace format produces an image of exceptionally high picture quality and because it uses the same scanning rate and style as the standard format NTSC transmission system is easily down-converted into standard NTSC. It is, however, difficult to convert a 60i picture into PAL or SECAM, the transmission systems used in Europe. Things are further confused by these high-definition systems not being completely compatible in another way. There is more than one standard for the number of vertical lines used, sometimes 1250 lines and sometimes 1125 lines.

It is also difficult to write successfully a 60 Hz picture onto movie film which runs at 24 frames per second because the 60 Hz image produces 30 complete frames per second. In order to achieve a film transfer one must step print the images in a 3/2 form where the lace and interlace frames have one or the other removed from the sequence in order to reduce the flow to 24 complete images per second. This can produce a curious and unnatural flow to movement, especially horizontal movement, when the resultant film is projected.

Despite the disadvantages in film transfer there are strong financial incentives to being able to shoot a picture on tape, cut and postproduce the picture digitally, and, only later, perhaps after a distributor has been found, to produce a cinema print. If this were possible it would enable many more low-budget films to be made. Some successful feature films have been made via this route but the final tape to film transfer has never been ideal.

The Sony HDCAM

Sony now produce what can be thought of as a revolutionary new camera for recording high-definition pictures, the HDW-F900. This camera has, in almost every sense, overcome all the standards problems between television systems and between television and film. For the first

time since the 35 mm film standard was adopted in 1932 there is another system that enables the world to shoot at very high definition and easily show the resultant images anywhere, anyhow.

The system uses a pixel array of 1080 × 1920. This gives a picture 1080 lines high with identical vertical and horizontal definition when using an aspect ratio of 16 × 9. This is so because if you divide 1080 by 9 and multiply the result by 16 you get 1920. Perhaps more importantly, the camera can be switched between five different picture scanning formats. There are three progressive scan formats available, known as 24P, 25P and 30P. There are also two interlace formats available – 60i and 50i. All record an image made up of 1080 × 1920 pixels.

Progressive scanning is a relatively new idea. Currently with an interlace system all the odd-numbered lines of the television picture are scanned first. The scan then returns to the top of the frame and scans all the even-numbered frames. Only then has a complete frame been recorded. (See Chapter 11 for a more detailed explanation.) With progressive scanning the vertical lines that make up the television picture are scanned, as one would expect, progressively, which means there is no need to return to the top of the picture for, once the scanning process has reached the bottom of the frame, all the information has been recorded. Hence the lines are scanned, from the top of the picture, in the sequence 1, 2, 3, 4, 5, 6, 7, 8, 9, etc. until line 1080 is reached. This scanning process delivers a picture which can be written onto film far more easily.

Further enhancing the film transfer capability is the choice of frame rate. If you know your primary sale of the film will be to cinema then by chosing to record in the 24P (24 frames per second progressive scan) format gives you the capability to write the images directly to film without the need for any standards conversion. Shooting in 25P mode will produce an image that will be seen by a PAL system to be the same as a film shot at 25 frames per second, as is the norm for PAL. If you are shooting for the USA where some high-quality films, especially commercials, are often shot at 30 frames per second to overcome the movement problems encountered when transferring film shot at 24 frames per second to the television standard of 30 frames per second, you would shoot the same production at 30P, again with complete compatibility.

If your production is only going to be shown on television and you are not going to need to supply copies in both NTSC and PAL, then you can shoot your high-definition images in an even more compatible format – 60i for NTSC and 50i for PAL.

If your production is going to be shown on television worldwide and you might need a cinema copy, the HDW-F900 camera can give you an almost perfect answer. Shoot your production at 24P. Feed this image, with very little conversion, into any known television system and tell that system it is looking at the output from a telecine machine and your problems are over. When you come to make your film transfer you have no conversion to do. Simply write the 24P image directly onto the film.

The Sony HDW-F500 digital recorder

The Sony HDW-F500 desktop recorder/player can play back a tape recorded on the camera in any of its five recording systems. Normally it would play out in the same standard as the recording. If the recording has been made in the 60i format then the recorder is capable of playing out

both a 60i high-definition and a 60i NTSC standard-definition signal. Thus down-converting within an NTSC environment ceases to be a problem. The same is true if images have been recorded in the 50i format and you are in a PAL environment.

If the recorder is fitted with the HKCV-507 pull-down board then a programme shot at 24P can be output in either NTSC or PAL with full sound and picture conversion taking place within the recorder. The superior image recorded by the high-definition system means that the signal output from this recorder in NTSC or PAL will always be at least as good as if it was originated in the standard definition system – often the resultant image will be superior. The recorder will also output a 25P or 30P signal from a 24P master. This facility further enhances the value of origination in 24P, as from this original you can output virtually any standard.

Inputting 24P into non-linear editing

It might not be unreasonable to think that before long 24P high-definition pictures will become the most popular origination medium across the television world and some of the cinema world. Having originated on 24P, this format can be played into any modern non-linear editing system, can be edited in this format, output to the HDW-F500 recorder and then further output in several formats for distribution worldwide. HDCAM is the first standard since the adoption of 35 mm film that can be truly called universal.

Panavision digital cinematography

In developing the HDCAM concept Sony have been in close touch with Panavision so it is no surprise that there is a Panavision version. The Panavision camera, of which there will be at least one hundred made, takes the whole concept of quality within the HDCAM recording system a step further. The camera has all the 24P, 25P, 30P, 60i and 50i recording capabilities of the original camera and records in exactly the same way. It has, in Panavision's words, been 'panavized' and 'ruggedized'.

The 'panavization' of the camera consists of making it completely compatible with Panavision film accessories. The base plate allows standard Panavision focus controls, matte boxes and lens control accessories all to be fitted directly onto the camera. Lenses supplied by Panavision with the camera will all have the focus control brought back to just in front of the camera, as is now found on all Panavision film cameras.

The ruggedization of the camera is most apparent at the front plate of the camera where the strength of the front of the camera and, more particularly the lens mount itself, has been greatly increased and a completely new lens mount designed. This has been particularly important, for as-new Panavision video lenses are as heavy as 35 mm film lenses and the new Primo zoom lenses are a crucial factor in Panavision's thinking.

Panavision high-definition lenses

It is Panavision's intention to be able to offer as full a range of lenses for their high-definition cameras as they can currently offer for film. Of particular interest, though, are the first two Primo zoom lenses they have designed specifically for their Panavision HDCAM. The lenses are a 5:1

zoom with a focal range of 6–27 mm and a 11:1 zoom with a focal range of 9.5–105 mm. These focal lengths give angles of view very similar to their most popular zooms for use with 35 mm, the 18–100 mm and the 25–250 mm.

Depth of field

Because the image size needed for the ⅔-inch CCDs that form the three colour receptors in the HDCAM is so much smaller than a 35 mm negative a lens giving the same angle of view, at the same aperture, will produce an image having far greater depth of field on the HDTV image than on 35 mm. For instance, given that you set up shots with identical angles of view, to obtain the same depth of field on a HDCAM as you would get using 35 mm film from a 135 mm lens at T4 you would have to expose the HDCAM at T1.7. For this reason Panavision have designed both the 5:1 and 11:1 Primo zooms for the HDCAM to have a maximum working aperture of T1.6, at which aperture they perform very close to their best. Panavision's philosophy is that most cinematographers who, Panavision reason, will most probably have a film background, will be trying to make HDTV pictures look very similar to 35 mm, so they will need to be working at these very wide apertures to get the depth of field they both like and are familiar with. I think they might be right for, when shooting 35 mm, my favourite stop is T4, so T1.7 will do nicely on HDCAM as far as I am concerned.

Camera control cards

In both Sony and Panavision's HDCAMs the camera control card from the Digi Beta camera has been replaced by a Sony memory stick. This is removable and it can hold up to five complete set-ups. This is a considerable improvement for I find that most programes I work on require at least three Digi Beta cards. I will now be able to store most or all the set-ups for a show on one card.

Digi Beta/HDCAM familiarity

With the exception of the different method of storing camera set-ups and, with the Panavision camera the lens mount, almost all the switches and controls are in the same place on the Digi Beta and the HDCAM. The cameras are almost exactly the same shape and weight so any cinematographer familiar with the Digi Beta camera can easily transfer their skills to the HDCAM.

The camera menus

The HDCAM in-vision menus are different from those found in the Digi Beta cameras. They are, however, simpler to understand and more logical in both layout and wording. It should not take a skilled cinematographer long to become familiar with the HDCAM menus.

Projection

There is a strong feeling in the industry that HDCAM will be of great advantage in large-venue presentation for the format is ideal for projec-

tion without any standards conversion in whichever format you chose to originate. This may lead to new business being created by HDCAM rather than it taking over from traditional methods. Business conferences can have original material shot for them at far higher quality and much lower cost, or both, than was previously possible.

But what does it actually look like?

To my eyes HDCAM shown on a high-grade 1080-line television gives a wonderful picture. It is far superior to any standard-definition picture. It still looks like television but, if the images are skilfully shot, the picture can be every bit as appealing as if it had been originated on film and displayed the same way. It does not look exactly like an image originated on film.

Elsewhere in this book I have given my opinion that it can be foolish to try to make an image from one medium look like images from another. My preference is to learn the capabilities of any medium and then try to light and shoot to bring out the best in the system I am using. I find the HDCAM image very exciting. It's neither film nor conventional television having a peculiar clarity and vividness that, though a little unfamiliar, is bright and engaging, and engaging my audience is something I love to achieve. I find it a bad policy to say something is bad simply because I am not familiar with it. Never has this been more true than when assessing a HDCAM image. You must look for yourself, with an open mind, and then decide.

HDCAM – a replacement for 35 mm?

There will undoubtedly be some arenas where HDCAM will take over from 35 mm, and the US sit-com market must be vulnerable. Multi-camera shooting with a higher record quality than transmission quality, thus allowing worldwide stands conversion and therefore sales, are now just as possible with HDCAM as they have traditionally been with 35 mm. Unless a very large cinema screen is envisaged then undoubtedly a HDCAM 24P original displayed via a 24P projector is capable of quite exceptional results.

Theoretically at least HDCAM, in its present form, is not capable of producing a picture having the resolution of a well-shot piece of 35 mm. Witness the arguments between post production houses as to the scanning rate needed for a digitally worked on image to be completely transparent when returned to and projected from a print. Do you need 3000 lines or 4000 lines of scanning and writing images from and to 35 mm for the digitization to be invisible? If these arguments are real then the 1080 lines of HDCAM is a poor relation.

Despite the above argument I have recently seen demonstration film shot with the Panavision camera and its HD Primo lens system which, subjectively, clearly has as much image resolving and capture power of any 35 mm film I have ever seen. It was, quite literally, stunning. So much for theories. It is my belief that the Panavision HD Primo lenses currently take the whole HD format a significant step forward.

Conclusions

Subjectively, then, we can assume that with the right lenses HD can

seriously challenge 35 mm film. This, together with the distributors' wish to deliver films to the cinema in an electronic form, should see a great acceptance of this new standard. Further, the ability to deliver in any of five image formats after post production is a significant virtue of the format.

It should also be remembered that camera origination in this digital domain is ideal for further digital post production.

It should be remembered that there are many applications that currently use 35 mm film where the ultimate resolving power of that format is never used or seen. For these applications HDCAM may also be ideal, especially when the very considerable cost saving in the storage medium is taken into account.

There are many programs currently being shot on Digi Beta or Super 16 mm film where the added picture quality of HDCAM is a considerable advantage. The ease with which the HDCAM recording can output in so many television formats to give added worldwide sales without any loss in picture quality may mean that the added cost of HDCAM over Digi Beta could bring appreciable extra profits.

Part Six
The Sony DVW
In-camera Menus

17
The Sony DVW camera menus

Described here is the principle of the menu system incorporated into the Sony DVW cameras. The following two chapters provide a line-by-line description of the menus in the DVW 700 and the DVW 790 cameras.

The set-up card

At the front of the camera, about half-way up and on the operator side, is a small door around 1 inch (2.5 cm) wide by 2 inches (5 cm) high, hinged at the bottom (see Figure 17.1 overleaf). Slightly to the right of this is a small black slider which if operated will allow the door to spring open. The inside face of the door is channelled and into the channel can be slipped a set-up card. The card will only go all the way into the channel one way round, so it cannot be inserted incorrectly. Once inserted, the door should be closed manually.

Reading data from a set-up card

Having inserted a set-up card into the camera, and with the camera switched on, depress the Menu on/off/page switch once to turn on the menus in the viewfinder and press the switch again as many times as are needed until the page called 'Set-up Card' appears on the screen. Press the 'Item' switch, the next one back down the camera, until the cursor sits opposite the line labelled 'Read'. Now press the rubber button labelled 'UP'. An ID (identity) block will appear: if this is the identity of the card you are expecting press 'UP' once again. At the bottom of the screen you will see the caption 'Reading Card'. After a couple of seconds this caption will disappear and the camera is now set on both the user and the engineering menus to the values that were stored on the card.

The idea behind having two separate menus is simple. The user menu is intended to give the camera operator a second copy of the basic modifications they may need on a day-to-day basis while the engineer menu contains every parameter that can be adjusted via the in-camera menu. This may seem a useful idea but, unfortunately, the values in both the user and engineer menus are added together and there is no way of

Figure 17.1 Camera control
card loading door

preventing this. If the camera operator were to leave the camera displaying only the user menu they will be totally unaware of the values that are set in the engineer menu, which may have a huge effect on the overall look of the image.

If you wish to make changes to the set-up in the camera select your desired changes using the menu system described below. If at any time you want to amend the set-up card so that it reflects the changes you have made to the settings in the camera go to the page labelled 'Set-up Card' and click the cursor down to 'Write'. If you now press the rubber button 'UP' the system will check you mean to proceed, probably by telling you the card already contains data, and will only transfer your new settings if you press 'UP' a second time. The caption telling you the card contains data will not appear if you are using a brand-new card as this will arrive blank from the factory.

If the camera refuses to write to the card the write protect function is almost certainly in the 'ON' position. To switch it off, while still on the 'Set-up Card' page, click the cursor down to the third line where you will see that the line reads 'Write protect : ON'. If you now press the 'UP' rubber button this will change to 'Write protect : OFF'. You can now go back to the Write to Card line and proceed as above. This time the camera should have no difficulty carrying out your commands.

Film gamma cards

Sony can supply a set of four set-up cards that are claimed to replicate, as nearly as possible, the characteristics of four of the most popular Kodak film stocks. While I realize there are cinematographers who like these cards, I have chosen not to use them, despite having been trained in film and having only started shooting Digi Beta after some fifteen years as a film cinematographer. To my mind the Digi Beta camera and the film camera or, more pertinently, film stocks are different in ways that are not necessarily compatible. For me trying to replicate exactly a film look on Digi Beta is wasting some of the image functions of which the Digi Beta camera is capable. It is important therefore, I think, to treat each medium in its own way in order to bring out the best of the recording system you are currently using. By learning, and using, the Digi Beta set-up menus I believe you can get a much more pleasing, and indeed more personal, look to your work than by slavishly trying to get near to a film look which, it is my belief, you will never quite achieve. Don't forget, you can do many things with a Digi Beta menu set-up that you can't with film even if you are transferring a negative through a very sophisticated telecine suite directly to tape.

The menu pages

There are thirty-four pages of menus in the DVW 700 camera and over forty in the DVW 790. On both cameras they are accessed by switching the primary control switch labelled 'Menu/on/off/page' which is situated at the bottom of the camera right to the front on the operator's side. First, lower the switch one click; this will bring up the menu in the viewfinder overlaid on the picture. If you wish to work on the menus without the picture behind the lettering then simply cap the lens. Alternatively, you may wish to view the effect of your changes on the image, in which case leave the image in the background. At this point you may like to connect a monitor to the BNC socket labelled 'Test Out' at the bottom-rear of the camera on the non-operator side: this socket will give an image on the monitor which includes menu information. The more commonly used BNC socket, next to the headphone socket, at the extreme rear, bottom, of the camera on the operator's side, does not include this overlay facility, so use that one when you are making adjustments in a situation where those viewing the monitor would not appreciate the confusion of the overlay.

Making adjustments

Having lowered the Menu on/off/page switch though the first click position you will bring up the last page that was accessed and not what you might consider the first page. To sequence through the pages press

the master switch down to a further position. It will not stay there as this is a spring-loaded position, and this enables you to sequence the pages rapidly. If you wish to go backwards through the pages hold the master switch down in this spring-loaded position and press the rubber button labelled 'DOWN'. Each time you press the down button with the master switch held down you will go backwards one page.

Having arrived at the page you wish to change you will, on most pages, see a cursor at the extreme left of one of the choices. This is represented by a horizontal arrow pointing right. If you press the metal switch which is just behind the master switch, known as the 'ITEM' switch, once, the arrow will drop one choice in the list. This switch is fully spring-loaded and will return upwards, thus allowing you to click down a long menu. When you reach the last choice a further depression will take the arrow up to the first choice at the top of the list in order to go through the options again. To make a change to one of the choices press either the UP or DOWN rubber buttons. UP usually means yes, or adds to a number, and DOWN usually means no or subtracts from a number.

When you have made all the changes you require flick the master switch up to its highest position and the menu will disappear from the viewfinder.

Rate of change

For most of the menu pages the adjustments that can be made are fairly subtle. For instance, you cannot make changes on the skin tone page that will radically change the colour of a presenter's skin nor can you reduce the definition overall, or to fine-line detail, to an extent that would become unnatural. Despite saying this, I feel that there is more than enough control for most circumstances and if the range may be just a little limited there is a more than helpful trade-off in that the differences between the settings is quite fine, which gives the cinematographer considerable control over the subject in hand. Remember, if you need greater changes in this area you can always add a glass filter in front of the lens – see Chapter 6.

The user menu

In the introduction to this book it was stated that there is an assumption that the reader will normally run the camera on the manual settings. Further, it is assumed that the reader will normally keep the camera set to the engineer menu system, thus accessing the full range of control pages.

It is possible to copy the most often used engineering pages, those that all end with the nomenclature 9 as in 2/9, the page dealing with skin tone hue and detail, into the user menu. If one or all the pages labelled 9 are copied to the user menu it makes for very ready access to the most needed pages. As I have said earlier, and make no apologies for repeating, this can be very dangerous. It must be understood that any page copied to the user menu is copied and not moved. If there are settings in the page that remain in the engineering menu these will be added numerically to those that are subsequently set in the user menu. Therefore if 10 units of skin tone detail are set in the engineering menu and −10 units are set in the user menu the overall effect will be zero – no

effect at all. If both menus were to be set at 10 then the overall effect would be 20.

This matter has been much improved on the later DVW 790 but when using a DVW 700 I always ensure that the user menu is set at the factory settings which are, in nearly all cases, set to zero. Therefore I strongly recommend you switch the camera to the engineering setting and only ever alter the engineering values and leave the user menu set to the factory settings. This results in a tedious grind through a number of menu pages you may have no interest in but this is by far the safest way to proceed.

Fathers and grandfathers

If you are to shoot much on Digi Beta you will eventually need at least three set-up cards. These I call my Father card, my Grandfather card and a Son card which will be the one in the camera. Your preferred set-up will evolve over time and your oldest card will be your Grandfather card. The card you used on your last job will be your Father card and the one you are currently using with some changes to the Father card will be the Son. Using this system you can, at any time, go back at least two generations to a set-up you liked previously either for a whole shoot or just for one sequence.

When you haven't rewritten the Grandfather card for some time, and you have just made some changes to your Son card, you can record your new settings onto the old Grandfather card, which now becomes the Son and the other two cards now age a generation.

Eventually you will find you need even more cards. As well as my three generations of drama cards I have two currently written for documentary, one for straight factual and the other for arts and music programmes, the latter being a gentler and more glossy look than the former. I also have a Day for Night card, but that's another matter altogether.

Different software – the quick reference lists

Sony have issued a number of versions of the camera software for both the DVW 700 and the DVW 790. It is therefore quite possible that the menu in the camera you are using will not have the choices in the same order as quoted in this book. To overcome this there is a quick reference table with all the lines of the menu so that you may easily find the setting you are looking for. This is followed by the full and detailed menu.

18
The Sony DVW 700 menus – quick reference list

Set-up card
 Read > Camera
 Write > Card
 Write Protect
 ID Edit
Function ½
 Detail
 Skin detail
 Aperture
 Matrix
 Gamma
 Chroma
 Test sawtooth
Function 2/2
 Genlock
 Cam.ret.
 Filter inhibit
 Field/frame
 A.Iris Override
Test Out
 ENC
 R, G, B
 R-G & B-G
 Widescreen
 16:9/4:3
 VF Aspect
 Box/4:3 Limits
 16:9 bars ID
 16:9 VF ID
Level 1/9 16:9
 Detail level
 V detail level

 H detail level
 V dtl. black clip
 Detail white clip
 Detail black clip
 Crispening
 Level depend
 Knee aperture
 Aperture level
Level 1/9 4:3
 Detail level
 V detail level
 H detail level
 V dtl. black clip
 Detail white clip
 Detail black clip
 Crispening
 Level depend
 Knee aperture
 Aperture level
Level 2/9
 Skin tone hue
 Skin tone detail
 Saturation centre
 Hue centre
 Saturation range
 Hue range
 Skin tone indicator
 Skin tone detail
Level 3/9
 Master black
 Master gamma
 Knee

Level 3/9 (continued)
Knee point
Knee slope
White clip
White clip level
Zebra 1 detect
Zebra 2
Zebra 2 detect
Level 4/9
R-Y burst level
B-Y burst level
R-Y chroma
B-Y chroma
R-Y
B-Y
Encoder Y level
Level 5/9
R, G, B black
R, G, B flare
R, G, B gamma
Test out
Level 6/9
White shading
Level 7/9
Black shading
Level 8/9
Matrix table
R-G
R-B
G-R
G-B
B-R
B-G
Level 9/9
H phase
SC phase, fine
SC phase coarse
SC-H
Iris set
Iris mode
Others
Battery warning
Time code display
Viewfinder display
D/A gain
Menu select 1/3
Marker 1/2
Marker 2/2
Viewfinder display
Master gain
Camera ID
Shutter
Clearscan
! LED

Set-up card
Menu select 2/3
Function 1/2
Function 2/2
Test Out
Widescreen
Menu select 3/3
Level 1/9
Level 2/9
Level 3/9
Level 4/9
Level 5/9
Level 6/9
Level 7/9
Level 8/9
Level 9/9
Others
Auto shading
Black
White
DCC adjust
DCC range
Point
Gain
Operation mode
R-G/B-G select
Zebra
Gamma table A, B, C or S
SG adjust measurement mode
Data reset
User
Engineer
LED Select
Upper left
Upper
Lower left
Lower
Lower right
Marker 1/2
Safety zone
Safety area
Centre
Centre horizontal
Centre vertical
Marker 2/2
Box cursor
Box width
Box height
Box horizontal position
Box vertical position
VF display
Display mode
Extender
Zoom

VF display (continued) EVS
 Filter 1/60
 White 1/125
 Gain 1/250
 Shutter 1/500
 Tape 1/1000
 Iris 1/2000
 Camera ID **Clearscan**
Master gain **! LED**
 Low Gain
 Medium Shutter
 High White preset
Camera ID Extender
Shutter speed Filter
 CLS Auto iris override

19
The Sony DVW 700 menus

There are thirty-four pages of menus and each is given an individual description below. Together with a textual description there is a table the first column of which shows the page name and the second column shows the exact function within the camera with which the line will deal. There then follow three similar columns, the first of which is the value, or setting, with which the camera leaves the factory. The second shows the value or setting that Sony UK recommend as a starting point for your own exploration of the menu values. The third column shows the settings that I had on my set-up card by the end of the series, with which I won my first of two Independent Producers Association Awards (INDIE) for Digital Cinematography.

In fairness, I should now state that the settings in the last column headed PW were not entirely arrived at alone. While I can now drive the Sony cameras in both extreme and subtle ways this was the first series on which I had used the Digi Beta camera. You will find that any decent hire house will help you set up any camera you take from them. I was extremely lucky in getting my first Digi Beta camera from Hammerhead Television in London, where one of the directors, Paul Turtle, spent several days with me trimming the set-up to something I really liked. In small ways the initial set-up was fine-tuned during the six-week shoot and the settings that are shown here are the final ones on the card at the end of the shoot.

Set-up card (Figure 19.1)

The set-up card allows you to both read a card to the camera and write a card from the camera settings to a set-up card. It also allows you to switch on or off the write protect function. Additionally you can write an ID name on the card from within this page.

To write an ID first click the cursor down using the 'ITEM' switch. Then work along the boxes that represent the letter spaces (this looks much like the boxes you write a credit card number into) and then use the 'UP' and 'DOWN' rubber buttons to sequence through the letters, the numbers 1 to 9 including zero and a number of useful exclamation marks.

Set-up card		Factory	Sony UK	PW
	Read > Camera			
	Write > Card			
	Write Protect :	OFF	ON	ON
	ID Edit		Your Name	PW-TQN-1

Function 1/2 (Figure 19.2)

This, the second page, allows you to switch on or off the whole of the settings on seven of the engineering pages. The first two lines are the most useful to the cinematographer for they allow you to switch off the detail settings and the skin tone detail. The second of these switches, skin tone detail, is the most used switch on this page during a shoot. If you imagine you are shooting a scene between your heroine and your hero, by simply using this on/off switch you can make your heroine look younger and more beautiful – with skin tone detail on – and your hero more manly and rugged – switch skin tone detail off.

Function 1/2		Factory	Sony UK	PW
	Detail	ON	ON	ON
	Skin detail	OFF	OFF	ON
	Aperture	ON	ON	ON
	Matrix	ON	ON	ON
	Gamma	ON	ON	ON
	Chroma	ON	ON	ON
	Test sawtooth	OFF	OFF	OFF

Function 2/2 (Figure 19.3)

Page Function 2/2 is not an often-used page once the parameters have been set to your liking. Genlock simply denotes whether you wish to send a genlock signal to the BNC socket on the non-operator side of the camera. There is no disadvantage in feeding this BNC outlet when it is not in use so the safe option is to leave it switched on. Cam. ret. ON enables the button on the lens hand grip which will allow you to back-space a few seconds from the end of a take and replay those seconds. This is very useful for a quick check that all is well. After playing back, the camera resets the time code ready for the next take. Filter inhibit switches off the facility that allows each position on both the filter wheels to have a separate white balance on the A and B preset switches. If left OFF each filter setting will have its own white balance setting so if the ND wheel is turned, for instance, the colour balance might change. I think this foolish, as I always wish the colour balance to remain consistent on any ND setting so I set this parameter to ON.

Function 2/2		Factory	Sony UK	PW
	Genlock	ON	ON	ON
	Cam. ret.	OFF	OFF	ON
	Filter inhibit	OFF	OFF	ON
	Field/frame	FLD	FLD	FLD
	A.Iris Override	OFF	OFF	ON

Field/frame is a slight misnomer. Set to the FLD (field) position, the camera will function as normal, scanning the lace and interlace fields alternately just as one would expect. Set to the FRM position, the camera does not scan a frame in the sense that we are becoming accustomed to with high-definition cameras, that is, scanning each line sequentially and in a consecutive order. What the FRM setting does give you is an increase in motion blur. I have used this very successfully for dream or memory sequences. It should be noted, however, that this effect in no way replicates the motion blur found on film.

A. Iris Override ON allows the auto-iris level to be adjusted in half-stop intervals using the UP and DOWN buttons on the side of the camera. I believe these cameras overexpose, to my eye at least, by around a third of a stop so I have adjusted the normal auto-iris on page 9/9 as well.

Test out (Figure 19.4)

The page labelled Test out simply sets the kind of signal to be delivered to the BNC socket on the non-operator side of the camera. The ENC position sends an encoded signal to the socket that any conventional monitor can decode into a television picture using its 'Line In' socket. Position R sends the red-only portion of the signal while position G sends the green-only portion of the signal and position B the blue-only. Position R-G sends the aggregate of the red and green signals and position B-G sends the blue and green aggregate signal. In practice the cinematographer rarely needs anything but a composite, encoded signal (the ENC setting) and all the other settings are to facilitate setting up and checking the camera in the workshop.

Figure 19.4 Test out

Test Out		Factory	Sony UK	PW
Test Out	ENC	ENC	ENC	ENC
	R			.
	G			
	B			
	R-G			
	B-G			

Widescreen (Figure 19.5)

Figure 19.5 Widescreen

Widescreen		Factory	Sony UK	PW
Widescreen	16:9 / 4:3	16:9	16:9	16:9
	VF Aspect	Auto	16:9 / 4:3	16:9
	Box / 4:3 limits		VF Aspect	Auto
	16:9 bars ID	OFF	ON	ON
	16:9 VF ID	OFF	OFF	OFF

This page, with the exception of the first line, sets up the viewfinder for the two different aspect ratios available in the DVW 700's menus. The first line should be set to the aspect ratio you are planning to use. The second line, VF Aspect, if left to Auto, will cause the viewfinder to automatically display the image in whatever aspect ratio the camera is shooting. The line, Box/4:3 limits, allows you to either display a 4:3 frame in the viewfinder or any box you have set up on page Marker 2/2. I often have a 14:9 box set up manually, by simply drawing the required

aspect ratios on a piece of paper and setting the box in the viewfinder to match, as this is very often the aspect ratio that will be transmitted in the UK for a standard 4:3 transmission that was originated in 16:9. The line, 16:9 bars ID, is most useful as in the ON position it will cause a small title '16:9' to appear in the bottom right of the screen whenever bars are recorded and at no other time. This tells everyone down the postproduction line the format in which the images were originated. Lastly the line labelled 16:9 VF ID controls whether the viewfinder has 16:9 displayed in it at all times. I keep this off at all times as I like as little information distracting me in the viewfinder as possible.

Level 1/9 16:9 (Figure 19.6)

This and page Level 1/9 4:3 are two of the most important pages for the cinematographer for they set most of the parameters that affect sharpness and definition. Each line will be discussed individually.

Figure **19.6** Level 1/9 16:9

		Factory	Sony UK	PW
Level 1/9 16:9	Detail Level	0	-20	-15
	V dtl. level	0	0	0
	H dtl. freq.	0	2	0
	V dtl. black clip	0	0	0
	Dtl. white clip	0	-20	-20
	Dtl. black clip	0	0	10
	Crispening	0	0	18
	Level depend	0	0	0
	Knee Aperture	0	-2	-2
	Aperture Level	0	-4	-4

It should be noted that page Level 1/9 16:9 only sets the parameters when the camera is in 16:9 mode. It does not set the parameters when the camera is in 4:3 mode.

Detail level

The first thing to note is that for this setting a minus number reduces the apparent detail, just as you would expect. Be warned: this is not so on all the settings or on all of the pages. Sony has a curious attitude to plus and minus signs. Altering the detail level will affect the whole of the picture area irrespective of the colour, density or the thickness of the line of detail. My most often used setting is −15 but I have worked with it as high as −30. This is something you must choose for yourself and it is very easy to see the changes on a monitor as you make the adjustments.

Vertical detail level (shown on screen as V dtl. level)

To a film cinematographer this is a curious setting for it will only change the apparent definition with respect to the vertical component of any given part of the image. My own opinion is that it should be adjusted with caution. My normal setting is 0 but I have run it as high as −8.

Horizontal detail frequency (shown on screen as H dtl. freq.)

This is similar to the previous setting with the exception that it affects only the horizontal component of any part of the image and does this by adjusting the maximum, or peak frequency, to which the horizontal detail will be allowed to rise. Again I urge caution when adjusting this setting to the extent that I always leave it at 0.

Vertical detail black clip (shown on screen as V dtl. black clip)

This setting reduces the detail of black edges on vertical detail. Again my feeling is that 0 works just fine.

Detail white clip (shown on screen as Dtl. white clip)

This setting reduces the white edges of an image. It is particularly notice-able where something pale in colour and density lies next to something dark. I like its effect and usually run it at –20.

Detail black clip (shown on screen as Dtl. black clip)

As you will by now probably expect, having got used to Sony's way of communicating on-screen, this setting reduces black edges. I can just see what it is affecting within the picture and have always had this line set at 10.

Crispening

For once the effect produced by adjusting this setting is much like its descriptive word but what is adjusted on the screen concerns mid-range detail rather than heavy or very fine lines. The technical term for this effect is Noise Coring. This setting again brings into question Sony's attitude to mathematical signs as you add positive value to the setting to reduce the apparent detail. I nearly always leave this setting at 18.

Level depend

Level depend, as its title suggests, trims the threshold at which the detail settings come into effect. As I wish my settings to affect the whole of the picture's brightness range, and all the small and large details within it, I always leave the setting at 0. This setting will still reduce the detail in the black areas a little. To have zero effect you must set this at the full neg-ative value.

Knee aperture

In video parlance the knee of the sensitometric curve, that is, the top of the curve, is where the highlights live. Therefore this setting puts detail into the compressed highlights of the picture. Film cinematographers should remember that in the video world the sensitometric curve is always for a positive image, therefore the higher end of the curve deals with highlights and the lower with the shadows. This is quite the reverse of what a film cinematographer is usually looking at for this sensitomet-ric relationship occurs, for them, only in a negative image.

Aperture level

This is where you can affect the amount of fine detail in an image. Try setting it to zero, compose a close-up of a middle-aged person then watch the smile lines at the corners of the eyes decrease as you take down the setting. Remember, you will have a version of this setting on the page dealing with skin tone detail so you don't have to get all the effect you want here. This setting affects all the fine line detail in the whole of the picture. I usually leave this setting at –4.

Level 1/9 4:3 (Figure 19.7)

This page is identical to the previous page with the exception that it sets the same parameters when the camera is in 4:3 mode. As a safety measure I suggest that you enter exactly the same data on both pages and update them with any new settings simultaneously. That way you can freely switch between formats, knowing you will obtain the same results. Having said this, it may be necessary to have the overall detail set a little higher in 4:3 mode as fewer pixels are used in this mode and it may, therefore, need more detail. As an example if you like a setting of –15 in 16:9 mode you might like to try a setting of –5 in 4:3.

Figure 19.7 Level 1/9 4:3

Level 1/9		Factory	Sony UK	PW
	Detail Level	0	-20	-15
4:3	V dtl. level	0	0	0
	H dtl. freq.	0	2	0
	V dtl. black clip	0	0	0
	Dtl. white clip	0	-20	-20
	Dtl. black clip	0	0	10
	Crispening	0	0	18
	Level depend	0	0	0
	Knee Aperture	0	-2	-2
	Aperture Level	0	-4	-4

Level 2/9 (Figure 19.8)

This is probably the second most important page to the cinematographer and operates in both 16:9 mode and 4:3 mode. Here you can set all the values both for detail and hue that, with the skin tone detail switched ON, will alter the settings within skin tone areas of the image without affecting any of the other portions of the scene. Again, as this is such an important page to the cinematographer when setting up their own personal look, I will give every line a separate description.

Figure 19.8 Level 2/9

Level 2/9		Factory	Sony UK	PW
	Skin tone hue	119	119	129
	Skin tone dtl.	0	0	8
	Sat. centre	0	0	-10
	Hue centre	0	0	-5
	Sat. range	0	0	0
	Hue range	0	0	4
	Skin tone ind.	OFF	OFF	OFF
	Skin tone dtl.	OFF	OFF	ON

Skin tone hue

Working out of the UK one finds that most north European Caucasian faces are a little pallid – we don't see too much sun. As I tend to be a cinematographer who, unless the script dictates otherwise, likes to flatter those before my camera my standard setting for skin tone hue is a little above a truly accurate rendition of the truth. In other words I give everyone a very slight tan. Remember, this can easily be modified up or down depending on circumstances, but for most of my work I find a setting of 129, ten points above the flat factory setting, gives a very subtle, and usually unnoticeable, improvement in Caucasian skin rendition.

Skin tone detail (shown on screen as Skin tone dtl.)

This controls the amount of detail taken out of a selected area of skin tone. As this setting assumes you will be reducing detail again we see Sony's curious approach to mathematical signs for here a positive number reduces detail. My standard setting, therefore, is 8.

Saturation centre (shown on screen as Sat. centre)

This chooses the target saturation levels that this page's parameters will affect. As I have said, working in the UK one tends to be photographing people with a fairly pallid skin tone so to have the best effect I need to make the target tone a little paler than the factory setting. Therefore my preferred value for this line is −10.

Hue centre

Again we are setting the target hue to be affected by this page so with my being in the UK I set this parameter a little low at −5.

Saturation range (shown on screen as Sat. range)

This covers the range of saturation of colours that will be affected by the controls on this page. I happen to be quite happy here with the factory setting so leave the value at 0.

Hue range

My settings here are again influenced by more often than not photographing rather pale Caucasian skin so I have extended slightly the range of hues that the page in total will affect by raising the value to 4.

Skin tone indicator (shown on screen as Skin tone ind.)

This simply switches on or off the indicator in the viewfinder that shows you which areas are being affected.

Skin tone detail (shown on screen as Skin tone dtl.)

This is the last line of this page and denotes whether your preference is for the whole page of effects to be permanently ON or OFF. I leave it permanently ON.

Level 3/9 (Figure 19.9)

This page is dedicated to what a film cinematographer would consider the basic sensitometric parameters of the image to be recorded. As I have mentioned before, if you come from a film background please remember that you are dealing with a positive image, so in this context the knee affects the highlights. The knee, the top of the sensitometric curve, is the word used in video parlance for that which a film cinematographer uses to refer to the shoulder. The toe in film parlance is normally referred to in the video world as black level. Would it be cruel of me to comment at this point that perhaps it is the much shorter tonal range that can be recorded on tape as against film, which causes technicians to refer to the upper end of the video curve as the knee whereas in film one can reach right up to the shoulder? Perhaps, perhaps not.

Figure 19.9 Level 3/9

Level 3/9		Factory	Sony UK	PW
	Master black	0	0	0
	Master gamma	0	0	20
	Knee	ON	ON	ON
	Knee Point	0	20	14
	Knee slope	0	0	25
	White clip	ON	ON	ON
	White clip level	0	8	8
	Zebra 1 detect	67	67	95
	Zebra 2	OFF	OFF	OFF
	Zebra 2 detect	100	100	100

Master black

This setting controls how much the black areas are either stretched or crushed. For most work I think the factory setting obtains the most natural blacks that are available, so I leave the factory setting at zero. I sometimes introduce a small change to –2 but usually only for my art programmes.

Master gamma

This parameter either stretches or crushes the mid-tones of the scene. I find a stretch of 20 very pleasing.

Knee

This is simply an ON / OFF switch to decide whether you wish to affect the knee of the gamma curve, I do, as I like a slight roll-off into the whites and therefore keep this line set to ON.

Knee point

This sets the point at which the whites will start to roll-off or compress into peak white. Sony UK's setting of 20 is to my eye a little aggressive and can sometimes look unnatural, so I set this parameter at 14.

Knee slope

This setting decides how quickly the highlights or whites roll-off or are compressed. After much fiddling and staring at a monitor I find a setting of 25 gives a noticeable improvement with most scenes without in any way looking unnatural.

White clip

This line of the setting simply allows you to chose if you would like to adjust the point at which the image highlights will, as they rise in value, switch or clip to peak white.

White clip level

If you set the level of white clipping too high you are in danger of over-modulating the high end of the video signal. This may have several effects. First, you may get some curious noises or unnatural responses in your brightest whites as there will be a signal there of a value higher than the camera's or the VCR's circuitry can handle. Second, if this is set higher than a normal signal should ever reach you may get complaints from the transmission station or even have them refuse to transmit your material. It should not happen these days but in times past an over-modulated highlight could blow a transmission valve, and this did not make you popular.

If you set the level too low you are unnecessarily reducing the tonal range of your recording.

As I am always looking for ways to extend either the actual or apparent tonal range of the image I set this value at 8, which allows a maximum level of video signal of 102 per cent to go through the system. An extension of only 2 per cent on the total tonal range may not, of its self, seem very significant but I come from the school of thought that believes that every little helps, and at this 102 per cent setting I have never received a complaint of highlights overmodulating.

Zebra 1 detect

There are two warning patterns that you can chose to appear in the viewfinder to warn you of the video signal reaching a predetermined level. These are called Zebra 1 and Zebra 2. As the camera comes from the factory Zebra 1 is set at 67 per cent, a point at which a diagonal strip-ing pattern, much like a zebra's skin, will be overlaid on any area of the scene that has reached or exceeds this value. A level of 67 per cent has been chosen for it is about the level of signal at which Caucasian skin tone is about to burn out. Therefore this will give you a warning that the highlights on the face are too bright. The numerical values on this line, and on the line Zebra 2 detect, are expressing percentages. Remember, this patterning appears only in the viewfinder.

I find this an extremely irritating effect and therefore reset the value to 95 where the Zebra patterning will only warn if things are getting very worrying.

Zebra 2

This, the first of the Zebra 2 settings, simply switches the second available patterning ON or OFF. In order that you can tell one warning from another the Zebra 2 pattern is different from the Zebra 1 pattern. Zebra 2 is not diagonal stripes but more like an animal's spots. Sony UK suggest it looks more like a leopard but I vote for a tiger. Look at it and chose your own animal. I hate the whole thing and as I have already set Zebra 1 to warn me about highlights I leave Zebra 2 firmly switched OFF.

Zebra 2 detect

As the factory setting for this parameter is 100 per cent I leave it there but, as I say, with it switched off. The recommendations from various sources are that you set it to 95 per cent or 100 per cent. It is from these recommendations that I have chosen to set Zebra 1 to 95 per cent.

Level 4/9 (Figure 19.10)

This is a purely engineering set-up page and the only recommendation I can give you is leave it severely alone. I always leave this page at the factory settings.

Figure 19.10 Level 4/9

		Factory	Sony UK	PW
Level 4/9	R-Y Burst level	0	0	0
	B-Y Burst level	0	0	0
	R-Y Chroma	0	0	0
	B-Y Chroma	0	0	0
	R-Y	ON	ON	ON
	B-Y	ON	ON	ON
	Enc. Y level	0	0	0

Level 5/9 (Figure 19.11)

Again this is a purely engineering set-up page and the only recommendation I can give you is leave it alone. I always leave this page at the factory settings with the exception of the last line where my usual camera suppliers like this setting left as ENC, that is, an encoded output.

Figure 19.11 Level 5/9

		Factory	Sony UK	PW
Level 5/9	R Black	0	0	0
	G	0	0	0
	B	0	0	0
	R Flare	0	0	0
	G	0	0	0
	B	0	0	0
	R Gamma	0	0	0
	G	0	0	0
	B	0	0	0
	Test out	0	0	ENC

Level 6/9 (Figure 19.12)

You may be tempted to see this and the following page as an extension of the white and black balance that is available on the switches on the front of the camera. They are not. Please do not try to run these programs in the field, they are for workshop use only.

Figure 19.12 Level 6/9

		Factory	Sony UK	PW
Level 6/9	White shading			

Level 7/9 (Figure 19.13)

As with the previous page, please don't adjust. I tried it once before I really understood the menus and cost the production an hour's shooting time.

Figure 19.13 Level 7/9

		Factory	Sony UK	PW
Level 7/9	Black shading			

Level 8/9 (Figure 19.14)

For a film-based cinematographer the purpose of this page might be very hard to grasp. Fear not. First, and unusually for these pages, you have two settings which, once you have set them, you can easily switch between. Second, if you change all the values on each line identically all you will change is the overall colorimetry. In film-speak that means if you go into negative figures you will be reducing the colour saturation. With these minus values this is something akin to using a low-contrast filter but with absolutely no loss in definition. I find it hard to imagine a film-based cinematographer wanting to increase the saturation except in unusual circumstances, perhaps for a special effect.

Figure 19.14 Level 8/9

		Factory	Sony UK		PW	
Level 8/9	Matrix table	A	A	B	A	B
	R-G	0	0	20	0	-7
	R-B	0	0	20	0	-7
	G-R	0	0	20	0	-7
	G-B	0	0	20	0	-7
	B-R	0	0	20	0	-7
	B-G	0	0	20	0	-7

It is important to realize that, in Europe, there is a European Broadcasting Union (EBU) standard, and a Sony DVW 700 camera, when set up for PAL transmission, will abide by the EBU standard with all the settings at zero.

I find the sensible thing is to set Matrix table B to my preferred setting and normally leave Matrix table A at the factory and EBU, zero, settings. If I then want to produce a special effect I will switch to, and alter, Matrix table A for after I have finished shooting the unusual scene I can easily remember that I should return all the settings in Matrix table A to zero.

Altering a line in a Matrix table page changes a relationship between two colours. For instance, changing the second line, R–G, will alter the red component relative to the green component. If you understand a

vector diagram you will know what this looks like on an oscilloscope. If you don't, don't worry, simply accept that the red value will change a lot and the green value very little. This goes for all the other lines. The first colour in the X–X ratio will change a lot and the second very little.

While I very rarely change these settings from my preferred values, fiddling about with them can be very interesting. But be warned. Leave yourself plenty of time. This is not an experiment to be undertaken in the heat of a shooting schedule. It took me nearly 4 hours to come up with the changes that contributed to my Day for Night card and I ended up making many changes to other pages after that. The production was more than happy to pay me for that day as it saved them a small fortune, but that particular card still only works if the sun is out. A dull day is a wholly different matter.

My normally preferred settings, set within Matrix table B, are for all lines to be at –7 for I have found I like a slight overall reduction in saturation.

Just one more note. Changing these values does not affect black, white or the grey scale, only the colour saturation.

Level 9/9 (Figure 19.15)

The first four lines of this page should be ignored and very definitely left at factory settings. The instruction book says that they affect timing controls and system integration and I am happy to admit I haven't the faintest idea what that means other than every camera engineer I have ever spoken to has said 'leave it alone guv, that's strictly a workshop job', and I am happy to believe them.

Figure 19.15 Level 9/9

		Factory	Sony UK	PW
Level 9/9	H phase	55	55	55
	SC phase, fine	0	0	0
	SC phase coarse	0	0	0
	SC-H	0	0	0
	Iris Set	0	-20	-10
	Iris mode	0	0	0

The fifth line is of great interest to the cinematographer for this is where you can adjust the exposure given by the auto-iris. As I have said before, I find the factory auto-iris setting gives me an overexposed image. Though I rarely leave the exposure on auto, if you set the lens grip switch to manual a quick touch on the rubber button will give a once-only auto exposure and this is a reasonable starting point for your own personal exposure setting, this to be judged on a colour monitor. My basic setting for this line is –10 but if I am shooting a 'moody' scene I might run it as high as –35. Both these settings reduce the auto exposure by the percentage figure set in the menu line, that is, they will cause the lens to stop down, always assuming that the last line in page Function 2/2 (which we are considering to be our second page) is set to ON thus allowing an override of the camera's normal auto setting.

The last line in this page which selects peak or average exposure mode is best left at the factory setting.

Others (Figure 19.16)

This page contains three useful decisions. The first line allows you to set the point at which you would like a warning that the camera battery is close to having so little power left in it that the camera will automatically shut down. Ten per cent seems to be most people's favourite but I much prefer 20 per cent. This may be because I work mostly in fiction and therefore the takes are often longer. We carry plenty of batteries and there is usually enough staff to rapidly effect a change and keep used batteries on charge throughout the day.

Figure 19.16 Others

		Factory	Sony UK	PW
Others	Batt. warning	10%	10%	20%
	Time code disp.	OFF	PB	OFF
	Viewfinder disp.	Y	Y or VBS	Y

The other two lines both concern information in the viewfinder. The middle line allows you to chose if you would like time code to appear in the viewfinder and if so whether you would like it to appear continuously or only when playing back. I keep it in the OFF position. The last line simply allows you to tell the camera whether there is a black and white or a colour viewfinder attached to the camera. Y, the symbol for luminance, indicates a black and white viewfinder and VBS (Video Burst and Sync, i.e. composite video) a colour one. I have yet to see a colour viewfinder I find less than thoroughly irritating so this is always set to Y on my set-up.

D/A gain (Figure 19.17)

This page is strictly for alignment use and should always be left blank.

Figure 19.17 D/A gain

	Factory	Sony UK	PW
D/A Gain			

Menu select 1/3, 2/3 and 3/3 (Figures 19.18–19.20)

Figure 19.18 Menu select 1/3

		Factory	Sony UK	PW
Menu select 1/3	Marker 1/2	Y	Y	N
	Marker 2/2	N	Y	N
	Vf display	Y	Y	Y i.e. *
	Master Gain	Y	Y	N
	Camera ID	Y	Y	N
	Shutter	N	N	Y i.e. *
	Clearscan	Y	Y	Y i.e. *
	! LED	N	N	N
	Setup Card	N	Y	Y i.e. *

All three of these pages select what you would like to appear in the user menu. As we have seen, the true setting of the camera will be the aggregate of the user menu and the engineering menu. I feel this is a dangerous situation and therefore do not transfer any of the parameters that

deal with the camera set-up to the user menu and always make my settings in the engineering menu. At this point it is worth repeating that when you read a set-up card to the camera it will always transfer both the user menu settings and the engineering menu settings from the card to the camera.

Figure 19.19 Menu
select 2/3

		Factory	Sony UK	PW
Menu	Function 1/2	N	Y	N
select 2/3	Function 2/2	N	N	N
	Test Out	Y	Y	N
	Widescreen	Y	Y	N

Figure 19.20 Menu
select 3/3

		Factory	Sony UK	PW
Menu	Level 1/9	N	Y	N
select 3/3	Level 2/9	N	Y	N
	Level 3/9	N	Y	N
	Level 4/9	N	N	N
	Level 5/9	N	N	N
	Level 6/9	N	N	N
	Level 7/9	N	N	N
	Level 8/9	N	Y	N
	Level 9/9	N	Y	N
	Others	N	Y	Y i.e. *

There are just a few warnings that I do transfer as can be seen in the pages above. On these pages the ON is represented by a star at the end of the line on the viewfinder screen and for the OFF setting it is left blank. I have shown this as a reminder in my column labelled PW.

Auto shading (Figure 19.21)

This is another page of the menus that should never be touched in the field. I was once foolish enough to think that operating the black auto shading would improve my blacks. All it gave me was a dark line some three lines high about 10 per cent of the way down from the top of the screen. A quick phone call ascertained that I should have left well alone and had produced something unique. A new camera was dispatched to me immediately. In the meantime I was advised to cap the lens with both the iris and the lens cap and try again. Having done this I felt the line might be a little fainter. After operating the black auto shading this way for eight consecutive tries I was finally convinced that the line had disappeared. Nevertheless when the new camera arrived I went over to it with some relief.

Figure 19.21 Auto shading

		Factory	Sony UK	PW
Auto	Black			
Shading	White			

DCC adjust (Figure 19.22)

DCC stands for Dynamic Contrast Control. The purpose of the DCC is to automatically adjust the knee, the highlight portion, of the sensitometric curve to a slightly different rate of change should the camera

detect a large area of very strong highlights so that more information can
be recorded in this part of the image.

Figure 19.22 DCC adjust

		Factory	**Sony UK**	**PW**
DCC adjust	D. range	4	4	4
	Point	0	0	0
	Gain	0	0	0

I used to think it did not really work but on a recent shoot in the
French Alps I was able to see a considerable improvement in the infor-
mation on the snow when the DCC was switched ON. I had, of course,
adjusted my set-up card to produce better pictures in these circumstances
anyway. If you wish to see the DCC's effect, aim the camera at a fluo-
rescent light in the ceiling, leave the iris set to auto and switch the DCC
ON and OFF. The switch is the middle position on the Bars/DCC/
Camera switch at the front of the camera. You will see more information
in the burnt-out section of the tube with the DCC switched ON. I now
leave the DCC on all the time for, at worst, nothing will happen and a
little more information at either of the extremes of the pictures tonal
range is always a good thing.

Operation mode (Figure 19.23)

The first line is purely for engineering workshop monitoring and should
always be left set at OFF. The second line switches the zebra warning
OFF for the engineer's output. This does not affect the zebra in the
viewfinder where the zebra switch on the front of the viewfinder will
still operate as normal if this setting is in the OFF position.

Figure 19.23 Operation
mode

		Factory	**Sony UK**	**PW**
Operation Mode	R-G/B-G select	OFF	OFF	OFF
	Zebra	OFF	OFF	OFF
	Gamma table A, B, C or S	A	A	B

The third and last line allows you to select between four different
gamma settings, three internal to the camera and one external and
obtained using special set-up cards.

Gamma tables A, B and C offer slightly different sensitometric
responses. The factory setting is table A. Having looked very carefully
at the effect of these settings using a large, high-grade monitor, my pref-
erence is for table B. Sony advises that this table will give an increased
definition in the shadows, with which I wholly agree and I like the effect.
Sony also warns that there may be some increase in noise. I can't see it,
so I am very happy to stay on table B. If you add the effect of DCC to
the effect of Gamma table B on the screen the tonal range appears to
have been extended by around a quarter of a stop with no adverse effects
that I can spot.

For me Gamma table C, which is supposed to be similar to B but with
the effect starting earlier in the blacks when they are still dark greys, is
not attractive.

Gamma table S is another matter altogether. Sony can supply a set of
four set-up cards and you must set this line to S if you are using them.
They claim each card will replicate the look of one of Eastman Kodak's

more popular film stocks. Maybe it's because, when shooting film, I tend to use Kodak and therefore know the sensitometric response of these stocks intimately but I, personally, hate the effect of these cards.

There is another reason why I steer clear of the film-look cards. I don't believe they do the camera justice. Modern digital cameras are superb tools, they are not film, but an instrument in their own right. I have never, with one exception, seen a picture shot on video with, supposedly, a film 'look' that didn't look like inferior film. The exception looked like good, ordinary photography, nothing special. So why bother?

SG adjust measure mode (Figure 19.24)

This is strictly a factory setting and should be left at the factory settings.

Figure 19.24 SG adjust measure mode

		Factory	Sony UK	PW
SG Adjust Measure Mode				

Data reset (Figure 19.25)

You operate the data reset by aligning the cursor to either the user line or the engineer line, and then pressing UP. This is very useful if you adopt my approach of not having any settings in the user menu and keeping all your personal settings in the engineer menu, for you can, at any time, clear the user menu back to the factory settings as a safety check.

Figure 19.25 Data reset

		Factory	Sony UK	PW
Data reset	User			
	Engineer			

LED select (Figure 19.26)

This page deals with placing the warning symbols wherever you prefer them in the viewfinder. The page labelled VF display is where you decide if you want them ON or OFF. As I find it confusing if a warning is indicated somewhere I am not expecting I stick firmly to the factory settings so that the few I like to use always appear in the same position.

Figure 19.26 LED select

		Factory	Sony UK	PW
LED select	Upper left	G-Tally	G-Tally	G-Tally
	Upper	Rec	Rec	Rec
	Lower left	Non Std.	Non Std.	Non Std.
	Lower	Ret	Ret	Ret
	Lower right	Save	Save	Save

The upper-left warning light, G-Tally, is a repeater of the two Tally lights at the front and rear of the camera. For those of you from the film industry a Tally light is the red warning light that tells those, other than the operator, that the camera is recording. Both the Tally lights on the outside of the camera can be switched OFF for discrete recording. If you are on a multi-camera shoot and the cameras are feeding their signals

back to a central control it is common for the camera selected by control to be the only one showing a Tally light.

The Upper (Record) warning will light whenever the camera is recording. During the run-up time before the camera is stable it will flash, moving to a continuous light until you stop recording.

Lower left, Non Standard is a general warning that you have some setting switched ON on the camera that is not the standard setting. An example would be when a gain other than 0 dB is in use, or a range extender or the shutter facility is switched ON.

With the factory settings the second setting, Upper, will light when you are replaying via the Ret. (return) button on the lens hand grip. This, at first sight, may seem unnecessary but, surprisingly often, the camera is still set on the same shot as you are replaying and it can be quite unnerving to see such a similar view in the finder without a warning that you are in replay. It is also useful to see the light go out when replay is over and know that you are clear to start recording again.

When the lower-right warning light is on (Save) it tells you that although the camera is switched on the recording drum is not spinning. It has been saved, and will therefore take approximately 3 seconds from your pressing the record button before the VTR is stable and recording has commenced. If the front of the four metal switches at the bottom of the operator's side of the camera is moved from Save to Standby the camera will run the tape drum up to speed but not move the tape forward. In this configuration, when the record button is pressed, the camera will go from stop to record in around half a second. You cannot leave the camera in standby for too long for the static tape pressed against the fast revolving drum will, after a time, start to show signs of wear or overheat. The camera is fitted with sensors to detect this and, if you have left it in standby too long, will automatically power down the drum and the Save light will come on to warn you that the camera has gone back to the mode requiring a longer run-up time.

Marker 1/2 (Figure 19.27)

This page deals with the standard markers in the viewfinder. The Safety zone is a box which will have the same proportions as the aspect ratio, that is, 16:9 or 4:3, but will appear as a fine-line white box overlaid onto the viewfinder image. The purpose of this is to replicate the underscan facility of most monitors one is supplied with and both these facilities are to warn the operator that on most domestic televisions the set slightly overscans the picture to ensure that the picture goes to at least the edge of the available screen area. In other words the audience usually sees a slightly tighter framing than the whole of the recorded image. This can be a very useful marker, but after many years of looking down the optical viewfinders of film cameras, and making these compensations quite automatically, I prefer to look at what I am familiar with – the whole of the recorded area.

Figure 19.27 Marker 1/2

		Factory	Sony UK	PW
SMarker 1/2	Safety zone	ON	ON	OFF
	Safety area	90%	90%	90%
	Centre	ON	ON	ON
	Centre H			
	Centre V			

The next line allows you to set how much smaller you would like the warning box than the total picture area. It is expressed as a percentage of the total area and the factory setting of 90 per cent seems just about right to me, though I know some operators prefer 95 per cent.

The last two lines, Centre H and Centre V, allow you to reposition the cross in the centre of the viewfinder. At first, moving a centre cross to anything but the centre might seem a complete waste of time but there have been occasions, although rare, when this has proved a useful facility. Imagine you are going to take two shots where there will, in postproduction, be a mix between two different characters but the director has asked for the two faces to be as close to the same position on the screen as possible. If you move the centre cross to be in the exact centre of the near eye of the first face and then set the second face to the cross you are a long way towards your goal. If you have to record these two shots with a considerable time gap between them, and you happen to have a spare set-up card, you can record the settings on this card and save it until you need it.

Marker 2/2 (Figure 19.28)

With the present transmission standards in the UK this is a most useful facility for it allows you to set a fine-line white box in the viewfinder of any dimensions you chose. At the time of writing, in the UK, digital systems all transmit in an aspect ratio of 16:9, therefore there is no problem. The majority of homes still have sets designed for UHF 4:3 reception. For most dramas and prestige documentaries the stations insist that the images are recorded in 16:9 so that they will be able to transmit them at any future date when the whole of the UK has moved to the 16:9 digital transmission/reception arena. The powers that be have decided that, more often than not, they will transmit to the UHF 4:3 sets a picture with a very small black line top and bottom as a compromise between the set and the format of origination. This produces a received image area format of 14:9.

Figure 19.28 Marker 2/2

		Factory	Sony UK	PW
Marker 2/2	Box cursor	OFF	OFF	ON
	Box width			
	Box height			
	Box H			
	Box V			

It is very convenient, therefore, to have a full picture in the viewfinder at the total recorded area of 16:9 and be able to set a box up for 14:9. The same would be true if you knew that the transmission would be in 4:3 and were still asked to record in 16:9. On the principle that with simplicity comes reliability I set this box by getting a sheet of art card, drawing a box 16 inches by 9 inches and adding a vertical line 1 inch inside the outside edges, 14 inches apart. I now set the camera up to exactly fill the viewfinder with the 16-inch by 9-inch box. Switch the box facility ON and set the height of the box to be the full height of the picture in the viewfinder then bring the left and right edges of the marker box in to fit the marked inner lines that are 14 inches apart. What could be simpler?

The box cursor line is simply an ON / OFF switch for the facility. The

box width sets the width via the UP and DOWN buttons, the same being true for the Box height. Box H and Box V set the horizontal and vertical centring of the drawn box.

VF display (Figure 19.29)

The whole of this page is concerned with how much information you receive in the viewfinder. As you will now be aware, my preference is for as little as is practicably possible.

Figure 19.29 Viewfinder display

VF Display		Factory	Sony UK	PW
	Disp. mode	3	3	3
	Extender	ON	OFF	OFF
	Zoom	ON	OFF	OFF
	Filter	ON	OFF	OFF
	White	ON	OFF	OFF
	Gain	ON	ON	OFF
	Shutter	ON	OFF	ON
	Tape	ON	OFF	OFF
	Iris	ON	ON	OFF
	Camera ID	ON	ON	OFF

Line one is the only line dealing on this page with the temporary warning display mode. The factory setting is 3 and this seems, when used in conjunction with the settings for viewfinder information already discussed, to be about right.

All the other lines deal with permanent displays so are more critical to the operator's peace of mind. Line two, the first of the permanent display choices, decides if you are to be warned that you have switched the lens focal length extender in or not, should such a facility be fitted to the lens in use. Frankly, if the operator does not realize that the lens is working at twice its normal focal length, with the associated loss of two stops on the iris setting, then they, perhaps, should try another day job. A note here: very few, if any, lenses are capable of as high a quality of image with the extender inserted as without. Therefore this is not a good way of opening the iris if you are trying to reduce the depth of field. You will also be reducing the overall quality of the image to what I believe is an unacceptable level. This is not to say that using the extender for an occasional shot is not a good idea, but if you have a longer lens to get the shot without deploying the extender you are likely to obtain a higher-quality image. So, if you can, change the lens rather than employ the extender.

The Zoom setting tells you (with luck, for not all lenses will give a read-out accurately) what focal length you are using. I am about to sound like a dyed in the wool film man but if a professional operator or the Director of Photography, back at the monitor, can't make a reasonable judgement of the focal length just by looking at the perspective of the shot, things aren't going too well. Having said that, if you are on a student shoot I suggest you keep this facility switched to ON as it's a great way of learning to judge the focal length of a shot.

There are too many filter options (eight, to be precise) to want all that information in the viewfinder. On a fiction shoot the filter wheel setting on the camera should be a conscious decision before you turn on the camera. Also you may well have filters in front of the lens which are not included in this feature. That said, if you are on a rush-around

documentary and are likely to be in and out of several locations, indoors and out, having this warning on might be a good idea. I say this advisedly, for I made a mistake when shooting for a friend of mine during which I had the camera on my shoulder for most of the day and shot a daylight scene with the camera set to tungsten. As he knew full well my 'art' background he was kind enough to think I had intended this effect, which did look rather good, and liked the shots very much. I wouldn't want to push my luck in that area again.

Always admit your mistakes while shooting. It's much easier to shoot again than come back later. If a mistake slips through and you notice it only at a rushes viewing keep quiet until someone else notices it – you never know, they may praise you for it. This has happened to me twice when I have suddenly realized I had committed what I thought were huge mistakes and in both cases the director and producer loved the effect.

The white balance line will remind you of the last colour temperature to which you balanced the camera. As I find this confusing I switch it OFF. You must choose for yourself.

The Gain warning is one I always worry about having OFF as it is all too easy to forget one has pushed up the sensitivity of the camera, and therefore reduced the quality of the image. If I am shooting a drama with my usual Gain settings (see the next page) I usually leave this warning OFF as even with the highest gain setting available from my set-up card there will not be much appreciable loss of quality. If, on the other hand, you are shooting a documentary, some of which happens at night where you might be using very high gain settings, then it might be advisable to keep this setting switched to ON.

For the Shutter warning I agree with the factory. It's all too easy to come away from trying to photograph a cathode ray tube, be it a television or a computer, and forget you have an unusual shutter setting on the camera for there will be few clues in the viewfinder, or on the monitor, but once you reach postproduction there might well be problems with such things as movement blur. I keep this warning to ON.

In normal circumstances I set the Tape warning to OFF. This is because I am normally shooting drama and the script supervisor or continuity person will be keeping a careful record of shot lengths and my camera assistant should be checking if we have enough tape for the next shot. If I am operating myself on a documentary I will change this setting to ON as I will probably have no idea where we are on the roll. Even if this is set to OFF the tape indicator on the side of the camera still operates.

The Iris warning actually appears as a very small number, expressed as an f-number, in the bottom of the image area. As some lenses cause the camera not to tell the truth, I switch this facility OFF.

The Camera ID (Identity from the set-up card) I leave OFF. Even on a multi-camera shoot I doubt the camera operator needs reminding which camera they are on and this just adds more confusing information to the viewfinder display. If, on the other hand, you are on, say, a student shoot where operators are expected to swap cameras on a regular basis keep this warning ON as things, in these circumstances, can become very confusing.

Master gain (Figure 19.30)

For some reason, inexplicable to me as a film man, Sony has chosen to show the increase or decrease in sensitivity of the camera, when related to the three positions on the sensitivity switch at the front of the camera, in the quantitative figure which originated in the sound world. Indicating plus or minus f stops of sensitivity would seem more universal. That said, in sound or video, an increase of 6 dB means an exact doubling of the signal strength. Sony often sell the Digi Beta camera as an alternative to film and are trying to persuade film DoPs to adopt the medium. Most DoPs will either have no idea of what dBs mean or will have heard their sound mixer talk of them and immediately shut down their brains. So for those film DoPs reading this, 6 dB doubles the sensitivity of the camera, the equivalent of doubling the ASA rating of the film and –6 dB halves the equivalent of the ASA rating. Fortunately for our sanity 3 dB is equal to half a stop in either direction.

Figure 19.30 Master gain

		Factory	Sony UK	PW
Master gain	Low	0db	0db	-3db
	Medium	9db	6db	0db
	High	18db	12db	6db

The factory settings of Low = 0 dB roughly equates on the Sony DVW 700 to an ASA rating of 320, the camera's normal equivalent film speed to tungsten light. The Mid setting adds 9 dB to the sensitivity, upping the equivalent ASA rating by one and a half stops to 800 ASA. The high factory setting of 18 dB therefore adds three stops to the equivalent ASA rating bringing it up to virtually 1000 ASA. The only problem with these, the factory settings, is that while the effect is far better than was ever achieved on any analogue camera it is possible to see an increase in picture noise at 9 dB and it becomes very noticeable at 18 dB. This is probably acceptable for news and for some documentary work but is quite unacceptable for fiction.

Sony UK's recommendations are a good compromise being Low, 0 dB, Mid, 6 dB, one stop increase, and High, 12 dB, two stops increase. I, on the other hand, when shooting fiction, set my three switchable choices at Low, –3 dB, the lowest setting the camera can achieve and which allows me to open the lens half a stop, Mid, 0 dB, the factory's normal setting and High, +6 dB, the highest amount of gain or amplification I feel is acceptable without a lay audience noticing any increase in picture noise.

The whole range of settings available on the Sony DVW 700 are; –3, 0, 3, 6, 9, 12, 18, 24 and 30 dB. A gain setting of 30 dB represents a rise in sensitivity of five stops of the equivalent of an ASA speed of 20 480, a quite phenomenal figure. You get a lot of picture noise at a +30 dB setting but it does enable one to photograph subjects impossible previously and is a quite remarkable achievement.

Camera ID (Figure 19.31)

This facility allows you to overlay a camera ID onto the bars which you should lay down at the front of each roll of tape, but appear nowhere else. I keep it switched OFF unless we are doing a multi-camera shoot, when it is very useful indeed.

Figure 19.31 Camera ID

		Factory	Sony UK	PW
Camera ID	ID - - - - - - - - - -	Y	Y	NO

Figure 19.31 Camera ID

Shutter speed (Figure 19.32)

Nothing on this page selects the shutter speeds in use. It simply chooses which are available via the front, covered, switch on the camera.

Figure 19.32 Shutter speed

		Factory	Sony UK	PW
Shutter	CLS	Y	Y	Y
Speed	EVS	Y	Y	N
	1/60	Y	Y	Y
	1/125	Y	Y	Y
	1/250	Y	N	Y
	1/500	Y	N	N
	1/1000	Y	N	N
	1/2000	Y	N	N

This is a bit of a strange one, especially for cinematographers from the film world. When filming the shutter speed always relates, in some way, to the number of frames being taken per second, most film cameras having a standard shutter opening of 180°. Therefore the shutter speed will be half the frame rate – 100 frames per second giving a 200th of a second exposure. With some film cameras it is also possible to vary the opening of the shutter to less than 180°, further complicating the issue.

With a video camera, barring a few exceptions developed for slow-motion sport analysis, the number of complete frames taken per second will always be, with the PAL system, 25 per second and, with the NTSC system, 30 per second. This frame-taking rate remains a constant.

Given all this, we now have to accept that the shutter speed on these cameras is much more akin to a still camera – independent of frame rate. So what is happening is that the various settings show how long it will take to scan a whole frame while always taking 25 frames per second for PAL and 30 frames per second for NTSC.

The various shutter settings are useful if trying to catch the frame rate of another scanning device, such as a computer or a television running on another standard to the camera. If you wish to reduce motion blur in circumstances where you are inputting the images into a postproduction procedure it could be advantageous to have them perfectly sharp. Motion blur can be added later after the image has been manipulated so that the composite picture will then appear to have a homogenous motion blur.

The lines you can select to flick through via the front switch on the camera are:

- CLS, standing for clear scan. This setting will depend on whether your camera is supplied for PAL 50 Hz or NTSC 60 Hz recording. Either way it will be the best setting for photographing a television set running on the same standard. This is a most useful tool. Keep it available via the front switch.
- EVS, standing for Enhanced Vertical Definition, increases the vertical resolution of the image and may be useful for rare shots that are to go into a lot of computer adjustment but check with the postproduction house first. I would never use this setting for normal cinematography.

There are now six shutter speeds which you can add to those quickly available via the switch on the front of the camera. They are 1/60th, 1/125th, 1/250th, 1/500, 1/1000 and 1/2000. I find I sometimes use the first three and rarely use the second three, so in the cause of simplicity I keep the first three available and leave the second three buried in the menu where I can always find them in an emergency.

Clearscan (Figure 19.33)

Clearscan is activated via the shutter switch at the front of the camera. The speed should be set at the timing that will most likely allow you to photograph the image on a domestic television in the country in which you are based. In the UK 50.2 seems to be very satisfactory.

Figure 19.33 Clearscan

		Factory	Sony UK	PW
Clearscan	—,- Hz	50.2	68.8	50.2

The speeds are set, not as on the Shutter speed page in fractions of a second, but as a frequency, or cycles per second, shown as Hz (for Hertz, the German physicist who thought up the concept of frequency).

! LED (Figure 19.34)

This, the last of the thirty-four pages, just sets the parameters for the warning light in the viewfinder, a light-emitting diode (LED), which has an exclamation mark on it and is designed to come on in the circumstances described on each line. If a setting is OFF the end of the line remains blank and if it is ON a star appears at the end of the line.

Figure 19.34 ! LED

		Factory	Sony UK	PW
! LED	Gain	Y	Y	Y i.e. *
	Shutter	Y	Y	Y i.e. *
	White Preset	N	N	N
	Extender	Y	Y	Y i.e. *
	Filter	N	N	N
	A. iris override	N	N	N

My preference is to leave these settings just as the factory set them, though I sometimes switch OFF the extender warning.

20
The Sony DVW 790 menus – quick reference list

The page control wheel
Set-up card
 Read > Camera
 Write > Card
 ID Edit
 Write protect
 White detail read
Function 1/2
 Detail
 Test out
 Skin detail
 Aperture
 Matrix
 Gamma
 Black gamma
 Test sawtooth
 Chroma
Function 2/2
 Genlock
 Cam ret.
 Filter inhibit
 Field/frame
 Auto iris override
 DCC function select
 Rear BNC Out
 VTR mode
 Record inhibit (CCU)
 Assign switch
Widescreen
 16:9/4:3
 Viewfinder aspect ratio
 Box/4:3/14:9

 16:9 bars ID
 16:9 viewfinder ID
VF setting
 Zebra 1 detect level
 Zebra 1 aperture level
 Zebra 2 detect level
 Zebra select
 VF detail level
 Test out zebra
Level 1 16:9
 Detail level
 Horizontal/vertical
 Horizontal detail frequency
 Crispening
 Aperture level
 Detail white clip
 Detail vertical black clip
 Detail horizontal black clip
 Level depend
 Level depend level
Level 2 16:9
 Knee aperture
 Knee aperture level
 Detail comb
Level 2 4:3
 Detail level
 Horizontal/vertical
 Horizontal detail frequency
 Crispening
 Aperture level
 Detail white clip
 Detail vertical black clip

Level 2 4:3 (continued)
Detail horizontal black clip
Level depend
Level depend level
Level 2 4:3
Knee aperture
Knee aperture level
Detail comb
Level 3
Skin tone detail
Suppression level
Skin tone detect
Saturation, hue and width
Skin tone indicator
Level 4
Master black
Master gamma
Master black gamma
Knee point
Knee slope
Knee saturation
Knee saturation level
Knee
White clip
White clip level
Level 5
Burst level
Burst phase
R-Y
B-Y
R-Y level
B-Y level
R-Y level 4:3
Level 6
RGB level
RGB sync
RGB set up
ENC Y level
ENC Y sync
ENC Y set up
RGB level 4:3
ENC level 4:3
Test out
Level 7
R, G, B black
R, G, B flare
Test out
Level 8
Gamma table
Master gamma
R gamma, G gamma and B
 gamma
Black gamma range
Master black gamma

R blk gamma, G blk gamma
 and B blk gamma
Level 9
Matrix
Matrix table
Detect colour
Axis number and saturation
Matrix area indicator
Multi matrix
Level 10
Matrix
Matrix table
R-G
R-B
G-R
G-B
B-R
B-G
Level 11
H phase
SC phase
SC 0/180 select
SC-H
Level 12
Iris mode
Iris weight
Iris speed
Clip highlights
DCC adjust
DCC range
Point
Gain
Offset white
Offset white A
Warm-cool A
Fine A
Offset white B
Warm-cool B
Fine B
Preset white
Colour temperature P
Fine
R gain
B gain
Operation 1
R-G/B-G select
Gamma table
Low light
Low light level
Select bars
White B channel
Battery warning
Wide auto white balance
Zebra

Operation 1 (continued)
 Turbo switch independent
Operation 2
 Auto white balance level gate
 Record tally
 Time code display
SG adjust
Encoder adjust
Data reset
 User
 Engineer
Menu select 1
 Marker 1/2
 Marker 2/2
 Marker 3/3
 Viewfinder display 1/2
 Viewfinder display 2/2
 Master gain
 Shot ID
 Shot display
 Shutter
 ! LED
Menu select 2
 Set up card
 Function 1/2
 Function 2/2
 Viewfinder setting
 Widescreen
 Level 1 (detail)
 Level 2 (detail)
 Level 1 (4:3)
 Level 2 (4:3)
Menu select 3
 Level 3 skin detail
 Level 4 knee
 Level 5 enc.
 Level 6 enc.
 Level 7 blk/fir
 Level 8 gamma
 Level 9 matrix
 Level 10 matrix
 Level 11 SC/H
 Level 12 Auto iris
Menu select 4
 White shading
 DCC adjust
 Offset white
 Preset white
 Operation 1
 Operation 2
Menu select 5
 SG adjust
 ENC adjust
 Data reset

 Cameraman 1–5
Marker 1/3
 Safety zone
 Safety area
 Centre
 Centre horizontal
 Centre vertical
Marker 2/3
 Box cursor
 Box width
 Box height
 Box horizontal position
 Box vertical position
Marker 3/3
 Test out mix
 Return mix
 Test out viewfinder display
 Test out menu
 RM viewfinder inhibit
Viewfinder display 1/2
 Display mode
 Extender
 Zoom
Viewfinder Display 2/2
 Filter
 White
 Gain
 Shutter
 Tape
 Iris
 Audio
Master gain
 Low
 Medium
 High
Shot ID
 ID-1
 ID-2
 ID-3
 ID-4
Shot display
 Date
 Time
 Model name
 Serial no.
 Cassette no.
 Shot no.
 ID select
Shutter speed
 CLS
 EVS
 1/60
 1/125
 1/250

Shutter speed (continued)
 1/500
 1/1000
 1/2000
! LED
 Gain
 Shutter

White preset
ATW run
Extender
Filter 2, 3, 4
Filter A, C, D
Auto iris override

21
The Sony DVW 790 menus

The menu system in the Sony DVW 790 is similar to the DVW 700 but there are some changes to the layout and position of certain lines and pages. Some functions remain very similar but are now called by different names. There are over forty pages of menus in the DVW 790.

In the figures the last three columns are labelled Factory, Sony UK and PW. These refer to the recommended settings that the camera comes set with direct from the factory; the setting currently recommended by Sony UK and the third column shows my own preferred settings.

The main change from the earlier camera is the ability to scroll through the menu pages using a small knurled wheel at the front of the camera. This wheel will drive the menu pages both forwards and backwards which speeds up access to the pages immeasurably. In addition a 14×9 box is now a switchable option in the viewfinder so you no longer have to draw your own. There is considerably more control over the way the automatic exposure system controls the iris and there is a whole new page allowing one to offset a white balance either colder or warmer than a straight balance.

The headings that follow are listed in the order, and with the page headings, of the Sony DVW 790. All the menu pages are shown and discussed. While this may seem unnecessary as many of the pages are similar to those in the DVW 700 described in Chapter 19, and therefore many of my comments and recommendations are simply repeated here, it would be just too confusing to have to cross-refer between chapters while setting up a DVW 790. Lines of the menu that are the same in both cameras will be shown, in this chapter only, in normal font and new lines, or ones used differently, are in bold italics.

As mentioned, the DVW 790 has a control not found on the DVW 700. At the front of the camera, below the lens and on the edge of the operator's side, there is now a knurled wheel (see Figure 21.1). This wheel has two ways of being operated. It will rotate and, as it does, will scroll through the menu pages. Turning the wheel clockwise progresses through the pages in the order prescribed in the software in use on the camera you have. There are various versions of the software, and the one described here is in the camera I have used most recently. The wheel can also be pressed in as if it were a click switch.

Figure 21.1 DVW 790 page control wheel

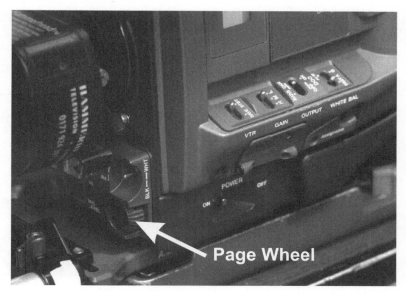

Page Wheel

To access the engineering menu first ensure the camera is switched off, hold the wheel in its clicked-in position and switch on the camera. The menu is now in engineering mode. If you lower the door marked Menu this reveals a metal switch. Pressing this switch down will now cause the menu to appear in the viewfinder. As well as using the wheel to progress through the pages the metal switch can be further depressed on a spring return, just as on the DVW 700, as an alternative way to progress through the menu pages.

Having spun the wheel to provide the page you wish to access, press the switch in. Turning the wheel will now cause the cursor to move up and down the lines on the page. Having moved the cursor to the line you wish to set, click the switch in again and a question mark will appear next to the value on that line. Rotating the knurled switch will now change the values. When you have set the value you require, click the switch in again and the question mark will disappear and the value will have been set. Now rotate the wheel and bring the cursor back to the top of the page where the page title lies. Click the switch in once more and the wheel has returned to its original function of scrolling from page to page.

All this may sound complicated but it quickly becomes second nature.

Set-up card (Figure 21.2)

The set-up card allows you both to read a card to the camera and to write a card from the camera settings to a set-up card. It also allows you to switch on or off the write protect function. Additionally you can write an ID name on the card from within this page.

To write an ID first scroll the cursor down by rotating the knurled wheel as described above. Then, by clicking in the wheel, work along the boxes that represent the letter spaces (this looks much like the boxes into which you write a credit card number) and then use the wheel's rotational function to sequence through the letters, the numbers 1 to 9 including zero and a number of useful exclamation marks.

Figure 21.2 Set-up card

Set-up card		Factory	Sony UK	PW
	Read > Camera			
	Write > Card			
	ID Edit		Your Name	PW-790-1
	Write Protect :	OFF	ON	ON
	White Data Read	**OFF**	**OFF**	**OFF**

The line labelled 'White data read' enables the A and B balance memories to be stored on the card, a feature not found on the earlier camera.

Function 1/2 (Figure 21.3)

This, the second page in the menus, allows you to switch on or off the whole of the settings on seven of the engineering pages and in this respect it is identical to the DVW 700. The first and fourth lines are now the most useful to the cinematographer for they allow you to switch off the detail settings and the skin tone detail.

Figure 21.3 Function 1/2

Function 1/2		Factory	Sony UK	PW
	Detail	ON	ON	ON
	Test Out	**ENC/R/G/B**	**ENC**	**ENC**
	Aperture	ON	ON	ON
	Skin detail	OFF	OFF	OFF
	Matrix	ON	ON	ON
	Gamma	ON	ON	ON
	Black Gamma	**OFF**	**OFF**	**ON**
	Test sawtooth	OFF	OFF	OFF
	Chroma	ON	ON	ON

Detail

This switches ON or OFF the overall detail setting.

Test out

This line is new on the 790 and reads 'Test out' and enables a choice, for line-up purposes only, of ENC, an encoded picture, or Red, Green or Blue alone to be selected from this page. I recommend you keep this set to ENC.

Aperture

This switches ON or OFF the high frequency detail settings. It is best left ON.

Skin detail

This, the fourth line, switches ON or OFF skin tone detail settings and is the most used switch on this page during a shoot. If you imagine you are shooting a scene between your heroine and your hero, by simply using this on/off switch you can make your heroine look younger and more beautiful – with skin tone detail on – and your hero more manly and rugged – switch skin tone detail off.

Matrix

Leave this in the ON position. Switching it OFF severely desaturates the image.

Gamma

Leave this switch ON. Switching it OFF gives heavily black crushed pictures which just might be useful if you are trying to shoot day for night.

Black gamma

This is another new line. Black gamma can be used to stretch the blacks. Similar settings can be found on the page labelled 'Level 8'.

Test sawtooth

This is an engineering test signal. Leave it switched to OFF.

Chroma

Switching this setting to OFF will send a black and white picture to the monitor. The picture recorded on the tape will still be in colour. I find it best to leave this set to ON.

Function 2/2 (Figure 21.4)

Page Function 2/2 is not an often-used page once the parameters have been set to your liking. The first five lines are identical to the 700 and read as follows.

Figure 21.4 Function 2/2

		Factory	Sony UK	PW
Function 2/2	Genlock	ON	ON	ON
	Cam. ret.	OFF	OFF	OFF
	Filter inhibit	OFF	OFF	ON
	Field/frame	FLD	FLD	FLD
	A. Iris Override	OFF	OFF	ON
	DCC func. select	*DCC/FIX*	*DCC*	*DCC*
	Rear BNC out	*VBS/SDI*	*VBS/SDI*	*VBS*
	VTR Mode	*OFF*	*OFF*	*OFF*
	Rec. inhibit (CCU)	*ON*	*ON*	*ON*
	Assign switch	*OFF*	*LOOP-REC*	*REC*

Genlock

Genlock simply denotes whether you wish to send a genlock signal to the BNC socket on the non-operator side of the camera. There is no disadvantage in feeding this BNC outlet when it is not in use so the safe option is to leave it switched on.

Cam. ret.

Switching this ON sends the signal on the genlock connection back to the viewfinder. You rarely require this so set it to OFF.

Filter inhibit

The filter inhibit switches off the facility that allows each position on both the filter wheels to have a separate white balance on the A and B preset switch. If left OFF each filter setting will have its own white balance setting so if the ND wheel is turned, for instance, the colour balance might change. I think this foolish as I always wish the colour balance to remain consistent on any ND setting so I set this parameter to ON.

Field/frame

To entitle this line Field/frame is a slight misnomer. Set to the FLD (field) position the camera will function as normal scanning the lace and interlace fields alternately just as one would expect. Set to the FRM position, the camera does not scan a frame in the sense that we are becoming accustomed to with high-definition cameras, that is, scanning each frame sequentially and in a consecutive order. What the FRM setting does give you is an increase in motion blur. I have used this very successfully for dream or memory sequences.

Auto iris override

Auto iris override ON allows the exposure compensation level which can be set in half-stop intervals. I believe these cameras overexpose, to my eye at least, by around a half a stop so I have adjusted this on page 9/9 and here switch that adjustment ON.

All the above lines on this page are identical to the DVW 700 but five new ones are added. They are as follows.

DCC func. select (Dynamic contrast control function select)

You can now choose to have the DCC switched on or off from within the menus using this line. Setting it to DCC will have the effect of switching it on and to FIX will switch it off.

Rear BNC out

There is a new option with the DVW 790 that allows you to have an internal PCB board to allow a direct feed of serial digital video to an external video recorder or monitor. If you have this board fitted and wish to feed the external recorder or monitor via the BNC socket at the rear of the camera set this line to SDI. If your monitor is capable of interpreting a serial digital feed you will get an improved picture quality. If you wish the rear BNC to feed a conventional monitor set this line to VBS. You can also arrange for there to be no output from this socket by setting the line to OFF.

VTR mode and rec. inhibit (CCU)

Both these lines are only for use when you are using an external VTR.

Assign switch

This assigns a function to the new assignable switch on the side of the camera. I usually set this to REC which makes this button a useful additional run switch.

Widescreen (Figure 21.5)

This page, with the exception of the first line, sets up the viewfinder for the two different aspect ratios available in the DVW 790's menus. All the lines are the same as on the DVW 700 but some of them have added facilities.

Figure 21.5 Widescreen

		Factory	Sony UK	PW
Widescreen	16:9 / 4:3	16:9	16:9	16:9
	VF Aspect	*Auto/4:3/ 16:9A/16:9B*	*16:9B*	*16:9B*
	Box / 4:3 / 14:9	*Box*	*14:9*	*14:9*
	16:9 bars ID	OFF	ON	ON
	16:9 VF ID	OFF	OFF	OFF

16:9/4:3

This, the first line, should be set to the aspect ratio you are planning to use.

VF aspect

The second line still switches the viewfinder automatically to the aspect ratio the camera has been set to work in but now has, as a switchable option, the ability to set a grey overlay at the sides of the image which is not being used in the composition being recorded. This means that if you are shooting in 4×3 you can see the composition perfectly clearly but under the grey area see an extra image which is not being recorded. Many cinematographers from the film world will greatly appreciate this as most film cameras show, in the optical viewfinder, a larger image than that being taken by the film and this warning area greatly aids camera operation as one can see an actor approaching the edge of frame before they enter the frame.

Box/4:3/14:9

The line allows you to either display a 4:3 frame in the viewfinder or a 14×9 box cursor facility which will be much appreciated in the UK where currently on analogue transmitting the frame will be shown on a 4:3 television as 14:9 with small black bars top and bottom of the frame. UK digital transmissions are in the full 16:9 format as recorded.

16:9 bars ID

This is most useful as in the ON position it will cause a small title '16:9' to appear in the bottom-right of the screen whenever bars are recorded and at no other time. This tells everyone down the postproduction line the format in which the images were originated.

16:9 VF ID

This controls whether the viewfinder has 16:9 displayed in it at all times. I keep this off, as I like as little information distracting me in the viewfinder as possible.

VF setting (Figure 21.6)

Zebra 1 det. level

The Zebra 1 detection level sets the point, as a percentage of overall brightness, which is the central point at which the zebra warning in the viewfinder operates for the first zebra. The range is from 20 per cent to 107 per cent, I set this to 95 per cent.

Figure 21.6 Viewfinder setting

		Factory	Sony UK	PW
VF Setting	Zebra 1 det. Level	70 (20-70)	70	95
	Zebra 1 apt. level	10 (1-20)	10	10
	Zebra 2 det. Level	100 (52-109)	95	100
	Zebra select	1 / 2 /	Both	Both 1
	VF detail level	0	0	0
	Test out zebra	OFF	OFF	OFF

Zebra 1 apt. Level

The Zebra 1 aperture level defines the range of image brightness over which the zebra effect will be overlaid onto the viewfinder image. This is, again, expressed as a percentage but is a range of brightnesses over which the zebra will appear. The range can be set anywhere between 1 and 20, so if you set the range at 8 the zebra will appear in the viewfinder over any brightness that falls within 4 per cent below the set Zebra detect level and 4 per cent above that figure. For my recommended setting of 10 at a level of 70 the zebra will be overlaid at any brightness that falls within the range 65–75 per cent. As I stated in Chapter 19, I don't favour using this intermediate zebra as I find it a confusion in the viewfinder and the line 'Zebra select' on this page deals with that.

Zebra 2 det. level

The Zebra 2 detect level does not have an associated range settings for it always works from peak white down to the level set. I, Sony UK and the BBC feel that this is best set at 95 per cent so the zebra will show in the viewfinder when the image brightness lies anywhere within the range from 95 per cent up to peak white. I say 'peak white' as this is not always 100 per cent. You will see I set my white clip level at +5 which sets peak white at 103 per cent.

Zebra select

Here you can set Zebra 1 to show in the viewfinder or Zebra 2 or both. My preference is to show Zebra 2 only as on this camera it is the only one that can be set to only show when that part of the image is about to become overexposed.

VF detail level

The viewfinder detail level allows you to force an increase in detail in the viewfinder without in any way affecting the recorded image. This can be helpful in finding sharp focus. My feeling is that for most of the time it gives a false impression and is disturbing, but I know many operators who like a little increase in detail in their viewfinder.

Test out zebra

This additional facility allows you to add the zebra effect to the image coming out of the Test out BNC socket on the camera. Adding it to the signal exiting this socket does not add the zebra to the recorded image.

Level 1 16:9 (Figure 21.7)

This and page Level 2 16/9 are two of the most important pages for the cinematographer for they set most of the parameters that affect sharpness and definition. Each line will be discussed individually. It should be noted that page Level 1/9 16:9 only sets the parameters when the camera is in 16:9 mode. It does not set the parameters when the camera is in 4:3 mode.

Figure 21.7 Level 1 16:9

Level 1 16:9		Factory	Sony UK	PW
	Detail Level	*0*	*-5*	*-5*
	H/V	*0*	*0*	*0*
	H dtl. Freq.	*0*	*80*	*25*
	Crispening	0	0	0
	Aperture Level	*0*	*40*	*-40*
	Dtl. white clip	*0*	*0*	*0*
	Detail V black clip	*0*	*-5*	*-5*
	Detail H black clip	*0*	*-20*	*-20*
	Level depend	*ON/OFF*	*ON*	*ON*
	Level dep. Level	*0*	*0*	*0*

Detail level

The first thing to note is that for this setting a minus number reduces the apparent detail, just as you would expect. Be warned: this is not so on all the settings on all the pages, Sony having a curious attitude to the plus and minus signs. Altering the detail level will affect the whole of the picture area irrespective of the colour, density or the thickness of the line of detail. My most often-used setting is –5 but I have worked with it as high as –30. This is something you must choose for yourself and it is very easy to see the changes on a monitor as you make the adjustments.

H/V

This line sets a balance between the horizontal detail level and the vertical detail level. I leave it set to zero.

Horizontal detail frequency (shown on screen as H dtl. freq.)

This is similar to the previous setting with the exception that it affects only the horizontal component of any part of the image and does this by adjusting the maximum, or peak frequency, to which the horizontal detail will be allowed to rise. Again I urge caution when adjusting this setting. Higher numbers increase detail in fine edges. I have recently started trying this setting at 25.

Crispening

For once the effect produced by adjusting this setting is much like its descriptive word but what is adjusted on the screen concerns mid-range detail rather than heavy or very fine lines. The technical term for this effect is Noise Coring. This setting again brings into question Sony's attitude to mathematical signs as you add positive value to the setting to reduce the apparent detail. I nearly always leave this setting at 0.

Aperture level

This is where you can affect the amount of fine detail in an image. Try setting it to zero, compose a close-up of a middle-aged person then watch the smile lines at the corners of the eyes decrease as you take down the setting. Remember, you will have a version of this setting on the page dealing with skin tone detail so you don't have to get all the effect you want here. This setting affects all the fine line detail in the whole of the picture. I usually leave this setting at 40.

Detail white clip (shown on screen as Dtl. white clip)

This setting reduces the white edges of an image. It is particularly noticeable where something pale in colour and density lies next to something dark. Most of the time I leave this set at 0.

Detail V black clip

This setting reduces the detail of black edges on vertical detail. I like Sony UK's setting of –5.

Detail H black clip

This setting reduces the detail of black edges on horizontal detail. I like Sony UK's setting of –20.

Level depend and Level depend level

Together these two lines affect the edges in the dark and very dark areas of the image, that is, those that are ignored by the detail corrector. Using this facility may help avoid noise in the blacks.

The first of the lines is a simple ON/OFF switch for the facility and the second adjusts the position along the sensitometric curve up to which it will be effective. I usually leave it set to ON and zero.

Level 2 16:9 (Figure 21.8)

Knee aperture

This line simply switches this facility ON or OFF. I usually set it to ON.

Figure 21.8 Level 2 16:9

Level 2 16:9		Factory	Sony UK	PW
	Knee Aperture	ON	ON	ON
	Knee Aperture Level	*0*	*0*	*14*
	Detail Comb	*0*	*0*	*0*

Knee aperture level

In video parlance the knee of the sensitometric curve, that is, the top of the curve, is where the highlights live. Therefore adjusting this setting puts detail into the compressed highlights of the picture. Film cinematographers should remember that in the video world the sensitometric curve is always for a positive image, therefore the higher end of the curve deals with highlights and the lower deals with the shadows. This is quite the reverse of what a film cinematographer is usually looking at, for this sensitometric relationship occurs, for them, only in a negative image. My normal setting is –4.

Detail comb

The Detail comb filter does not have any effect when shooting in the PAL format. When shooting in NTSC introducing it reduces aliasing as a side-effect of detail correction. I suggest you set it to 0.

Level 1 4:3 and Level 2 4:3

I have not included any figures for these two pages as they are identical to the 16:9 pages with just the caption 16:9 changed to 4:3. This said, it may be necessary to have the levels set a little higher in 4:3 mode than in 16:9 if you wish to reproduce the same effect. You will need to experiment to find the best settings.

Level 3 (Figure 21.9)

This page, with its slightly different approach, takes over from the page labelled Level 2/9 in the DVW 700.

Figure 21.9 Level 3

Level 3		Factory	Sony UK	PW
	Skin tone detail	*OFF*	*OFF*	*OFF*
	Suppression lvl.	*0*	*50*	*50*
	Skin tone detect	*OFF/EXEC*	*OFF*	*OFF*
	Saturation	*0*	*0*	*0*
	Hue	*0*	*0*	*0*
	Width		*0*	*0*
	Skin tone ind.	*OFF*	*OFF*	*OFF*

Skin tone detail

This is simply an on/off switch for the Skin tone detail function.

Suppression lvl.

Suppression level is a new way of describing the effect of the DVW 700's line called Skin tone detail. It now works in higher numbers and a good starting point would seem to be Sony UK's recommendation of 50.

Skin tone detect

Here we have a completely new and very useful control. Simply by pointing at the skin tone you wish to alter and pressing the EXEC (execute) control you can set this parameter. If you are not currently using this facility leave it set to OFF.

Saturation, Hue and Width

All these settings allow you to manually set the skin tone to be targeted.

Skin tone ind.

If the skin tone indicator is switched to ON a marker pattern will appear over the areas of the image which will be altered by the skin tone detail effect. This marker will appear both in the viewfinder and on the image coming out of the Test out BNC socket. It will never appear on the recorded image.

Level 4 (Figure 21.10)

This page covers everything in the DVW 700's page 3/9 and is dedicated to matters which a film cinematographer would consider the basic sensitometric parameters of the image to be recorded. As I have mentioned before, if you come from a film background please remember that you are dealing with a positive image, so in this context the knee affects the highlights. The knee (the top of the sensitometric curve) is the word used in video parlance for that which a film cinematographer is used to referring to as the shoulder. The toe in film parlance is normally referred to in the video world as peak black. Would it be cruel of me to comment at this point that perhaps it is the much shorter tonal range that can be recorded on tape as against film which causes technicians to refer to the upper end of the video curve as the knee whereas in film one can reach right up to the shoulder? Perhaps, perhaps not.

Figure 21.10 Level 4

Level 4		Factory	Sony UK	PW
	Master black	*0*	*0*	*-2*
	Master gamma	*0*	*-5*	*-10*
	Master blk. gamma	*0*	*0*	*20*
	Knee Point	*0*	*85*	*90*
	Knee slope	*0*	*40*	*40*
	Knee saturation	*ON*	*ON*	*ON*
	Knee saturation lvl.	*0*	*0*	*0*
	Knee	ON	ON	ON
	White clip	ON	ON	ON
	White clip level	*0*	*+5*	*+5*

Master black

This setting controls how much the black areas are either stretched or crushed. For most work I think the factory setting obtains the most natural blacks that are available so I leave the factory setting at zero. I sometimes introduce a small change to –2.

Master gamma

This parameter either stretches or crushes the mid-tones of the scene. Setting it at values of –5 and –10 can be useful.

Master blk. gamma

The Master black gamma line allows you to adjust the initial gain in the lower end of the Gamma curve which deals with the blacks. Occasionally I set this to 20.

Knee point

This sets the point at which the whites will start to roll-off or compress into peak white. I think Sony UK's setting of 85 per cent is a good starting point though I frequently raise this to 90 per cent.

Knee slope

This setting decides how quickly the highlights or whites roll-off or are compressed. Again Sony UK's setting of 40 per cent is a fine starting point.

Knee saturation and Knee saturation level

These settings deal with this camera's ability to restore the colour saturation within overexposed highlights. This could be a very valuable new facility compared with the DVW 700.

Knee

This is simply an ON/OFF switch to decide whether you wish to affect the knee of the gamma curve, I do, as I like a slight roll-off into the whites and therefore keep this line set to ON.

White clip

This line of the setting simply allows you to chose if you would like to adjust the point at which the image highlights will, as they rise in value, switch or clip to peak white. I set this to ON.

White clip level

If you set the level of white clipping too high you are in danger of over-modulating the high end of the video signal. This may have several effects. First, you may get some curious noises or unnatural responses in your brightest whites as there will be a signal there of a value higher than

the camera's or the VCR's circuitry can handle. Second, if this is set higher than a normal signal should ever reach you may get complaints from the transmission station or even have them refuse to transmit your material. It should not happen these days but in times past an over-modulated highlight could blow a transmission valve. This did not make you popular.

If you set the level too low you are unnecessarily reducing the tonal range of your recording.

As I am always looking for ways to extend either the actual or apparent tonal range of the image I set this value at +5 which allows a maximum level of video signal of 103 per cent to go through the system. An extension of only 3 per cent on the total tonal range may not, of itself, seem very significant but I come from the school of thought that believes that every little helps, and at this 103 per cent setting I have never received a complaint of highlights overmodulating.

Note that the settings are slightly different from those on the DVW 700.

Level 5 (Figure 21.11)

This is the page that deals with PAL coder alignment, it is strictly a page only to be adjusted in the workshop. It is different from and replaces page 4/9 in the DVW 700.

Figure 21.11 Level 5

Level 5		**Factory**	**Sony UK**	**PW**
	Burst level	*0*	*0*	*0*
	Burst phase	*0*	*0*	*0*
	R-Y	*ON*	*ON*	*ON*
	B-Y	*ON*	*ON*	*ON*
	R-Y level	*0*	*0*	*0*
	B-Y level	*0*	*0*	*0*
	R-Y level 4:3	*0*	*0*	*0*

Level 6 (Figure 21.12)

This is a new page which is for maintenance use only.

Figure 21.12 Level 6

Level 6		**Factory**	**Sony UK**	**PW**
	RGB Level	*0*	*0*	*0*
	RGB sync	*0*	*0*	*0*
	RGB set up	*0*	*0*	*0*
	ENC Y Level	*0*	*0*	*0*
	ENC Y Sync	*0*	*0*	*0*
	ENC Y set up	*0*	*0*	*0*
	RGB Level 4:3	*0*	*0*	*0*
	ENC Y Level 4:3	*0*	*0*	*0*
	Test out	*Enc*	*Enc*	*Enc*

Level 7 (Figure 21.13)

This, in the main, replaces page 5/9 in the DVW 700. I leave all the settings at 0.

Figure 21.13 Level 7

Level 7		Factory	Sony UK	PW
	R Black	0	0	0
	G	0	0	0
	B	0	0	0
	R Flare	0	0	0
	G	0	0	0
	B	0	0	0
	Flare	ON	ON	ON
	Test out	0	0	ENC

Level 8 (Figure 21.14)

This page replaces page 5/9 in the DVW 700 though it handles matters relating to Gamma slightly differently.

Figure 21.14 Level 8

Level 8		Factory	Sony UK	PW
	Gamma Table	*A/B/C/D/F*	*F*	*B*
	Master Gamma	*0*	*0*	*10*
	R Gamma	*0*	*0*	*0*
	G Gamma	*0*	*0*	*0*
	B Gamma	*0*	*0*	*0*
	Blk gamma range	*Low/Mid/High*	*Low*	*HI*
	Master blk gamma	*0*	*0*	*20*
	R blk gamma	*0*	*0*	*0*
	G blk gamma	*0*	*0*	*0*
	B blk gamma	*0*	*0*	*0*

Gamma table

The DVW 790 has a more useful range of preset Gamma tables.

The first, A, is the Sony factory setting. The second, B, is very much the same as before in that it gives an initial high gain in order to increase the information in the very dark areas of the scene. It is, in fact, both the BBC's and my preferred setting. Setting C gives a medium initial gain which, while useful, I feel is not effective enough. Setting D is something of a quandary as I can't quite see what it is trying to achieve so you will have to look at the effect of this setting for yourself. The last setting, F, represents a single internal version of the old Film set-up cards. It may be very useful to have an on-board film look that can simply be switched in.

Master gamma

Adjusting this setting lifts or crushes the middle tones in the image. In effect it alters the rate of change of one tone relative to another in what, in film terms, would be considered the straight-line section of the sensitometric curve. I tend to prefer it set to 10.

R gamma, G gamma and B gamma

These three lines give a colour offset to the mid-range brightness, each line controlling a single colour red, green or blue.

Black gamma range

Low, Mid or High describe the range over which the gain in black gamma works. For Low the range that will be affected will be 0–7.2 per cent of the total brightness range. The Mid range extends from 0 per cent to 14.4 per cent and the High range works over the range 0–28.2 per cent.

Master blk gamma

Master black gamma changes the gain of the black end of the gamma curve. I often set this at 20.

R blk gamma, G blk gamma and B blk gamma

These three lines adjust, one colour at a time, a colour offset to the low-luminance or dark areas of the image.

Level 9 (Figure 21.15)

The first two lines behave very much as their twins in the DVW 700's page 8/9. The subsequent six lines are new features which allow you to target a particular colour or hue and alter just that area of the image. For instance, you could target pale-green grass and increase its saturation to make it look more lush or change its hue, I'm told one can achieve purple grass, though I have never felt the need to try this.

Figure 21.15 Level 9

Level 9		Factory	Sony UK	PW
	Matrix	*OFF*	*OFF*	*ON*
	Matrix Table	*A/B*	*A*	*B*
	Det Colour	*OFF/ON*	*OFF*	*OFF*
	Axis Number	*B/Mg/R/Yl/G/Cy*	*-*	*B*
	Saturation	*0*	*0*	*0*
	Hue	*0*	*0*	*0*
	Matrix area ind.	*OFF*	*OFF*	*OFF*
	Multi Matrix	*ON*	*OFF*	*ON*

Matrix

The Matrix line simply switches ON or OFF the effect of the rest of the page. I set it to ON.

Matrix table

As in the DVW 700's page 8/9, this allows you to swap between two pre-chosen matrix tables which are designated A and B. I tend to set it to B where I have my preferred settings.

Det. colour

This line allows you to target a particular colour and then change the hue and saturation of that colour in the picture. To do this make the setting EXEC.

Axis number and Saturation

Within the way the video image is controlled the colour spectrum is divided into 12 sectors each of which can be assigned a value both for hue and saturation. These values are known as their hue and saturation offset. The colours shown in the menu are B – Blue, Mg – Magenta, R – Red, Yl – Yellow, G – Green and Cy – Cyan.

Matrix area ind.

This is the Matrix area Indicator and allows you to overlay the picture with a zebra-type pattern only on the areas which will be affected by this page.

Multi matrix

This is simply an on/off switch for the last five lines.

Level 10 (Figure 21.16)

For a film-based cinematographer the purpose of this page might be very hard to grasp. Fear not. First, and unusually for these pages, you have two tables of settings between which you can easily switch. Second, if you change all the values on each line identically all you will change is the overall colorimetry. In film-speak that means if you go into negative figures you will be reducing the colour saturation. With these minus values this is something akin to using a low-contrast filter but with absolutely no loss in definition. I find it hard to imagine a film-based cinematographer wanting to increase the saturation except in unusual circumstances, perhaps for a special effect. To do this you go into positive values.

Figure 21.16 Level 10

Level 10		Factory	Sony UK		PW	
	Matrix	ON	ON		ON	
	Matrix table	A	A	B	A	B
	R-G	0	0	10	0	−7
	R-B	0	0	0	0	−7
	G-R	0	0	10	0	−7
	G-B	0	0	0	0	−7
	B-R	0	0	10	0	−7
	B-G	0	0	0	0	−7

It is important to realize that, in Europe, there is a European Broadcasting Union (EBU) standard and a Sony DVW 790 camera, when set up for PAL transmission, will abide by the EBU standard with all the settings at zero.

I find the sensible thing is to set Matrix table B to my preferred setting and, normally, leave Matrix table A at the Factory and EBU, zero, settings. If I then want to produce a special effect I will switch to, and alter, Matrix table A for after I have finished shooting the unusual scene I can easily remember that I should return all the settings in Matrix table A to zero.

Altering a line in a Matrix table page changes a relationship between two colours. For instance, changing the second line, R–G, will alter the

red component relative to the green component. If you understand a vector diagram you will know what this looks like on an oscilloscope. If you don't, don't worry, simply accept that the red value will change a lot and the green value very little. This goes for all the other lines: the first colour in the ratio will change a lot and the second very little.

While I very rarely change these settings from my preferred values, fiddling about with them can be very interesting. But be warned, leave yourself plenty of time. This is not an experiment to be undertaken in the heat of a shooting schedule.

My normally preferred settings, set within Matrix table B, are for all lines to be at −7 for I have found I like a slight overall reduction in saturation. If you prefer a slight overall warming try setting the six lines to 10, 0, 10, 0, 10 and 0 as shown in the Sony UK column.

Just one more note. Changing these values does not affect black, white or the grey scale, it affects only the colour saturation.

With the addition of a complete on/off switch on the first page this is identical to page 8/9 in the DVW 700's menu.

Level 11 (Figure 21.17)

This is the equivalent of part of the DVW 700's page 9/9. It is for factory use only and should be left well alone.

Figure 21.17 Level 11

Level 11		Factory	Sony UK	PW
	H phase	*0*	*0*	*0*
	SC phase	*0*	*0*	*0*
	SC 0/180 select	*0/180*	*0*	*180*
	SC-H	0	0	0

Level 12 (Figure 21.18)

Figure 21.18 Level 12

Level 12		Factory	Sony UK	PW
	Iris set	0	0	-1
	Iris mode	*0*	*0*	*0*
	Iris weight	*0 to 4*	*0*	*-2*
	Iris speed	*0/1/2/3/4*	*2*	*2*
	Clip highlights	*Off*	*Off*	*ON*

Iris mode

Iris set

This sets the auto iris level. Each unit is the equivalent to half a stop. As I think these cameras overexpose I set this to −1.

The first line of this page comes from page 9/9 on the DVW 700. In the second line, Iris mode, positive figures equal peak weighting and negative figures equal average weighting.

Iris weight

Increases in positive figures in this line increasingly tell the auto iris feature to ignore more and more the top part of the picture. This can be very useful if you wish to ignore the effect of bright skies. Try setting this to −2.

Iris speed

Sets the reaction time of the auto iris. Higher numbers will make the iris react quicker.

Clip highlights

Switching this facility ON tells the auto iris feature to ignore any extreme highlights in the image.

W Shading G, W Shading R and W Shading B

All three of these lines allow a shading correction in the three separate colours and are used to correct individual lenses. This should only be adjusted in the workshop so I have not illustrated them here for they are only a single line each.

DCC adjust (Figure 21.19)

This is exactly the same as in the DVW 700's menu and affects the auto knee adjustment.

DCC stands for Dynamic Contrast Control. The purpose of the DCC is to automatically adjust the knee (the highlight portion) of the sensitometric curve to a slightly different rate of change should the camera detect a large area of very strong highlights so that more information can be recorded in this part of the image.

Figure 21.19 DCC adjust

		Factory	Sony UK	PW
DCC adjust	D. range	4	4	-50
	Point	0	0	0
	Gain	0	0	0

I used to think it did not really work, but on a recent shoot in the French Alps, using a DVW 700 camera, I was able to see a considerable improvement in the information on the snow when the DCC was switched ON. I had, of course, adjusted my set-up card to produce better pictures in these circumstances anyway. If you wish to see the DCC's effect, aim the camera at a fluorescent light in the ceiling, leave the iris set to auto and switch the DCC ON and OFF. The switch is the middle position on the Bars/DCC/Camera switch at the front of the camera. You will see more information in the burnt-out section of the tube with the DCC switched ON. I now leave the DCC on all the time for with both cameras, at worst, nothing will happen and a little more information at either of the extremes of the pictures tonal range is always a good thing.

The knee point for DCC is set lower on the DVW 790 than on the DVW 700. It is therefore a lot fiercer than on the old camera and this can cause colours in the highlights to become washed out unless the knee saturation setting is set at ON. If you wish to replicate the effect you were getting on a DVW 700 try making the setting –50.

Offset white (Figure 21.20)

This is a new feature and one which I wholly welcome. It enables you to add or subtract a colour temperature to that achieved by operating the

white balance feature on the camera. You can therefore set preset A to be, say, a little warm and preset B to be a little cool after white balancing to a perfectly white card. The effect is something like putting a ¼ blue filter over the lens when white balancing the camera, thus warming the overall effect when the white balance is completed and the filter is removed, or white balancing to a pale-blue card, for the reverse effect, which gives you a much subtler level of control.

Figure 21.20 Offset white

Offset White		Factory	Sony UK	PW
	Offset wht.A	*OFF*	*OFF*	*OFF*
	Warm-cool A	*0*	*0*	*0*
	Fine A	*0*	*0*	*0*
	Offset wht. B	*0*	*0*	*ON*
	Warm-cool B	*0*	*0*	*40*
	Fine B	*0*	*0*	*0*

Offset wht. A

This simply switches ON or OFF the effect of the colour temperature shift on preset A.

Warm-cool A

This adjusts the colour balance. Positive figures warm the picture and negative figures cool the picture but it only affects this colour temperature as set when the camera is switched to preset A.

Fine A

This adjusts the coarseness of the effect.

Offset wht B, Warm-cool B and Fine B

These have exactly the same effect as the previous three lines but only affect the picture when it has been white balanced with the camera switched to preset B.

Preset white (Figure 21.21)

This is an entirely new facility and one which may prove very useful. It enables you to predetermine the base colour temperature the camera will align to when preset white is selected. It also allows you to give the camera a red or blue bias by adjusting the red gain or the blue gain.

Figure 21.21 Preset white

Preset white		Factory	Sony UK	PW
	Colour temp P	*3200/4300/ 6300*	*3200/4300/ 6300*	*3200/4300/ 6300*
	Fine P	*0*	*0*	*0*
	R Gain P	*0*	*0*	*0*
	B gain P			

Colour temp. P

This line allows you to set the base colour temperature, in degrees Kelvin, to which that the camera will align.

Fine

This adjusts the coarseness of the control.

R gain

Red gain allows you to, independently of all other parameters, adjust the amount of red in the scene. Plus figures will warm the picture.

B gain

Blue gain allows you to increase the amount of blue in the picture and cools the image.

Operation 1 (Figure 21.22)

Figure 21.22 Operation 1

Operation 1		Factory	Sony UK	PW
	R-G / B-G Select	*OFF*	*OFF*	*OFF*
	Gamma Table	*A/B/C/D/F*	*F*	*B*
	Low Light	*OFF*	*OFF*	*OFF*
	Low light level	*0*	*0*	*0*
	Select Bars	*EBU/SNG/SM*	*SMPTE*	*SMPTE*
	White B channel	*AWB/ATW*	*AWB*	*AWB*
	Battery warning	*10% / 20%*	*10%*	*20%*
	Wide AWB	*OFF*	*OFF*	*OFF*
	Zebra	*OFF*	*OFF*	*OFF*
	Turbo sw. indep.	*OFF*	*OFF*	*OFF*

R-G/B-G select

This line deals with the relationship of red to green and blue to green and is for registration measurement only, which will never be carried out in the field as it is strictly a workshop job.

Gamma table

This line selects the gamma table to be used.

Low light

The Low light line is simply an ON/OFF switch for the low light warning light in the viewfinder.

Low light level

This parameter sets the brightness level at which the Low light warning light comes on.

Select bars

Here we have a really useful new feature. The straightforward colour bars used by the EBU have never been anything like as useful for setting up a monitor, or the viewfinder, as have those universally used in the USA. By switching to the US bars, SMPTE (Society of Motion Picture and Television Engineers), the US standards body, one finds that you can use the PLUGE test to set up the monitor. To find out how to do this see Chapter 10 and read the US section.

White B channel

This allows you to set the Pre-select switch B to either AWB (Auto White Balance) or ATW (Auto Tracking White). In the ATW setting the white balance will adjust automatically if, for instance, you track from a day exterior to a tungsten interior.

Battery warning

This is now a simple switch between a warning at 10 per cent or 20 per cent. Documentary cinematographers seem to prefer 10 per cent and I, together with a number of other cinematographers working in fiction, prefer 20 per cent.

Wide AWB

OFF leaves the range over which the Auto White Balance operates as standard, ON increases the range of brightnesses to which it will react.

Zebra

This is only for use with a viewfinder without an external switch for the zebra effect. It enables you to turn the zebra effect ON and OFF prior to the viewfinder switch. You can then control its appearance via this setting.

Turbo sw. indp.

This allows the turbo switch to operate independently.

Operation 2 (Figure 21.23)

AWB level gate

This shows the range over which the Auto White Balance operates.

Figure 21.23 Operation 2

		Factory	Sony UK	PW
Operation 2	**AWB level gate**			**ON**
	Rec Tally			**BOTH**
	Time code display			**ON**

Rec tally

This switches ON or OFF the Record Tally light.

Time code display

Turns Time code display ON or OFF in the viewfinder and/or on the test output socket. I often set it so that the time code does not appear in the viewfinder but does appear on the monitor attached to Test out. This allows the script supervisor to see the time code relevant to any shot.

SG adjust

SG (sync generator) sets the timing of the output, particularly the horizontal blanking width. This is definitely not a cinematographer's adjustment and is for workshop use only.

Enc. adjust (Figure 21.24)

This page is strictly for the workshop and controls the PAL coder alignment. The standard setting is zero.

Figure 21.24 Encoder adjust

		Factory	Sony UK	PW
Enc. adjust	*Burst start*	*0*	*0*	*0*
	Burst stop	*0*	*0*	*0*
	R-Y carrier bal	*0*	*0*	*0*
	R-Y carrier bal	*0*	*0*	*0*
	Sync start	*0*	*0*	*0*
	Sync stop	*0*	*0*	*0*
	Int SC freq.	*0*	*0*	*0*

Data reset (Figure 21.25)

This page is exactly the same as in the DVW 700 and enables you to reset either or both the user menu and the engineer menu to the factory settings. More often than not, this setting is zero.

Figure 21.25 Data reset

		Factory	Sony UK	PW
Date reset	**User**	OFF	OFF	OFF
	Engineer	OFF	OFF	OFF

You operate the Data reset by aligning the cursor to either the user line or the engineer line, and then pressing UP. This is very useful if you adopt my approach of not having any settings in the user menu and keeping all your personal settings in the engineer menu, for you can, at any time, clear the user menu back to the factory settings as a safety check.

Menu select pages 1–5 (Figures 21.26–21.30)

Each line in all these pages contains a simple YES/NO selection. A YES selection will cause the line to appear in the user menu and a NO selection will keep it out. As we have seen, if any lines contain settings in both the user menu and the engineering menu the effect on the camera will be the sum of both settings. I therefore favour only having these lines in the engineering menu so most control lines in all five of these pages I set to OFF.

Figure 21.26 Menu
select 1

		Factory	Sony UK	PW
Menu select 1	Marker 1/2	Y	Y	ON
	Marker 2/2	N	Y	ON
	Marker 3/3	*N*	*Y*	*ON*
	Vf display 1/2	*Y*	*Y*	*ON*
	Vf display 2/2	*Y*	*Y*	*ON*
	Master Gain	Y	Y	ON
	Shot ID	*Y*	*Y*	*ON*
	Shot display	*Y*	*Y*	*ON*
	Shutter	N	N	ON
	! LED	N	N	ON

Figure 21.27 Menu
select 2

		Factory	Sony UK	PW
Menu select 2	*Set up card*	*Y*	*Y*	*ON*
	Function 1/2	N	Y	OFF
	Function 2/2	N	N	ON
	VF setting	*N*	*Y*	*ON*
	Widescreen	N	Y	ON
	Level 1 (Detail)	*N*	*Y*	*ON*
	Level 2 (Detail)	*N*	*Y*	*ON*
	Level 1 (4:3)	*N*	*Y*	*ON*
	Level 2 (4:3)	*N*	*Y*	*ON*

Figure 21.28 Menu
select 3

		Factory	Sony UK	PW
Menu select 3	*Level 3 skin dtl*	*N*	*Y*	*OFF*
	Level 4 knee	*N*	*Y*	*OFF*
	Level 5 Enc.	*N*	*N*	*OFF*
	Level 6 Enc.	*N*	*N*	*OFF*
	Level 7 Blk/Flr	*N*	*Y*	*OFF*
	Level 8 Gamma	*N*	*Y*	*ON*
	Level 9 Matrix	*N*	*Y*	*ON*
	Level 10 Matrix	*N*	*Y*	*ON*
	Level 11 SC/H	*N*	*N*	*OFF*
	Level 12 A. Iris	*N*	*Y*	*ON*

Figure 21.29 Menu
select 4

		Factory	Sony UK	PW
Menu select 4	*White shading*	*N*	*N*	*OFF*
	DCC Adjust	*N*	*N*	*OFF*
	Offset Wht	*N*	*Y*	*OFF*
	Preset White	*N*	*Y*	*ON*
	Operation 1	*N*	*Y*	*ON*
	Operation 2	*Y*	*Y*	*ON*

Figure 21.30 Menu
select 5

		Factory	Sony UK	PW
Menu select 5	*SG adjust*	*N*	*N*	*OFF*
	Enc Adj	*N*	*N*	*OFF*
	Data reset	*N*	*Y*	*OFF*
	Cameraman 1-5	*Y*	*Y*	*ON*

Measurement

This line is strictly for factory use only.

Marker 1/3 (Figure 21.31)

This page deals with the standard markers in the viewfinder. The Safety zone is a box which will have the same proportions as the aspect ratio, that is, 16:9 or 4:3, but will appear as a fine-line white box overlaid onto the viewfinder image. The purpose of this is to replicate the underscan facility of most monitors one is supplied with to warn the operator that on most domestic televisions the set slightly overscans the picture to ensure that the picture goes to at least the edge of the available screen area. In other words, the audience usually sees a slightly tighter framing than the whole of the recorded image. This can be a very useful marker, but after many years of looking down the optical viewfinders of film cameras, and making these compensations quite automatically, I prefer to look at what I am familiar with – the whole of the recorded area.

Figure 21.31 Marker 1/3

Marker 1/3		Factory	Sony UK	PW
	Safety zone	ON	ON	OFF
	Safety area	90%	90%	90%
	Centre	ON	ON	ON
	Centre H	0	0	0
	Centre V	0	0	0

The next line allows you to see how much smaller you would like the warning box than the total picture area. It is expressed as a percentage of the total area and the factory setting of 90 per cent seems just about right to me, though I know some operators prefer 95 per cent.

The last two lines, Centre H and Centre V, allow you to reposition the cross in the centre of the viewfinder. At first moving a centre cross to anything but the centre might seem a complete waste of time, but there have been occasions, although rare, when this has proved a useful facility. Imagine you are going to take two shots where there will, in postproduction, be a mix between two different characters but the director has asked for the two faces to be as close to the same position on the screen as possible. If you move the centre cross to be in the exact centre of the near eye of the first face and then set the second face to the cross you are a long way towards your goal. If you have to record these two shots with a considerable time gap between them, and you happen to have a spare set-up card, you can record the settings on this card and save it until you need it.

Marker 2/3 (Figure 21.32)

This page allows you to set a box shape in the viewfinder of any aspect ratio and size you might require. The box cursor line is simply an ON / OFF switch for the facility. The box width sets the width via the UP and DOWN buttons, the same being true for the Box height. Box H and Box V set the horizontal and vertical centring of the drawn box.

Figure 21.32 Marker 2/3

Marker 2/3		Factory	Sony UK	PW
	Box cursor	OFF	OFF	OFF
	Box width			
	Box height			
	Box H			
	Box V			

Remember, new to the DVW 790 is the facility on the page entitled Widescreen to insert a preprepared 14:9 or 4:3 box together with the side panels greyed out if required. The adjustable box is therefore only required when shooting in some other aspect ratio.

Marker 3/3 (Figure 21.33)

Test out mix

Switching this facility ON adds the viewfinder markings to the image output coming from the Test out socket on the camera. It can be very useful if, as so often, currently in the UK, you are recording a 16×9 picture but primary transmitting will be in 14×9 for by feeding the director's monitor from the Test out socket they can see the 14×9 box overlaid on the picture.

Figure 21.33 Marker 3/3

		Factory	**Sony UK**	**PW**
Marker 3/3	*Test out Mix*	*OFF*	*ON*	*ON*
	Return Mix	*OFF*	*OFF*	*OFF*
	Test out VF disp.	*OFF*	*ON*	*OFF*
	Test Out Menu	*OFF*	*ON*	*ON*
	RM VF menu inhib.	*ON*	*ON*	*ON*

Return mix

Return mix adds all the viewfinder markings to the return video signal.

Test out VF disp.

The Test out viewfinder display, when in the ON position, adds all the characters that are normally only seen in the viewfinder to the signal coming out of the Test out socket.

Test out menu

Moving this setting to the ON position allows all the menu information to be overlaid onto the picture coming out of the Test out socket. This can be very useful if the operator is trying something new and the DoP is back at the monitor. It makes a decision, and the communication that goes with it, very quick and precise.

RM VF menu inhib.

This is a little-used option but allows the menus to be adjusted via the RM-B150 remote control unit without them being shown in the camera's viewfinder.

VF display 1/2 (Figure 21.34)

This page together with VF display 2/2 comprise the DVW 700's page entitled VF display. All the lines simply decide whether a warning light in the viewfinder comes ON or OFF when the function in question is deployed.

Figure 21.34 Viewfinder
display 1/2

		Factory	**Sony UK**	**PW**
VF Display 1/2	Disp. mode	3	3	3
	Extender	ON	OFF	OFF
	Zoom	ON	OFF	OFF

Disp. mode

This is the only line dealing on this page with the temporary warning display mode. The factory setting is 3 and this seems, when used in conjunction with the settings for viewfinder information already discussed, to be about right. All the other lines deal with permanent displays so are more critical to the operator's peace of mind.

Extender

The first of the permanent display choices decides if you are to be warned that you have switched the lens focal length extender in or not, should such a facility be fitted to the lens in use. Frankly, if the operator does not realize that the lens is working at twice its normal focal length, with the associated loss of two stops on the iris setting, then they, perhaps, should try another day job. A note here. Very few, if any, lenses are capable of as high a quality of image with the extender inserted as without. Therefore this is not a good way of opening the iris if you are trying to reduce the depth of field. You will also be reducing the overall quality of the image by what I believe is an unacceptable level. This is not to say that using the extender for an occasional shot is not a good idea, but if you have a longer lens to get the shot without deploying the extender you are likely to obtain a higher-quality image. So, if you can, change the lens rather than employ the extender.

Zoom

The Zoom setting tells you (with luck, for not all lenses will give a readout accurately) what focal length you are using. I am about to sound like a dyed in the wool film man but if a professional operator or the Director of Photography, back at the monitor, can't make a reasonable judgement of the focal length just by looking at the perspective of the shot things aren't going too well. Having said that, if you are on a student shoot I suggest you keep this facility switched to ON as it's a great way of learning to judge the focal length of a shot.

VF display 2/2 (Figure 21.35)

Filter

There are too many filter options (eight to be precise) to want all that information in the viewfinder. On a fiction shoot the filter wheel setting on the camera should be a conscious decision before you turn on the camera. Also you may well have filters in front of the lens which are not included in this feature. That said, if you are on a rush-around documentary and are likely to be in and out of several locations, indoors and out, having this warning on might be a good idea.

Figure 21.35 Viewfinder display 2/2

		Factory	Sony UK	PW
VF Display 2/2	Filter	ON	OFF	OFF
	White	ON	OFF	OFF
	Gain	ON	ON	ON
	Shutter	ON	OFF	ON
	Tape	ON	OFF	ON
	Iris	ON	ON	OFF
	Audio	*ON*	*OFF*	*OFF*

White

The white balance line will remind you of the last colour temperature to which you balanced the camera. As I find this confusing I switch it OFF. You must choose for yourself.

Gain

The Gain warning is one I always worry about having OFF as it is all too easy to forget one has pushed up the sensitivity of the camera, and therefore reduced the quality of the image. If I am shooting a drama with my usual Gain settings (see the next page) I usually leave this warning OFF as even with the highest gain setting available from my set-up card there will not be much appreciable loss of quality. If, on the other hand, you are shooting a documentary, some of which happens at night where you might be using very high gain settings, then it might be advisable to keep this setting switched to ON.

Shutter

For the shutter warning I agree with the factory. It's all too easy to come away from trying to photograph a cathode ray tube, be it a television or a computer, and forget you have an unusual shutter setting on the camera for there will be few clues in the viewfinder, or on the monitor. However, once you reach postproduction there might well be problems with such things as movement blur. I keep this warning to ON.

Tape

In normal circumstances I set the Tape warning to OFF. This is because I am normally shooting drama and the script supervisor or continuity person will be keeping a careful record of shot lengths and my camera assistant should be checking if we have enough tape for the next shot. If I am operating myself on a documentary I will change this setting to ON as I will probably have no idea where we are on the roll. Even if this is set to OFF the tape indicator on the side of the camera still operates.

Iris

The Iris warning actually appears as a very small number, expressed as an *f*-number, in the bottom of the image area. As some lenses cause the camera not to tell the truth, I switch this facility OFF.

Audio

The last thing I want to see in the viewfinder is the gain indicator for the soundtrack. That job belongs to the sound mixer so this is always set to OFF.

Master gain (Figure 21.36)

This operates in exactly the same way as with the DVW 700 but has some added facilities. The range of switchable gains has been extended to include 36, 42 and 48 dB and surprisingly acceptable images can still be obtained at these settings. The second addition is a line which controls the gain that is instantly switched in when you hit the new Turbo button on the top of the camera. This may be set at any of the twelve options in the menu.

Figure 21.36 Master gain

Master gain		Factory	Sony UK	PW
Master gain	Low	0dB	0dB	-3dB
	Mid	9dB	6dB	0dB
	High	18dB	12dB	6dB
	Turbo	42dB	-3dB	12dB

As I am usually looking for the highest possible picture quality rather than a more sensitive camera the three settings I choose to assign to the external switch are Low −3 dB, Mid 0 dB and High 6 dB. The Low setting is the one I use most as it enables my to open the aperture a little more and reduce the depth of field, which I like.

The Turbo setting I set to 9 dB in case I suddenly need just a little more sensitivity.

Later software for the camera has a further line which allows you to chose between dB figures and ISO / ASA ratings. Gain steps can then be displayed as approximate ASA ratings. According to Sony 0 dB is equal to 320 ASA.

Shot ID (Figure 21.37)

This new and very useful facility enables you to add much more information to that overlaid when you record bars. It appears only on the bars and not on any of the images. You can write up to four separate IDs each having up to twelve characters.

Figure 21.37 Shot ID

Shot ID		Factory	Sony UK	PW
Shot ID	ID-1	Up to 12 characters		
	ID-2	"		
	ID-3	"		
	ID-4	"		

Shot display (Figure 21.38)

Switching any of these lines ON adds the data to the overlay on the colour bars but not to any pictures. I don't switch the cassette number on for at present the convention in the UK is to put the cassette or roll number into the user bits but I do feel that as the DVW 790 becomes the camera of choice this convention may change to one where both the

user bits and the bars ID will be expected to have the roll number on them.

Figure 21.38 Shot display

		Factory	Sony UK	PW
Shot Display	*Date*	*OFF*	*ON*	*ON*
	Time	*OFF*	*ON*	*ON*
	Model Name	*OFF*	*ON*	*ON*
	Serial No.	*OFF*	*ON*	*ON*
	Cassette No.	*OFF*	*OFF*	*OFF*
	Shot No.	*OFF*	*OFF*	*OFF*
	ID select	*OFF*	*ID1*	*ID1*

The ID select line decides which of the four lines on the previous page are to be overlaid on the bars. I think one should be very selective with all this information over the bars as it would be very easy to insert so much that the whole thing became very confusing and really important information was actually hard to find. Having said that, I very much welcome the chance to add more identification at the head of each roll.

Shutter speed (Figure 21.39)

This page is identical to the one on the DVW 700's menu so I will give the same advice. Nothing on this page selects the shutter speeds in use, it simply chooses which are available via the front, covered, switch on the camera.

Figure 21.39 Shutter speed

		Factory	Sony UK	PW
Shutter speed	CLS	Y	Y	ON
	EVS	Y	Y	ON
	1/60	Y	Y	ON
	1/125	Y	Y	ON
	1/250	Y	N	ON
	1/500	Y	N	OFF
	1/1000	Y	N	OFF
	1/2000	Y	N	OFF

This is a bit of a strange one especially for cinematographers from the film world. When filming the shutter speed always relates, in some way, to the number of frames being taken per second, most film cameras having a standard shutter opening of 180°. Therefore the shutter speed will be half the frame rate – 100 frames per second giving a 200th of a second exposure. With some film cameras it is also possible to vary the opening of the shutter to less than 180°, further complicating the issue.

With a video camera, barring a few exceptions developed for slow-motion sport analysis, the number of complete frames taken per second will always be, with the PAL system, 50 per second and, with the NTSC system 60 per second. This frame-taking rate remains a constant.

Given all this, we now have to accept that the shutter speed on these cameras is much more akin to a still camera – independent of frame rate. So what is happening is that the various settings show how long it will take to scan a whole frame while always taking 50 frames per second for PAL and 60 frames per second for NTSC.

The various shutter settings are useful if trying to catch the frame rate of another scanning device, such as a computer or a television running

on another standard to the camera. If you wish to reduce motion blur in circumstances where you are inputting the images into a postproduction procedure it could be advantageous to have them perfectly sharp. Motion blur can be added later after the image has been manipulated. The composite picture will then appear to have a homogenous motion blur.

The lines you can select to flick through via the front switch on the camera are:

- CLS (standing for clear scan) will depend on whether your camera is supplied for PAL 50 Hz or NTSC 60 Hz recording. Either way it will be the best setting for photographing a television set running on the same standard. This is a most useful tool. Keep it available via the front switch.
- EVS (standing for enhanced vertical definition) increases the vertical resolution of the image and may be useful for rare shots that are to go into a lot of computer adjustment but check with the postproduction house first. I would never use this setting for normal cinematography.

There are now six shutter speeds which you can add to those quickly available via the switch on the front of the camera. They are 1/60th, 1/125th, 1/250th, 1/500, 1/1000 and 1/2000. I find I sometimes use the first three and rarely use the second three, so in the cause of simplicity I keep the first three available and leave the second three buried in the menu where I can always find them in an emergency.

! LED (Figure 21.40)

This page simply switches ON or OFF the named warnings and there are two differences to the same page in the DVW 700. There is the addition of a warning when the new facility of ATW (Automatic Tracing White) is switched ON. I keep this line set to ON as on the rare occasions I use this facility I need to be absolutely certain that I have switched it OFF when I have finished with it. The second addition is that the camera's internal filter warning lights have been separated into two lines to enable separate warnings for the neutral density and the colour correction wheels.

Figure 21.40 ! LED

! LED		Factory	Sony UK	PW
	Gain	Y	Y	ON
	Shutter	Y	Y	ON
	White Preset	N	N	OFF
	ATW Run			**ON**
	Extender	Y	Y	ON
	Filter 2,3,4	**N**	**N**	**OFF**
	Filter A,C,D	**N**	**N**	**OFF**
	A. iris override	N	N	OFF

Index